Art, Design and Craft
A manual for business success

John Crowe MA, MSc, FRCA, FBIM, MCSD
James Stokes BA, Dip. Business Studies

Foreword by the Marquis of Queensberry

Edward Arnold
A division of Hodder & Stoughton
LONDON BALTIMORE MELBOURNE AUCKLAND

© John Crowe and James Stokes 1988

First published in Great Britain 1988 by
Edward Arnold, the educational, academic and medical
publishing division of Hodder & Stoughton Limited,
41 Bedford Square, London WC1B 3DQ

British Library Cataloguing in Publication Data
Crowe, John, *1929–*
 Art, design and craft : a manual for
 business success.
 1. Small business——Great Britain——
 Management
 I. Title II. Stokes, James
 658'.022'0941 HD62.7

ISBN 0 7131 7514 1

All rights reserved. No part of this publication may be reproduced or
transmitted in any form or by any means, electronically or mechanically,
including photocopying, recording or any information storage or retrieval
system, without either the prior permission in writing from the publisher or
a licence permitting restricted copying. In the United Kingdom such licences
are issued by the Copyright Licensing Agency, 33–34 Alfred Place,
London WC1E 7DP.

Text set in 10/11 Plantin
by Colset Private Limited, Singapore
Printed and bound in Great Britain by
Biddles Ltd, Guildford and King's Lynn

Contents

	Foreword	v
	The Preliminary Framework	1
1	Who is This Book For?	1
2	Pre-planning	3
3	Starting up	7
4	Premises	12
	The Legal Framework	16
5	Contracts	16
6	Forms of Business Organisation	22
7	Protecting your Work	25
	The Financial Framework	38
8	Financial Records	38
9	Financial Management	51
10	Cash Flow Calculation	64
11	Raising Money	68
12	Taxation	74
13	Insurance – Protecting your Livelihood	78
	The Marketing Framework	82
14	The Concept of Marketing	82
15	Range Building	87
16	Promotion	91
17	Pricing, Costing and Paperwork	104
18	Selling your Work	114
19	The Artist/Gallery Relationship	125
20	A Guide to Commissions	129
21	Exporting	143
	The Supporting Framework	146
22	Protecting Yourself – Health Hazards	146
23	Photographing Artwork	151
24	Getting Help	171
	Appendix	181
	Index	195

Foreword

Many students at universities study a subject without any wish or intention of pursuing it after they graduate. Students of art, craft and design, on the other hand, usually consider their study as the beginning of a professional career. Many graduates of art colleges want to set up their own studios, and this effectively means starting their own businesses.

During the years I taught at the Royal College of Art, I witnessed the appalling difficulties that graduates faced when setting up workshops or designer studios. John Crowe joined the College in 1973 to provide courses in Management Studies, as we knew that we had to give students some guidance and help for survival in the outside world. During the years that John has worked at the College, he has given enormous assistance to many students, and many workshops around the country may well owe their survival to him.

At last he and his associate, James Stokes, in their *Manual for Business Success* have put together all the relevant information that artists, craftspeople and designers need to start up on their own. It does not, of course, mean that they will all survive the vicissitudes of the commercial world, but at least they will have a better chance. Art students who want to do their own thing and set up on their own will benefit enormously from this book. I know of no other that tackles this subject in such a simple and straightforward way.

David Queensberry

Acknowledgements

The authors' sincere thanks are due for contributions made to the preparation of this text: to Roger Broadbent for the photography section, Anna Harbert for the legal framework, Thomas Crowe for the computer programs, and to those who gave their time towards the preparation of the study briefs.

The Preliminary Framework

1 Who is This Book For?

This book has been written primarily for creative people who wish to profit from their creativity.
 It is for:

- fine artists
- designers
- craftsmen and craftswomen

whether:

- student
- beginner
- established
- despairing

working:

- overtime
- full-time
- part-time
- for recreation

All people have their personal myths about who they are, where they came from and where they are going. It doesn't matter whether they are true or not, the important point is whether they are believed. For, if they are, they condition the way decisions are made and therefore the behaviour of the believer.

A common belief about artists and craftspeople is that they cannot be effective in business, as if good commercial practice were somehow damaging to the creative process. Belief in this myth is reflected in the traditional attitudes held by artworkers towards the business side of their work. Through sloppy commercial practice they have, in the past,

subsidised the other parties to their business dealings: customer, collector and inland revenue. This attitude has been generated by the structure of many educational courses where syllabuses focus solely on the theoretical and technical aspects of arts and crafts. It has been assumed that the skills and techniques of business will be assimilated painlessly and naturally.

In reality, however, it is more probable that this knowledge will be acquired slowly, painfully and expensively as the result of unpleasant experience. Few have recognised the reverse position that ignorance of and aversion to commercial concepts and procedures can in themselves stifle creativity. Why is the artist traditionally depicted as living in a garret? How much talent has remained latent because artworkers have been unable to support their creative activities? They have not introduced sufficient added value to their work to give time for thought, research and experiment.

There is an opposite, positive view that an informed attempt to structure the financial, promotional and organisational aspects of an art or craft venture is in itself a creative exercise, rich and fulfilling to the individual.

This book is written in the conviction that there is nothing magical about being a competent business person or entrepreneur. The basic principles of management are well known and tested, and while some may criticise the lack of depth in the treatment of some topics, to do so is to misunderstand the aims of the book. It is not intended to provide a complete coverage of all topics. More detailed treatments are available in any number of texts, some of which are listed in bibliographies under relevant chapters and at the end of the book. The aim is to develop in emerging artworkers, or established professionals, positive attitudes towards the many aspects of running a business, so that the pursuit of sound practices and procedures becomes a continuing personal goal.

Note

Some of the repetitive processes in use – the preparation of cashflows, overhead calculation and costing – have been designed for simple use on a home microcomputer. Programs for the BBC Micro can be found in the appendix.

2 Pre-planning

You may be a student looking towards your finals, an employed craftsperson, or an amateur considering turning professional. Whatever your situation, if you are reading this book you either intend or would like to set up your own craft workshop as a self-employed person.

It is essential to start saving, thinking, planning and, most important, putting it down on paper as early as possible. Enthusiastic discussion with friends and relations gets toned down to practicality if you write it out and read it the following morning. The section below on objectives will help you decide what you want to do, but your objectives must be considered, written down, modified and polished if you are to have a clear plan of development. Also write down what you see yourself doing in five and ten years from now. Is it possible? Does it fit into the rest of your life? Will you enjoy it?

For as long a period as possible (starting *now*), before you switch on the power in your workshop and start producing, you must accumulate the tools you will need for success. These tools, listed below, will be covered more fully later in the book; this is a preliminary checklist, and should be read in conjunction with the next chapter on *Starting up*.

Money

Whatever your plans, you will certainly need capital. If you have no savings, you will have to borrow. How much? From whom? When?

Experience

You may be a skilled weaver or potter, but do you really know how established businesses do it, at what cost, and how quickly? What shortcuts do they take, and what services do they use? Visit them and find out. As a student or amateur you will be reasonably welcome; as a competitor you may not.

Contacts

Collect names, addresses and catalogues from everyone you know or have heard of in your field of activity. If you are still a student, your college departments and lecturers will have a wealth of information built up over

the years ready to be plundered. For every trade there are small specialist firms equipped to do certain difficult, time-consuming operations. These can help you in the early stages when you are short of plant and machinery. Find out who they are. In your card index include possible customers, their location, size, what they buy and in what quantities, price levels and when they do their buying. Visit trade fairs, shops and galleries to find the ones which might eventually be interested in you.

Plans

Start with a rough timetable and elaborate it as you progress. It is important to find out at an early stage how long it takes to get things done. Suppliers of equipment and contractors of services are not sitting at home waiting for you to contact them; they have other jobs and orders in hand. A piece of machinery that is urgent for you may take three months to deliver.

Yourself

Presumably you have the enthusiasm, but have you got the nerve, and are you articulate enough to sell yourself along with your product? You must learn to convince people that you are good at your job. Customers like to buy from artists and craftsmen because they are personally committed to their trade, and have a feeling for what they make. It is up to you to persuade people that this is true in your case. Customers will then go away happy, not only with the goods, but with the atmosphere in which they bought them – and maybe come back for more. All selling is to some extent acting, and if you do not bother to become professional at it, you will not do justice to your products. So study other people's methods, and select those which suit you and which you can use convincingly.

Objectives

In running a workshop, as in many other activities, it is important to know where you want to go and to know the laws or rules which reduce your freedom of action. Both objectives and constraints may change over a period of time, and objectives certainly vary from person to person. Most people have to take some note of the views of others, and for the newly established artist or craftworker there can be nothing more likely to cause stresses and strains in the studio than if spouse, family or partner disagree substantially over the objectives of the enterprise. Only the truly one-person business is in the fortunate position of not having to reconcile the individual preferences of several people. Whether you are working with others or alone you should be as clear as possible about your aims from the start, or you may experience the financial costs and personal frustrations of having travelled down the wrong road and being obliged to retrace your

steps and start again. The success of a business can only be measured by the extent to which it achieves its objectives, however unusual or particular to yourself they may be.

Objectives may usefully be divided into economic and non-economic factors, and those applying to the short and to the long term. Economic objectives might include:

- to earn £5000 after tax in the next year
- to increase this annually ahead of inflation
- to achieve a return of 10% after tax on the capital tied up in the studio.

Non-economic objectives could include:

- to remain a one-person business
- to move the studio to the country
- to work only 50 hours per week after the first two years.

In the business world generally, objectives and the means of achieving them are quite distinct. Most traditional business objectives are formulated in terms of money, and an entrepreneur may not be too concerned over the form of his product, or whether his markets are domestic or export, up- or down-market, the industrial buyer or the man in the street.

To the artist or craftsperson, what to many in business is a means to an end may be an end in itself. Making individual pieces of fine furniture would, to an entrepreneur, be a possible means of making money. If this activity did not fulfil his financial objectives, he would probably discontinue it and find another product rather than accept a lower profit.

For the craftworker the making of fine furniture may be of prime importance. If this cannot be done while maintaining an economic objective (say, earning £5000 in the first year), he may prefer to modify this aim (and earn £4000) while continuing to make the kind of furniture that is personally rewarding.

Personal objectives may themselves be conflicting. One may wish to live and work in the country, and also to increase the scale of the business by employing skilled staff. It may be possible that such employees are only to be found in the town. It is therefore most important to assign priorities to the list. The disruptive financial consequences of changed objectives can be considerable. If the change is caused by external circumstances, it is unavoidable and must be coped with, but if it is simply an admission of not having thought the matter through at the beginning, then it is something which is within one's control, and could have been prevented.

It has been mentioned that conventional business aims are expressed in terms of products and markets. As a craftsperson you may be inflexible about what you are prepared to make, but you should from the start continuously research what your markets might be. Time and money spent on finding the widest range of possible customers for your work, and establishing clear marketing objectives, is an activity too often neglected by small, new businesses.

6 Art, Design and Craft

To sum up: you need to think about:
- money
- experience
- contacts
- plans
- yourself
- objectives

3 Starting up

Whatever the scale of your projected business, and regardless of whether you have already begun or are planning it for the future, you need to acquire a basic business survival kit *now*. These are the components: most of them should be put together at once, the last three can wait until the launch of your enterprise. The items are discussed more fully later in the text; this is a checklist for immediate action.

- diary
- address book
- filing system
- card index
- calendar of trade events
- year programmer
- letterhead
- business cards
- curriculum vitae
- account book or ledger
- accountant
- business bank account
- personal computer

Diary

A large page-a-day diary acts as a log of your activities. You should include in it not only a record of appointments and people seen, but also events in the future:

- work to be carried out
- deliveries to be made
- supplies to be collected
- promises to be met

If you have agreed a delivery on the 14th and it will take four days to complete, insert a warning on the 9th that you need to start the job on the following day. Use the bottom few lines of each day to record all business expenditure, as a reminder for your entries into your account book.

Address book

A portable record of addresses and telephone numbers. Be sure to include postcodes as they are now important for quick delivery.

Filing system

In business many pieces of paper are valuable and are actually worth money: receipts of purchases, orders, letters from customers. You will begin to accumulate some of these even before you start trading and, if they are not safely stored and easily retrievable, money or goodwill may be lost. A set of cardboard file folders may be used, but the most convenient and least loseable is a concertina file, a set of file pockets joined at the spine between hard covers and closed with a tape or clip. The pockets can be labelled to suit your requirements:

- receipts for materials
- equipment
- heat, light and power
- premises
- tax
- bank
- customer orders
- customer correspondence
- copies of your invoices

Card index

An alphabetical index of small cards (3 × 5 inch) must duplicate the information stored in the address book, and constantly be kept up to date. Briefcases and handbags are often lost or stolen, and the loss of an address book can be as expensive to a business as the loss of money and credit cards. The card index should also be used to build up a register of customers, suppliers, contacts, subcontractors, materials and technical information. It should be cross-indexed by names and by types of information (for example, a weaver would have a card headed 'Yarn Suppliers' under 'Y', listing all suppliers alphabetically by name).

Calendar of trade events

Most shops and galleries have periods of buying activity (and inactivity) during the year. They may be related to the seasons, to Christmas or Easter, to tourism or holiday periods, or even to a particular customer's internal accounting. You must know the optimum time to make a selling approach, and plan your development of new products, sampling and production accordingly. Consult the trade journals, colleagues and friends, and above all customers, and construct a calendar showing selling and buying periods

and, projected back from these, your own dates for production, purchase of materials, sampling, designing and developing.

Year programmer

This is a single-sheet calendar that should be permanently displayed and to which should be transferred all the future information from the diary and the key dates from the calendar of trade events. It can then be used as a basis for planning all business activities: purchase of materials, production, selling trips, exhibitions and holidays (if you can afford the time or money).

Letterhead

A business letterhead gives a professional appearance. Even if you have not yet begun to trade, a simple heading will help to convince suppliers, customers and loan- or grant-awarding bodies that you are committed to your enterprise. It is a mistake initially to pay large sums for the design and production of a large quantity of headed paper, particularly as you will probably at the first attempt either omit some vital information or come to dislike the format before the stock of paper is used up. Any artist or craftsperson should be capable of producing a competent layout from which a copy bureau can xerox 25 or so sheets to be used for correspondence, invoices and statements. When the business is under way and you are certain of how you want to project yourself is the time to procure a larger quantity of professionally produced headed paper.

Business cards

The same arguments apply to business cards. While they are not immediately essential if you are trading only in the UK, you must have them if you have business dealings with any overseas customers or suppliers who may not take you seriously if you are unable to produce a card. Copy bureaux can produce small quantities from a separate original layout, or can reduce your letterhead to card size if the proportions are suitable. As with the letterhead, do not be seduced by the lower cost of large quantities, but order initially only a small number. Bear in mind, however, that if you intend showing at a trade fair or exhibition you would expect to hand out between 50 and 100 cards per day.

Curriculum vitae

This is your personal history, which you will need to draw on when making applications for grants, loans, teaching or other jobs, insurance, or when preparing material for PR or promotional purposes. A master copy containing all information in full – which will almost certainly never be issued in its complete form – should be kept on file and periodically updated. The master copy should consist of four sheets.

Sheet 1
Personal details. Name, address, telephone number, age, date of birth, nationality, marital status, children.
Sheet 2
Education and qualifications. Schools and colleges attended, with dates. Exams taken, dates and grades. Professional qualifications, membership of societies and professional bodies.
Sheet 3
Experience. All work experience with dates, competitions entered or won, countries visited, languages spoken or written, driving licence.
Sheet 4
Other interests. Sports, leisure activities, hobbies, both past and present.

When making out an application or preparing a resumé for publicity purposes, the relevant and interesting data can be selected from the master copy of the CV and arranged to maximum advantage. If applications are filled out each time from scratch and without reference to the master copy, the emphasis will almost certainly be wrong or some vital elements may be omitted.

Account book or ledger

As with a filing system, there is a tendency to delay setting up a system of bookkeeping until the business is well under way. By this time there will have been considerable and varied expenditure, all of which will eventually be tax-allowable. If it is not recorded centrally as it is spent, some – maybe major – items will be left out.

As soon as the decision is made to start a commercial operation you should buy a ledger or account book and begin to keep a financial record, even though you will probably change to a more complete system soon after you begin trading.

Accountant

Self-employed people need an accountant. He or she will give financial advice, instruct you in your bookkeeping and negotiate for you with the inland revenue. While you do not neccessarily need an accountant before you begin trading, you should not delay until you are in conflict with the inland revenue, but should engage one at an early stage to benefit from the advice available.

Business bank account

Open a second business account at your bank, with its own cheque-book, to avoid any confusion with your private income. Never pay business expenses from your private account or vice versa. If necessary, transfer money from one to the other first, and then pay with the appropriate cheque-book.

Personal computer

A computer may seem excessive for a business that has hardly begun. However, with the range of small computers available, with many programs for bookkeeping, planning and data storage, and with their price falling towards that of an electric typewriter, it will not be many years before even the smallest enterprise will use one as a matter of course.

That is the checklist for starting up a small business. It is a survival kit, so put it together now.

4 Premises

Location

Where you set up is likely to be governed by a combination of factors – where you live, where your customers are and what you can afford. Working from home has the advantages of security (you have your premises already), accessibility and cost savings, but is likely to be restricted by the suitability of the premises, lack of space, possible annoyance to your neighbours and planning controls. Separate business premises will be more expensive, but may have more space for later expansion and be more convenient for your suppliers and customers.

You may well find that to take premises within easy reach of your customers, whether these are shops or private individuals, is more profitable in the long run than to take more remote premises at a lower rent. This applies even more if you want to attract casual sales at a shop or showroom of your own; to do so you should be in an area of heavy customer traffic, and ideally the customers should be in a mood to spend money as in a holiday resort or tourist area. (For further remarks on having your own showroom, see Chapter 18 on *Selling Your Work*.)

It is almost certain that you will not have as much money as you need and this will restrict your choice. If you are obliged to take premises that are barely adequate for your initial needs but intend to move to something larger as business increases, you should spend as little as possible on installations or fittings which you will have to leave behind when you go, or on which you will not be able to recover the cost.

Local authorities have funds available for grants and loans or initially rent-free premises, to encourage the setting up of new enterprise in their areas. Their objectives are to provide extra employment and to improve the environment, particularly in decayed city centres. For lists of premises and details of selective assistance, consult the regional offices of the Department of Trade and Industry (in the phone book) or the New Enterprise Office of your county or town hall.

Planning controls

Planning law restricts what can be done to a building and the uses to which it can be put. Any external alteration to a building – from building an

extension to affixing a neon sign – must be approved by the local authority. Providing you are not so foolish as to spend a lot of money on alterations without getting permission, this type of restriction should present few problems.

A craft workshop is more likely to fall foul of the regulations concerning the use of the building. The planning laws divide buildings into various 'use classes', such as residential, office, and industrial. Often only certain types of use are allowed in a particular area of a town; it is obviously desirable to prevent heavy industry from starting up in a residential area, for example. For this reason, you must get permission before embarking on any 'change of use'. The problem for craftworkers is that, strictly speaking, even the quietest and cleanest craft is 'light industry' to the planning officials. The 1971 Planning Act defines as an industrial building any premises where goods for sale are processed, made, or part-made. Therefore all craft studios, and even painters' studios, fall legally into this category. In the 'Use Classes Order' forming part of this Act, *light industry* is defined as 'an industry such as may be carried out in a residential area without nuisance'. Nuisance in this context could include noise, fumes, unsightly structures or stocks of material, and a continual stream of suppliers' lorries or customers' cars blocking the road and annoying the neighbours.

The Act does allow for some measure of alteration or erection of outbuildings for 'uses incidental to the enjoyment of the dwellinghouse as such', and so a kiln in an outhouse for hobby purposes could be allowable, while a commercial kiln operating at all hours very probably would not.

Many craftsmen take a chance when they first go into business, and operate from home in the hope that no-one will notice. This is a dangerous and illegal procedure. They are likely to be discovered and ordered to stop operating by their local planning authority just at a time when the business is increasing; the result will be loss of orders, of goodwill, of customers, and often of the business itself.

There are two rules to follow in the process of establishing a business at home. First, you should consult your local planning authority at an early stage to establish whether there are in fact restrictions applying to the proposed premises and how they can be met. If you intend making application for change of use, you should discuss with them how the premises should be described – craft studio or craft workshop, perhaps – and get their advice on how to present your case. Planning authorities are not antagonistic to studio operations, but they do have tidy minds and tend to try and relate all businesses to the appropriate section of the Act. To avoid finding yourself housed in an overlarge factory unit on an industrial estate, you may need to exercise some persuasion. Here, as with raising money, there is no harm in emphasising the artistic nature of the business, the improvement-of-the-quality-of-life element. Show the planning representative what is to be made and get him interested. Mention any backing that you may have, for instance from the Crafts Council or CoSIRA.

The second rule is to be on good terms with your neighbours. They are the ones who will complain to the council if you keep them awake by hammering or drive them out of their garden with smoke, or kill off their plants. They will also be consulted by the authority as to whether you do constitute a nuisance in the area. You will be dependent on their goodwill as long as you work at home, so make a point of being a good neighbour yourself and throw in the occasional present from your surplus stock.

Preparing for use

Getting your workshop equipped and ready for use will involve you in sudden unexpected expenses, unless you plan ahead. The installation of services, such as electricity, may involve delays over which you have no control, and substantial lump sum payments. It is better to try and foresee these by preparing a schedule which includes, as fully as you can determine, all the factors involved: the time needed for completion of each stage, and an indication of when you will have to spend money. This programme acts as useful checklist when discussing what you want done with builders, suppliers and public service installers. It also tells you whether or not your preparations are running to time, while work is in progress.

The example shows the planned preparation of a pottery which, because of its large scale of operation, is spread over sixteen months. The items of personnel and sales, while not strictly related to premises, are included to show how they relate to the progress of the premises.

	JAN	FEB	MAR	APR	MAY	JUNE	JULY	AUG	SEPT	OCT	NOV	DEC	JAN	FEB	MAR	APR
Premises	Find premises Premises found £						Planning permission Premises Kiln Contracts space ready		First Dryer Heating Service Toilets	Jolley area Build racks Benches, plaster tables etc.		Factory inspectors All production areas completed All building completed £				
					Finance Contracts											
Services						Instal ordinary power Consult Electricity Board Gas Board and Water Board		£Instal Three Phase £		Instal Gas £		Kiln ready £				
Kiln	Find best kiln builders/materials				Consult kiln expert Finalise type and firing fuel			£ Kiln order	Lead Time		Kiln building	Kiln Testing £ +		Kiln ready for Production		
												Find and engage a general hand				
Personnel	Look for assistant/partner				Architect £ Assistant found		2 salaries 2£		Advertise for 3rd person £ 2£	2£		Third person begins work (Jolleying) 3£				3£
Production	Absolutely finalise clay body				Multiply moulds and saggars		Moulds ready (transport)		Mix clay/Begin making pots				Full scale production			
							All main equipment found or ordered									
Equipment	Weather eye open for good secondhand equipment, jolley arms, butting pugmill, mixer £						Order day for moulds £ Clay for saggars £	Plaster Wall clay mixer and Pugmill £ Order glaze materials Clay arrives £		All miscellany ordered instal butting machine and jollies £		Delivery of Scales, Buckets etc. £ Glaze materials arrive £		Acquire whirler for mould replacement	Material replacements	
												Mix glazers				
Samples	Making samples, market testing £ + provisional orders													Industry Trades Fair Exhibit orders	First main delivery	

The Legal Framework

5 Contracts

There is no special magic about contracts. We all make many minor ones daily, every time we catch a bus, park in a car park or buy goods in a shop. The basic elements of all contracts are the same, but contracts differ widely in their terms and in the seriousness and time span of their effect on us. Contracts can be made either by word of mouth or in writing, and both kinds are valid in law. (There are some specific instances where a written contract is obligatory – as in the lease or purchase of land.) Remember, however, that if you need to enforce the contract, it is far simpler to establish the precise terms – or indeed the existence – of a written contract than an oral one, where it will often be your word against that of the other party. (See *Forming a contract* below.)

Essential elements

Behind all contracts lies the concept of a bargain made between two or more parties. To be enforceable a contract must contain the following essential elements.

Offer

First, there must be an offer made by one party: to sell something, to buy something, to create something or to do something. This must be unequivocal, in that the offerer shows a willingness to enter into a binding agreement if, and as soon as, the person to whom it is made accepts. Thus, 'I will give you £30 for your pot' is an offer to buy; 'I am thinking of asking you to paint my portrait' is not, as the offerer is clearly still making up his mind.

Goods priced in a shop window do not constitute an offer. Such display for sale is termed an 'invitation to treat' ('treat' as in 'treaty', meaning to

trade). The offer is made only when a customer enters the shop and says that he wants to buy the article displayed.

Acceptance

To create a binding contract, acceptance must also be unconditional. If the person to whom the offer is made (the offeree) responds with an offer of varied terms – such as a lower price – this will constitute a counter-offer, not acceptance. For example, in the situation above, if instead of accepting the £30 offered, the potter asked for £40, this would be a counter-offer. The purchaser who made the original offer now becomes the acceptor, and if he agrees to the £40 there is a matched offer and acceptance, and hence a contract. If he does not agree, there is no bargain and no contract.

Consideration

This, in legal terms, is the price that is paid. Something of economic value must be paid by both sides – money, goods or services. Subject to certain special exceptions, the law will not enforce gratuitous promises (where there is consideration on one side only). A promise to paint a picture for your aunt would not on its own entitle her to sue you if you failed to produce it. There must be something capable of valuation in economic terms given in return for the promise. This is usually money, goods or services, but it can also be a promise given in exchange.

If a painter offers to paint a picture in exchange for a promise to make for him a set of bookshelves, the exchange of promises can create a binding contract. Once both parties have agreed, the production of the picture would require the other party to keep the bargain. Conversely, a promise by your aunt to declare you her favourite nephew in return for the painting would not be enforceable, as such a declaration would have no economic value.

The terms of the contract

Terms can be divided into two sorts: those the parties make themselves – express terms – and those imposed by legislation or implied by custom and practice.

Express terms

Broadly speaking, unless they are illegal, immoral or contrary to public policy or statute, parties to a contract are free to select whatever terms they choose, and the form in which they appear. Each situation may require different terms, and it is not practicable to list every eventuality. There are, however, some common aspects of formulating a contract where care is needed to avoid future disagreements.

Pessimists make the best contracts, so sit down and think what could go wrong. Be clear about:

- what precisely you are buying or selling, for how much and when.
- how payment is to be made, whether by cash or cheque (with a cheque card from unknown customers), and in what currency (in overseas trading).
- your terms of payment – if they exist – which should be referred to in the contract.
- loss, damage and insurance in transit. If the goods are to be sent, who carries the risk that they will be spoilt or lost on the way? If you are responsible, are you insured? The risk must lie with you, the carrier or the customer. Be sure that each party knows where it lies, and write it into the contract.
- loss or damage on your premises. The risk for purchased goods awaiting shipment or collection or for the clearance of a customer's cheque, may still be yours, or may have passed to the other party. If the risk is yours, be certain that your insurance covers it. If it has passed to the other party, be sure that he is aware of it.
- deposits: they may be an advance (part-payment on a firm sale: a contract to buy) or a sum paid to obtain an option to buy at a later date. In both cases a precise time limit must be set for the completion of the payment or for the option to be taken up. This period should be as short as you can make it. You must agree whether the goods are to be removed from your display or from exhibition in the interim. Both parties must be clear whether the deposit is refundable or not, or in what circumstances a refund will be made or retained. In general, where the temporary withdrawal from sale might reasonably have involved loss of trade or profit, the deposit is non-refundable. Where you have suffered no likely loss, the arguments for retaining the deposit are less strong. An element of common sense is needed here. You would be unwise to risk offending a regular customer who changes his mind by hanging on to a deposit. Galleries and exhibition organisers will have their own prescribed terms of business and methods of reserving sales through deposits or other means. Find out what they are, and while showing on their premises, ensure that your terms do not conflict with theirs.

For the process of making a quotation and costing a commission, with stage payments, see the chapter on *A Guide to Commissions*.

A rule to remember

Customers or clients who will not talk money at the start of a negotiation never pay at the end. Those who promise to 'see you all right' never do so.

Forming the contract

Contracts are bargains freely entered into by both sides, and must not have been entered into under duress or undue influence, nor as a result of misapprehension (known in law as 'mistake'), nor as a result of misrepresentation by one or both parties.

Duress and undue influence

Contracts entered into as a result of violence or threats of violence, criminal procedures or seizure of property, either to one of the parties or to someone sufficiently close to him for the threat to be treated as a threat to himself, will be set aside by the court at his request. A contract may also be voidable where the law presumes from the nature of the parties' relationship that undue influence has been brought to bear (unless it can be proved that the weaker party had taken independent legal advice). This arises particularly between parent and child, doctor and patient, solicitor and client, trustee and beneficiary.

Mistake

Where the parties entering into a contract do so under a fundamental mistake about some element of the subject matter, there can have been no true bargain. In this context the law considers only mistakes of fact, and only those which fundamentally undermine the parties' agreement. Mistakes as to the law, and their effect on the contract, will not be considered, as all persons are presumed to know the law. There are two main types of mistake:

- mistakes as to the existence or identification of the subject matter (for example, the sale of a painting which, unknown to both parties, has been destroyed.) Mistakes as to value or quality, on the other hand, will not generally invalidate the contract.
- mistake as to the nature of the contract. The courts have been willing to set aside contracts where one party enters under a misunderstanding as to its nature, (for example, when an artist contracts to paint a picture and subsequently finds out that it is intended for Christmas cards).

Note, however, that the courts will not set aside a contract on grounds of mistake if one party simply fails to read the contract before signing.

Misrepresentation

This is an untrue statement of fact made at the time or before the contract is made, with the intention that the other party will act upon it. If he does so, he may subsequently be entitled to set the contract aside, and, depending on whether the statement was made fraudulently, negligently, or innocently, may be entitled to damages.

- Misrepresentation is fraudulent when made knowingly or recklessly (not caring or believing it to be true): provided the person misled has not reaffirmed the contract after discovering the fraud, and provided the goods have not passed into the hands of a third party, the wrong party will be entitled to terminate the contract and sue the other for deceit.
- A statement is negligent if the party making it had no reasonable grounds for believing it to be true. The party to whom it is made may recover damages and declare the contract void.
- Innocent misrepresentation, where the party does not know the statement to be untrue, similarly allows the other party to set the contract aside, but not normally to claim damages. Only if it is impossible to restore the parties to their original position will the court grant damages instead of setting the contract aside: it will not, however, order both.

You must therefore be most careful that the statements you make before entering and while forming a contract are accurate, and contain terms that you can fulfill.

Breach of contract

All contractual terms can be divided into conditions and warranties. Breach of condition gives the right to treat the contract as at an end; breach of warranty gives the right to damages only. Conditions are therefore fundamental terms, and warranties less important ones.

The Sale of Goods Act, 1979, implies certain terms into contracts for the sale of goods. These are:

- that goods sold in the course of a business (as opposed to by private sale) by description, specification, colour, size, weight, quality, etc., shall correspond to that description.
- that the seller has the right to sell the goods; i.e. they do not belong to somebody else, nor do they infringe upon another's patent, copyright, trademark, or other right.
- where goods are sold by sample, the bulk of the goods supplied will correspond to the sample.
- that goods sold in the course of a business must be of a merchantable quality, except where the defects are specifically drawn to the buyer's attention, or where the buyer examines the goods before purchase and such examination ought to have revealed the defect. Goods are of 'merchantable quality' only if they are, 'as fit for the purpose for which goods of that kind are commonly bought, as is reasonable to expect having regard to any description applied to them, including the price'.
- that the goods will be reasonably fit for the purpose for which they are

supplied. Where the buyer wants goods for a particular purpose, and makes it known to the seller either expressly or by implication; if the goods are of a kind commonly sold by the seller and the buyer relies on the seller's skill and judgement, there is an implied condition that the goods shall be reasonably fit for that purpose.

The following warranties are also implied:

- that the purchaser's possession of the goods shall not be disturbed. For example, if the goods were stolen, they might be recoverable by the person from whom they they were stolen.
- that the goods shall be free from any charge or encumbrance in favour of a third party, unless declared or known to the buyer before the contract is made. This might occur when goods initially bought on credit are sold before they are fully paid for. The credit company may still therefore have rights, or a charge on them.

Remedies for breach of contract

Wherever a contractual term is broken, the innocent party may claim financial compensation. In legal terms this is called 'damages'. In certain circumstances, where for example the breach affects the whole or a major purpose of the contract, or where one party shows no intention of performing the contract, the innocent party may treat the contract as discharged, and will be relieved of the obligation to continue to perform his part of the bargain.

Damages for breach of contract may be agreed in advance. If this is done, they are called 'liquidated damages'. Where damages are *un*liquidated, they aim to compensate the innocent party for the financial loss caused by the breach. This will include not only loss immediately caused by the breach itself, but also any consequential loss that results from the breach, for example, loss of an important order due to non-delivery. Such damages are recoverable, however, only if it was a reasonably foreseeable consequence of breach: in the previous example, the purchaser could only be compensated for his lost order if the supplier was aware of the order, and of the importance of the timing of his supply.

6 Forms of Business Organisation

What kind of business?

Choosing a structure for your business is an important first step in setting up; the framework you select will affect the tax you pay, your liabilities for debt and your working relationships with others.

Sole trader

If you choose to operate alone, and are self-employed, you will be a sole trader. This has two main advantages: you will be answerable to no-one, and, although the income of the business will be treated by the inland revenue as your personal income, you may – unlike the employed person – set off against tax a range of running expenses, including up to two-thirds of domestic running costs if you work from home. (See Chapter 12 on *Taxation*.)

Setting up as a sole trader requires no capital outlay, and there are no formalities to complete before you can begin trading. The main disadvantages are:

- it can often be a lonely way of working
- it may be difficult to attract backers to finance expansion, as you cannot offer them a share in the business
- you will be liable for all debts, to the full extent of all you own, including your own home.

Partnership

If you do not like the idea of going it alone, entering into partnership with one or more associates may seem an attractive proposition, particularly if you will be able to share costs and equipment. Togetherness of this kind can, however, be a mixed blessing. You will share not only the savings in cost, but also the debts and liabilities of the partnership. This means that if a wronged person wishes to take legal action they may sue the partnership and/or each member separately by name. If, for example, your partner allows dangerous chemicals to escape from your premises, or runs over a passer-by in the firm's van, or if you are sued over a contract, the liability

Forms of Business Organisation 23

will be both 'joint' (the partnership) and 'several' (each partner individually).

Liability, as with sole traders, will be to the full extent of almost all your assets and possessions, with the added danger that if your partners are unable to pay, you will be liable to pay their share as well as your own. This would be less critical if it were possible to control the contracts made by your fellow partners, but legally each partner has the ability to bind the partnership to the deals he makes on its behalf.

You may agree among yourselves that no contracts will be entered into without the written consent of all partners, but the law of agency provides that each partner is deemed to be the agent of the others. Therefore, because ostensibly he has the authority to enter into agreements on behalf of the partnership, his contracts will be legally binding on all partners, despite any internal agreement they might have to prohibit the making of such contracts, unless the other party knows that your partner has no authority to contract. Your only remedy would be for you to sue the offending partner, but as he may be insolvent by this time, it could be too late. The extent of this liability for the mistakes of the others makes it imperative that you select partners very carefully.

Setting up a partnership

There are no formal requirements, but partnerships are normally set up by a deed, which will included:

- the purpose of the business
- the rights to share in profits
- the authority to enter into contracts on the partnership's behalf
- the authority to sign cheques
- procedures for resolving partnership disputes
- provision for dissolving the partnership
- other special provisions to meet your business circumstances.

If no such deed is drawn up, your rights and obligations will be implied by law under the Partnership Act of 1890, and will, for example, require decisions by majority vote on both the day-to-day running of the business and any fundamental changes of operation.

Before you start to trade as a partnership, read the Act and be sure you understand it; have a clear understanding on how the business is to be run; preferably, consult a solicitor and have a partnership deed drawn up.

Limited company

In setting up a limited company you create a legal entity which is separate from you personally. The company can own property, have a bank account, employ people (including you), go into debt, he sued. If the company becomes insolvent only those assets owned by the company may be sold

to meet its debts. Your personal property will not usually be involved.

At first sight this looks like a blank cheque for unlimited credit, but of course both banks and suppliers are aware of the potential risks and may be even less ready to extend credit to a new, small company than to an individual who owns assets. There is a growing tendency for banks lending to small companies to require personal guarantees of repayment from the directors of the company. This may well include an agreement that the loan should be secured against your own home.

In this way the benefits of limited liability can become illusory for small companies. There is, however, an important distinction between the director of a limited company and a sole trader or partner. The director has the option to refuse to jeopardise his personal assets, whereas the trader and partner have no choice.

Limited companies are taxed, as are sole traders, on a preceding year basis. Unlike sole traders, they can set trading losses incurred in one year against future profits or against those of the preceding year.

Forming a limited company

To become a limited company, you must comply with the provisions of the Companies Acts, submit a prescribed set of documents to the Registrar of Companies and pay a fee. The Registrar will then issue a Certificate of Incorporation – the company's birth certificate.

Details of requirements and application forms are obtainable from:

The Registrar of Companies
Companies Registration Office
Crown Way
Maudy
Cardiff CF4 3UZ

You may engage a solicitor or Companies Registration Agent to perform the registration on your behalf, or you can purchase from one of several company formation agents a ready-made company, off the shelf, which is fully constituted but which has never traded, or no longer trades. Alternatively, you might buy a going concern.

A limited company must have at least one director and one company secretary (who may be your spouse, other relation, or business associate).

Before setting up or buying a registered company you should seek the advice of your solicitor, your accountant and your bank manager, who will each advise you of likely pitfalls and of any tax advantages in the timing of your registration, and of the risks involved in your purchase.

7 Protecting your Work

The ability to prevent others copying your work is essential if you are to profit from your skill and creativity. Britain, unlike other European countries, gives no general protection against unfair business practices. In order to protect your work against imitators you must therefore be able to bring your claim within one of the established protection frameworks.

For artists, craftspeople and designers, the principal form of protection is provided by the Copyright and Registered Designs Acts and to a lesser extent by the Trademarks Act and passing-off, but it is important, particularly for those working on the borders of design and technology, to be aware also of the protection provided by Patents and Trade secrets.

Copyright

Copyright is a negative right in the sense that it gives the copyright owner the right to prevent others from copying the products of the skill, taste or judgement of their originator. For the artist/designer its importance is economic in that it allows him to ensure that no-one uses his work without suitable payment, and protects his reputation in that he is enabled to impose restrictions on the way that his work is used and presented.

Copyright protects the expression of ideas; it will not protect your work against those who take only the idea that lies behind it, unless, in making use of that idea, the imitator also reproduces the work itself or a substantial part of it.

Whether what is taken amounts to a 'substantial part' of the work or not depends on the quality rather than the quantity of what is taken. To extract the original plot from a novel and rewrite it in your own words would be an infringement of the author's copyright even if your version barely filled a page. Similarly, if a single feature of a design is reproduced, that too may be an infringement of copyright, though small in size when compared with the design as a whole.

What kind of works are protected?

Copyright protection derives mainly from the Copyright Act of 1956 and the recent amendments made to it which provide stronger penalties for video and record piracy and ensure protection for computer programs. The

Act protects literary, dramatic, musical and artistic works, as well as sound recordings, films, television and sound broadcasts, and published editions. Of these, the most important for artists and craftworkers is the protection given to artistic works, although the protection given to literary works can be important for its impact on the area of computer-aided design.

Artistic works include:

- paintings, sculptures, drawings, engravings, and photographs 'irrespective of artistic quality'
- works of architecture, either buildings or models for buildings
- works of artistic craftsmanship which are not any of those listed above

With the exception of 'works of artistic craftsmanship' and buildings, the question whether a work is sufficiently artistic in character to be entitled to protection as an 'artistic work' does not arise. A railway timetable and an engineer's drawing of an exhaust pipe are respectively as much literary and artistic works under the Act as the poems of Betjeman or a painting by Dali, and the Act has, for this reason, become more important in the protection of creative output of all kinds.

Paintings are not defined by the Act but will probably include any application of a pigment or other material to a surface.

Sculpture. A wide variety of items have been defined as sculptures including metals, tombstones and wooden patterns and there would seem no reason why the term should not also include carved or sculpted moulds for casting ceramics, glass or other material.

Drawings. This term is also widely interpreted. Under the Act, 'drawings' include any 'diagram, map, chart or plan'. The term has been held by the courts to include knitting patterns, drawings for light fittings, exhaust pipes, furniture and cartoon characters.

Engravings under the Act include any 'etching, lithograph, woodcut, print, or similar work which is not the product of photography or a process similar to photography'.

Photographs are the product of photography or any process similar to photography, but do not include films, which are protected separately under the Act. Holograms and the products of holography would also fall within this category.

Works of artistic craftsmanship

To be protected under this category the work must be both artistic in character and a work of craftsmanship, in the sense that an element of care and pride in its execution must be present. The question 'what is artistic?' is one that few professional artists could answer, nor would they find it easy to produce a formula by which it would be possible to establish in all cases whether or not a work is 'artistic'. Our law courts have equally failed to produce clear guidelines from which it would be possible to say with any

certainty that a given work is sufficiently 'artistic' to be entitled to protection.

The creator of a work which is not also protected under one of the other categories discussed above runs the risk that although he may regard his work as being a work of craftsmanship, which is also artistic, a court asked to enforce copyright in it may not agree with his assessment.

In the leading case on works of 'artistic craftsmanship', the court said that the term could be used to describe works produced by an artist or craftworker as that term was used by the arts and crafts movement at the turn of the century. The kind of works likely to fall within its scope were said by the court to include hand-painted tiles, stained glass, wrought-iron gates, high class printing, bookbinding, cutlery, needlework and cabinet-making. In the same case, however, the court refused to accept that a prototype sofa of a commercially very successful design, which one expert witness described as in his opinion 'horrible' but likely to appeal to the young, had the requisite degree of 'artistic' quality to allow it to be protected as a work of 'artistic craftsmanship'. Even with the examples cited by the court, and certainly with fields of work outside their scope, the safest course is to ensure, wherever possible that your work is protected under one of the categories to which protection is given irrespective of artistic quality, for example by ensuring that you work from initial sketches or drawings.

A second difficulty in relation to protection of 'works of artistic craftsmanship' lies in the requirement that the 'artistic' input and the execution of the finished article should be by the same hand. On this basis the court found that, within the terms of the Act, no work of artistic craftsmanship existed when the director of a design company produced a sketch for a dress which was then made up by a highly skilled dressmaker. This means that few commercial design operations would be able to protect their designs within this category.

Literary works

Literary works are not defined in the Act. The Act does, however, make it clear that they need not be literary in character and provides that they shall include any written table or compilation. It has now been established that computer programs, which were long considered to fall within the ambit of tables, are protected as literary works. The absence of any requirement of literary merit in this category makes it useful for the protection of catalogues, price lists etc. against imitation by competitors.

How do you 'copyright' a work?

In the United Kingdom you need do nothing more than create the work in order for it to be entitled to copyright protection. The copyright comes into being the moment the work is created and fixed in a permanent or semi-permanent material form, provided only that the work is original and has

been made by a qualified person. To be an original work in copyright terms, the work does not have to be unique or inventive or unlike anything that has preceded it. The only requirement is that the work should originate from its creator, and that he should have spent a substantial amount of his own skill, labour, taste and judgement in its creation.

A slavish copy of someone else's work would never be entitled to protection, however laborious it was to produce it, but a simple design involving the skill, labour, taste and judgement of its originator would be. Even a reworking of an earlier design might be capable of protection if it satisfied these criteria and for this reason it is possible to have a number of copyrights belonging to different owners in a single piece of work. For example, an artist might paint a picture which is photographed in order to be published in a book. Three separate copyrights will then exist: in the painting, the photograph and the book as a published edition.

To be a qualified person you must be a British subject, a British protected person or a citizen of the Irish Republic. Failing that, your work will be protected in the United Kingdom if you are domiciled or resident in the United Kingdom, or in one of the countries to which the Act extends protection. The Act extends protection to countries with which the United Kingdom has signed reciprocal treaties, by which it has agreed to protect the copyright works of nationals of those countries in the same way as it protects those of UK nationals.

Those countries have, in return, agreed to protect works created by British subjects in the same way as they protect the works of their own subjects. The principal treaties under which copyright protection is given to UK copyright owners abroad are the Berne Convention and the Universal Copyright Convention (UCC).

Under the UCC all the member countries, which include the United States, agree to give protection for a minimum of the author's or artist's life time plus 50 years (10 years for photographs and works of applied art).

You will often see, particularly in books, a © symbol followed by the date of first publication and the name of the copyright owner. This is not a requirement for protection in the UK but it is in certain other countries which are members of the UCC, including the USA. If you want your work to be protected in those countries, you must put this symbol on your work by a label, by engraving it into the work or in some other way. You should also find out whether there is any requirement in those countries that you should register your work before it can be protected.

Even if you are not concerned to protect your work abroad, the application of the copyright symbol with name and date still acts as a useful warning to a would-be copyist that you are aware of copyright and claim copyright in your work.

How long does copyright last?

Under the UK Copyright Act, copyright in artistic and literary works lasts

for the life of the artist or author plus 50 years. This period is 15 years in the case of artistic works capable of registration as a Registered Design (see below) and which have been 'applied industrially', i.e. where more than 20 copies of the work (including three-dimensional copies of a two-dimensional design) have been supplied or made available to the public.

Who owns copyright?

Generally, the author of the work is the first owner of copyright in it. There are, however, four exceptions to this rule. Of these the most important for the artist/designer are those which apply to works created by an employee in the course of their employment (where the copyright will normally belong to the employer), and those which relate to commissioned works. Copyright works created by an employee of a newspaper, magazine or similar periodical give the newspaper owner exclusive rights to publish the work in a newspaper or periodical, but in the absence of a contrary agreement the artist or author would retain the copyright for other purposes.

The person who commissions and pays for the taking of a photograph or the drawing or painting of a portrait is normally entitled to the copyright in it.

The fourth situation in which the first ownership of the copyright does not belong to the creator of the work is where the author/artist assigns copyright in the work to someone else, before the work is created. This will be discussed later in this chapter.

What protection does copyright give?

The most important right given to the author of an artistic work is the right to prevent others from reproducing the work in a material form, from publishing the work, or from including the work in a television broadcast. The term 'material form' includes almost any tangible medium in or on which the work can be recorded, e.g. paper, canvas, print tape, computer disk, or as a three–dimensional object.

Copyright protects only against reproduction of your *work* or a substantial part of your work. Copyright protection is limited in that it will provide protection only against direct or indirect copying; it will offer no protection against the person who arrives independently at a similar design, nor, in most cases, will it provide protection against someone who takes the idea or design concept that lies behind a work and develops a design which is totally different in form and appearance from the original.

Copyright in a design can be infringed not only by direct copying from the drawing, a copy of the drawing or an object created from the drawing, but also by indirect copying, if, for example, the design is seen on display somewhere and the copyist retains a mental picture of it from which he then reproduces the design.

Registered designs

Unlike copyright, registered designs must be applied for. This is usually done through a patent agent, who completes all the necessary forms, which are then lodged with the Designs Registry (a part of the Patent Office).

Only designs which are new when compared with previous designs can be registered. The requirement that the design be new when it is applied for means that the design must be kept secret until registration is applied for. If it is revealed to anyone it must be only to someone who is under an obligation to keep it confidential. (See the section on confidentiality.) This means also that the design should not be marketed before registration has been applied for. The advantage of registration lies in the fact that once the design is registered it becomes unnecessary to prove that your design has been copied, only that the Registered Design and the one complained of are similar in substance. If this is the case then even if the other design has been arrived at independently it will still constitute an infringement of your Registered Design.

Fees are payable to obtain registration, initially for a period of five years, renewable for two further periods of five years on payment of renewal fees.

Registration is most useful in the field of industrial design, where it is likely that competitors may be working independently on similar lines. A valid registration of the design that constitutes the best solution to a particular problem can monopolise that solution for the owner, forcing competitors to adopt an inferior solution, and thus to develop an inferior product.

Not all designs are capable of registration. To be registrable they must have 'features of shape, configuration, pattern, or ornament which are applied to an article by any industrial process or means, and which in the finished article appeal to and are judged solely by eye'. (In the sense of appealing to, or attracting the eye of, a potential purchaser.)

The following cannot be registered:

- methods or principles of construction or features of shape dictated purely by form (e.g. a round wheel)
- designs for articles which are primarily literary or artistic in character
- works of sculpture not intended to be multiplied by any industrial process, wall plaques and medals
- printed matter which is primarily literary or artistic in character: book jackets, calendars, certificates, coupons, dressmaking patterns, greetings cards, leaflets, maps, plans, postcards, stamps, trade advertisements, trade forms and cards, transfers and the like.

Since 1968 the Design Registration system and the copyright system have operated together. Failure to register a design which is capable of registration no longer results in loss of protection under the copyright system.

A design, however, which could have been registered, but was not, has a copyright protection period for industrial application of only 15 years, the

same as the maximum protection period for Registered Designs. Many recent designs, therefore, are not registered, but are nevertheless protected by copyright.

Trade marks and passing-off

The trademark system and the action for passing-off protect the badges or identification symbols of one business against imitation by others. The action for passing-off is based on the principle that no-one has the right to offer his goods as those of someone else. Anyone who has walked down a high street and been offered expensive brand-named French perfumes for £1 by street traders has probably witnessed passing-off at first hand.

A well-known name or badge is a very valuable marketing tool. If it projects a quality or luxury image, this will often allow its owner to command a higher price for his goods than could be possible if the name were not attached.

Since pre-Roman times craftsmen have marked their goods so as to distinguish them from those of their competitors, and you should follow suit, either with a signature or some more elaborate symbol. The public, once they know the mark, will use it to obtain your goods again, and will expect them to be of the same quality. If the mark is imitated and they receive inferior goods, they are likely to avoid goods marked in that way in future, and the potential harm to the owner of the mark is obvious.

The law will restrain this type of activity by an injunction and damages for loss of business. To succeed in an action for passing-off, the owner of the mark must prove that the public will be confused, and will believe that the passed-off goods are his. In order to do that, he will have to establish that he has a recognised reputation in that mark. This is normally done by producing witnesses prepared to swear to their knowledge of the owner's product, and that they would be confused by the other trader's use of it, into believing that they were getting the owner's product. The owner may have to do this in several localities, if he or she wishes to ensure protection throughout the country. If one fails to establish one's reputation countrywide, and another person or business acquires a reputation for the same badge or mark in one area, the first owner of the mark may find that they themselves can be restrained from selling similarly marked goods in that area. The stronger the reputation of the owner, the easier it is to protect.

New businesses which are beginning to acquire goodwill, or foreign businesses which are successful in their country of origin, but have yet to acquire a similar following in the UK, are particularly vulnerable to the use of their trade marks or badges by others, in a way that will destroy the goodwill of their identifying marks. The fact that a business has only a developing reputation with the public may make it difficult to find people who know the product by name, and who would believe a similarly marked product to originate from them.

The difficulty in finding such witnesses is likely to put the cost of legal action to defend their rights to the name or mark in question beyond the reach of an emergent business. The safest course is to adopt from the outset a trademark or badge which is registrable and to ensure that it is registered.

Trademarks

Registration of a trademark gives the owner the exclusive right throughout the United Kingdom to the use of the mark for the goods for which it is registered.

The mark chosen must be the name of your company, or of an individual represented in a special or particular manner, or:

- an invented word
- a word which has no reference to the character of the goods. (It would not be possible, for example, to register the mark 'woolly socks' for socks made of wool because it is descriptive of the socks themselves.)
- some other distinctive mark

Having first listed all the goods you produce or will be selling using the trademark, you should select a number of suitable names or marks and then check the Register of Trademarks to see whether any similar marks appear there. This is usually done through a trademark agent, although you may wish to make a preliminary check yourself. You may not register a mark already entered for the same, or similar, class of goods.

If you want to do a preliminary check yourself, the staff of the Trademarks Registry are very helpful in directing searchers to the correct sections of the Register.

The Register is divided into numbered classes, each of which corresponds to a different category of goods. Generally only a few categories will be relevant to your business. For example, if you are a dress designer you clearly need to search the class that covers clothing, but you should also have a look at marks registered for similar goods such as shoes, handbags and other accessories.

Once you have selected marks that you think you may be able to register in the UK it is worth thinking where else in the world you may wish to sell your goods under those marks. Have a look at dictionaries of the languages of those countries and check whether any of the marks you have chosen has a vulgar meaning or a secondary meaning which could cause you embarrassment in the future.

Once you have narrowed your choice to a few marks you are then ready to approach a trademark agent. Lists of trademark agents can be obtained from the Trademarks Registry or the telephone directory. Your agent will usually conduct a search of the Register and advise you whether there are any similar marks which will effectively bar you from registration. Once this process is complete he will file applications in the relevant classes for the marks you want to adopt. Fees are payable for each mark in each class.

The process of registration can take up to two years, sometimes longer if there are complicated issues to resolve.

Many countries require UK businesses to have a registration in the UK (or a local business establishment) before they will register the trademark in their country, so the sooner you can obtain registration in the UK the better.

Even if, as a young business, you find you cannot afford to apply for registration until later, you should check that no other business in your field is using the marks or names you have chosen to adopt, and if possible check the Trademarks Registry. Having to change your trading name or trademark under threat of legal action for infringement of trademark or passing-off from an existing business is a bad way to start.

Patents

Patents are granted for products which constitute improvements over those previously produced, or a better method of making them. Patents give only national rights, so the inventor must apply in each country in which he wants protection. UK patents are issued by the Patents Office and are granted for a maximum of 20 years from the date of filing the application. An annual renewal fee is payable after the fourth year.

While the patent is in force it allows the owner to take legal action to prevent anyone doing certain acts in relation to the invention without his consent. If the invention is a product, these acts include making, disposing of, offering to dispose of, using, or importing into the UK any product covered by the patent. With a patent for a process, the owner will be able to prevent anyone from using that process in the UK, or offering the process for use in the UK without his consent, or from disposing of, offering to dispose of, using, importing, or keeping any product obtained by that process.

The owner of a patent is thus given a powerful monopoly over the exploitation of the invention within the territory for which it is granted. That monopoly is granted in respect of the invention as it is disclosed in the Patent Specification, in the section called 'The Claims'. The intention is that an inventor is entitled to profit from his work, while the disclosure will further scientific and technological knowledge.

The claims which define the extent of the monopoly must therefore be very carefully drafted. This is usually done by a patent agent. A list of chartered patent agents can be obtained from:

The Institute of Chartered Patent Agents
Staple Inn Buildings
High Holborn
London WC1V 7PZ

The work is complex and requires technical expertise, and you are advised not to attempt it yourself. If, however, you cannot afford to pay a

patent agent's fees, and the choice is between doing it yourself, or not patenting your invention, you can obtain advice and guidance from a free booklet published by the Patent Office, entitled *How to Prepare a UK Patent Application and Apply for a Patent*, available from:

The Patent Office
State House
66-71 High Holborn,
London WC1R 4TP

or from the Science Museum Reference Library.

It is imperative that you keep your invention totally secret until you have applied for the patent. You should not reveal it to anyone unless it is with the express undertaking, preferably in writing, that they will keep it confidential and will not use it in any way.

Confidentiality

One of the greatest problems shared by all creative people is how to protect ideas. This can become particularly difficult where the idea requires backing to allow it to be developed; there is always a risk that the person to whom it is shown will take it and develop it themselves.

The solution to this problem lies partly in the legal protection given to confidential information. To provide protection, the person receiving it must be under an obligation to keep it confidential. This can arise through a contractual term, whether express or implied by the relationship of the parties. For example, secrets passing between husband and wife are generally regarded as confidential, as is information about the employer's business passed to employers and communications between doctor and patient, and lawyer and client.

In contractual terms, before communicating an important idea or design concept to someone outside your business, it is best to require them to enter into and sign a confidentiality agreement. This should be drawn up by a solicitor or at least passed to a neighbourhood Law Centre or a solicitor for approval. Once you have a reasonable model you can then adapt it to meet new situations, but it is important, particularly in circumstances where disclosure of a new idea could jeopardise future patent rights, to have a well drafted agreement.

In it you would normally state that you are going to impart information of a confidential nature relating to a certain area. They, for their part, would be expected to agree to pass the information only to those within their organisation it would be necessary to inform in order to discuss the project and then only after they have made it clear to them that the information is confidential. They should also agree not to use the information in any way unless or until you have come to terms on the project's development.

The courts may also assume that an obligation of confidence is implied in

certain business contracts, specifically where the contractual arrangement would be unworkable without it. For example, the courts held that there was an obligation of confidence when one company supplied a mould for making swizzle-sticks to another to manufacture swizzle-sticks for them. The court decided that the manufacturer had no right to use the mould or the information gained in carrying out the order to manufacture on its own account. The courts also held that there was an obligation of confidence in a case when information about a new form of carpet grip was revealed during abortive discussions with a potential backer.

It goes without saying that information already publicly known cannot be confidential. It is also true that if confidential information falls into the hands of someone who has no obligation to keep it confidential it may be freely used. If information which is initially confidential but subsequently becomes public knowledge, through no fault of the person to whom it is passed in confidence, the rule is that that person cannot use the information to obtain a commercial advantage over those who acquire the information from a public source.

Copyright – its sale or retention

The need to cover copyright in your contracts will depend largely on the type of transaction involved. The general rule is that copyright can pass from the owner to someone else only with the owner's written consent. In selling paintings or craft works you will therefore not normally need to mention it. The person who buys the object will own it but will have no copyright in it.

This is not always understood by purchasers, so some artists try to avoid later misunderstandings by stating on a label attached to the object that its price does not include the copyright. Some also give a telephone number and an address for anyone wishing to reproduce it to contact them.

Commissioned works

The position of an artist commissioned to create a work of art will normally be as discussed above, unless the artist has agreed to assign his copyright in it to the purchaser.

This may not be the case where what is commissioned is a design, pattern or model intended for reproduction. In certain circumstances, and in the absence of any agreement between the parties, the courts have held that the person commissioning the design is entitled to the copyright in it. Factors which may influence the question of entitlement to ownership are the price paid for the commission, the degree of assistance given by the commissioner in developing the design, the nature of the work and any custom or practice in the trade.

These situations are often very difficult, particularly as the parties cannot be certain who owns the copyright until the court has decided the matter. In

the interim the designer may have licensed someone else to reproduce the design, who may then be sued by the commissioner of the work for infringement. Before you agree to take on any commission you should therefore check who will own the copyright in the finished work and for what purpose.

Assignment or licence?

Copyright can be passed from one person to another by assignment, by will or by operation of the law. Dealings in copyright tend to be either assignments or licences. The difference between a licence and an assignment is that the former passes no legal interest in the copyright but merely gives a right to do something otherwise prohibited by the copyright. On the other hand, the assignee acquires a legal interest and can deal with the copyright as he pleases.

Assignments can be either total (of all copyright in a particular design) or partial.

If they are partial you may divide the rights given geographically, for example, you may assign the right to reproduce and sell the design in Australia or you may divide the rights:

- by restricted act, for example, you might assign all rights to publish the design in a book
- by period, for example, you might assign all rights to publish a design for the next three years
- or you may combine all or some of these divisions.

Whatever you do must be in writing and you should be very careful, particularly when effecting a partial assignment, that you keep track of the rights you have granted.

If your work is in constant demand for reproduction, licensing and keeping records may take up increasing amounts of your time, in which case you may consider it worth paying commission to an artists' agent to manage that side of the business for you.

Licence

Rights granted under a licence may be divided up in much the same way as assignments, ranging from an exclusive licence throughout the world to do all acts within the copyright for the whole of the copyright period (the broadest possible licence) to a non-exclusive licence to reproduce the design on a single occasion for a single purpose. The exact terms will always depend on what you negotiate. (See also the section on royalties in Chapter 18.)

Bibliography

Copyright

Michael Flint *A User's Guide to Copyright* (Butterworth, 1985)
Laddie, Prescott and Vitovia, *The Modern Law of Copyright*

Trademarks

Amanda Michaels, *Practical Guide to Trademarks* (E. S. C. Publications, 1982)
Applying for a Trademark obtainable from:

> Trademark office
> State House
> 66-71 High Holborn
> London WC1R 4TP

Registered designs

Applying for a Registered Design obtainable from:

> Patent Office
> State House
> 66-71 High Holborn
> London
> WC1R 4TP

Patents

How to Prepare a UK Patent Application and Apply for a Patent, The Patent Office.
Introducing Patents, The Patent Office.
Basic Facts about Patents and Inventions in the UK, The Patent Office.
Inventions, Patents and Patent Agents, obtainable from:

> The Chartered Institute of Patent Agents
> Staple Inn Buildings
> High Holborn
> London WC1V 7PZ

The Financial Framework

8 Financial Records

Basic bookkeeping

This section is an introduction to bookkeeping. The method described is very simple and is adequate for the part-time or part-hobbyist craftsperson. It is also suitable if you have not yet begun your business, but wish to keep your commercial affairs in good order as you go into the start-up phase. When you do start to operate commercially, and when you have an accountant, you should discuss the advisability of setting up a full financial set of records as described in the next section.

There are three main bookkeeping methods: simple records, double-entry records, and stuff-everything-in-a-drawer. Stuff-everything-in-a-drawer is attractive as a method, but fatal to success. You will leave bills unpaid and annoy your suppliers. You will forget to ask for money due to you, and annoy your customers when you ask for it months later. Finally, you will not know whether you are making a profit or not until it is too late. Double-entry bookkeeping is the professional method used by some accountants, but is complicated to keep up. Simple records are a compromise system designed for the small business and the self-employed.

Cash analysis

Buy a cash analysis book (W H Smith and John Menzies sell them). The Simplex edition is a good example. It uses one page a week throughout the year and contains very explicit instructions.

Keep all invoices and receipts for goods and services paid for and carbons of all invoices sent out to customers. You must also keep bank statements, paying-in and cheque-book counterfoils. Enter payments and receipts in the analysis book *daily*. If you leave it until the weekend or the end of the

month it will take longer and you will leave something out. A daily entry takes 10 minutes, a weekly entry takes two hours, a monthly entry takes 12 or more hours – so enter it daily.

A tidy way of storing vital pieces of paper is in large A4 envelopes, numbered to correspond with the week numbers on each page of the cash book. Put every paper – invoices, receipts, carbons of your invoices – relating to that week in the same numbered envelope. They can then be easily found if you need to refer to them. Remember that it is simple to file papers away. The only test of the effectiveness of a system is how readily they can be retrieved.

Claimable expenses which should be entered in the cash book include such things as:

Materials: paper, paint, brushes, inks, films, small tools under £5.
Studio: rent, rates, insurance, repairs to equipment, electricity, gas.
Travelling: fares, taxis, hotels, travels abroad, if on business.
Motor expenses: petrol, oil, licence, insurance, repairs to car, parking.
Postage and stationery.
Telephone.
Depreciation on equipment over £5 in value: tables, chairs, typewriters, industrial machines.
Repairs to equipment.
Subscriptions: to magazines, to professional societies etc.
Special clothes: overalls, protective gloves etc.
Accountant's fees.
Magazines and books.
Exhibitions and catalogues, whether visiting or participating.
Entertainment of overseas clients.
Advertising.
Outworkers and models.

Note
Always enter the full amount in the cash book and let the accountant work out a % base if there is any. You may use only, say, 30% of your house, 50% of your telephone, and 70% of your car for your business; the accountant will work these out with HM Inspector of Taxes.

At the end of your tax year you hand your books in to your accountant who will produce a balance sheet and forward this and forms to HM Inspector of Taxes.

Anyone in business on his own account needs an accountant to negotiate with the Inland Revenue. Accountants charge fees according to the complexity of the account and if your business is small the cost will be correspondingly low. He talks the same language as the tax inspector and will keep your tax liability to a minimum. In almost every case he will over a period save you more money in tax than he charges you in fees, and since his fee is itself a claimable expense, you should think seriously of engaging one at an early stage of setting up your workshop as he will then be available for advice.

Accountants may not advertise their services, although they are listed in the Yellow Pages. To find one, you should ask relatives, friends or fellow craftworkers who may use an accountant and could recommend one. Your bank manager may be able to suggest one, although he is likely to offer the bank's tax accountancy service, which may be a little remote and not geared to the beginner in business. Your local Society of Chartered Accountants can suggest members who specialise in tax accounting for small business or sometimes even for the craftsman. Look for your local branch in Yellow Pages under 'Professional Institutes'.

The petty cash system

It is often inconvenient to make minor payments by cheque. Examples of such payments include postage, use of a courier service, payments for coffee with business associates and taxi fares for business purposes.

Convenience and a record of these expenditures can be provided by adopting a petty cash advance system.

The features of a petty cash system are:

1. A cheque for petty cash is drawn for, say, £40.00 and the cash is placed in a container in the business premises.
2. When payments are made or reimbursement for payments previously made out of personal funds is sought, the following procedure is followed:
 (i) The nature of the expense, the date and the amount are recorded on a petty cash docket.
 (ii) The money required is taken and replaced by the petty cash docket.
 Hence the cash and the sum of the petty cash dockets at any time will add up to the original advance.
3. When the cash becomes depleted draw a further cheque for the amount used. This will return the level of petty cash to the amount of the original advance. The replacement cheque is written against the items that the petty cash was spent on, thus recording them as a business expense.

Essential business practices

Some fundamental advice, no matter how small or large your business may be:

- keep business transactions and personal transactions separate
- open a separate business bank account
- bank all business receipts intact and promptly
- pay all accounts by cheque except for small payments which may be made out of petty cash. If this is done, keep a record of the expenditure

- record all receipts and payments
- keep documents such as invoices and statements and bank statements in an organised file
- if credit is extended, send bills promptly and get the amount right, otherwise you may lose both money and goodwill
- keep the collecting and recording side of accounting up to date in order to save costs. Systematic recording on your part will help the professional accountant to do his job efficiently
- know when to ask for expert advice. If you use the services of a professional accountant to design your accounting system and to prepare tax returns and other complex functions you will save money

Accounting

The majority of artists and craftspersons regard time devoted to record-keeping as an unwarranted intrusion into their creative activities. It is, however, an unpleasant reality that once artistic endeavours develop from a recreation into an occupation it is essential to keep suitable financial and other records. Failure to do so will threaten the survival of the business.

Thus we have a paradox – unless artists and craftspeople devote time to the dismal task of record-keeping they will be denied the enjoyment of following their art professionally.

This may seem an exaggeration. However, the long-term survival of any business depends on the owner making sound business decisions. It is necessary to coordinate production and marketing, costing and pricing and to assess whether additional equipment should be purchased, and, if so, how the purchase should be financed. Decisions, in the long run, reflect the soundness of the information on which they are based. The major sources of information on which business decisions are based are the accounting records. It is therefore essential both that the accounting system be adequate to provide reliable information for decision making and that the decision-maker has some understanding of the fundamentals of accounting.

Two further points need to be emphasised:

- It is necessary for the business to maintain records apart from accounting records. Such records include evidence of the entity's existence and ownership, and of legal obligations, including contracts, loans and insurances. Records of this type complement the accounting records and provide additional insight into decision making. These records are not the subject of this chapter but are mentioned elsewhere.
- Accounting is a service function. Its function is to serve the business by ensuring that information necessary to comply with legal obligations, e.g. taxation requirements, and to make business decisions, is

available. Accounting has no other reason to exist. It is therefore essential that any accounting system be efficient enough to provide adequate information and concise enough not to take up too much of a proprietor's time or money.

What knowledge of accounting is desirable for the artist and craftsperson?

Quite obviously, expert knowledge is both unnecessary and unattainable without giving up the art or craft. On the other hand, complete ignorance can lead to disaster. It can also be argued with some justification that a little learning is a dangerous thing. Despite the element of truth in all these statements, a business person is better able to make decisions if he or she at least understands the basic elements of the process and knows when to seek expert advice.

This chapter is intended to acquaint readers with some of the fundamental concepts underlying the accounting process and which impinge on the interpretation of accounting statements. It is also designed to explain the nature and role of the most frequently encountered financial statements and to demonstrate in a simplified form how these statements are prepared.

Above all it is aimed to sweep away some of the misconceptions that surround accounting in the hope that understanding will promote a positive attitude towards record-keeping.

The meaning of terms commonly used in accounting

Accountants use many terms which have meanings peculiar to accounting. An understanding of the most frequently encountered concepts in their world is necessary to interpret accounting statements.

To accountants, *assets* are items of value to the business. Their value lies in their future service potential to the business. Broadly speaking, assets which have a life expectancy of more than one year are called *non-current* or *fixed assets*. They are capable of providing a useful service to the business for a long time. They would include land, buildings, machinery, motor vehicles.

Current assets are assets that would not normally be kept in their present form for more than one year. They include trading stock, raw materials, debtors and cash.

Liabilities are amounts owed by the business to parties outside the business. If they are not required to be met within one year they are described as *long-term liabilities*, whereas if they fall due within one year they are described as *current liabilities*.

The assets of a business can be viewed either as the productive resources that a business possesses or as a means of satisfying liabilities. In the latter sense, liabilities place restrictions on the use of assets. A business must maintain sufficient cash or cash equivalents (i.e. assets that can be readily

converted into cash) to satisfy its current liabilities. Failure to do so will result in the business being denied essential commodities and being unable to continue operation. This important issue is developed in the following chapter.

The entity possesses *non-current assets* which generally cannot be turned into cash and used to pay debts without affecting the productive capacity of the business. For example, if a woodturner sells his lathe or a potter his kiln they destroy the future of their business. Thus, non-current assets are not generally available to meet the liabilities of an entity.

The contribution that the owner has made to the business is referred to as the *owner's equity* or *owner's capital*. The owner's capital is increased when the business makes a profit and is decreased when a loss occurs or if the owners uses goods or cash from the business for personal use. This is a meaning of capital peculiar to accountants. Economists, engineers, etc. regard capital as being productive equipment, i.e. the assets that a business owns. It is important to understand this distinction.

Capital and borrowings (liabilities) provide the only source of funding for the productive resources (assets) that a business acquires. We can express this as an equation which forms the basis of accounting:

$$\text{assets} = \text{liabilities} + \text{proprietorship or owner's equity.}$$

The financial position of a business in terms of what it owns (assets) and what it owes (liabilities) can be represented at any point in time by a document known as a *balance sheet*.

One of the important things to remember about a balance sheet is that liabilities are shown at the amount that must be paid in order to discharge them, whilst assets are normally shown at what was paid for them when they were purchased. Thus a balance sheet is only a valuation statement in the sense that it reflects the value of the asset in a transaction at the date of purchase. The value in use of the asset to the business now, or its sale value now, may be quite different to the amount shown on the balance sheet.

If the balance sheet equation is extended it can be expressed as:

$$\begin{array}{c} \text{current assets} + \\ \text{non-current assets} \end{array} = \begin{array}{c} \text{capital} + \text{current liabilities} + \\ \text{non-current liabilities.} \end{array}$$

In the short term the only claims that a business has to be concerned about are the current liabilities. Repayment of non-current liabilities is not urgent and repayment of owner's capital is not necessary. An entity cannot, in general, use its non-current assets to satisfy these liabilities without impairing its future production and hence its capacity to stay in business. As a rule, only current assets are available to meet current liabilities. The difference between the amount of current assets and the amount of current liabilities is referred to as the *working capital* of the business. That is, it is the uncommitted short-term funds that can be directly used to earn income.

One of the major causes of failure in small businesses is lack of working capital. Artists and craftspeople should be careful not to commit too large a

proportion of their funds to purchasing non-current assets at the expense of working capital.

One means of achieving this is to lease equipment rather than purchase it. This point is taken up in the next chapter.

In addition to the real items, assets and liabilities, accountants identify two further important concepts: revenues and expenses.

Revenues are amounts received or receivable by a business during the normal course of trading activities. For instance, the main revenues earned by most trading firms are the sales made to its customers. Revenues involve a flow of resources into the business and so increase the wealth of the business.

Businesses incur *costs* in order to obtain the *benefit* of goods or services. Sometimes the benefit is obtained at once and sometimes it is obtained gradually. The part of a cost relating to a benefit that has been used up is called an *expense*. For example, if a business pays rent in advance it obtains an asset in the form of the right to the future use of premises. As time passes the service is used up and the cost becomes an expense. Expenses decrease the wealth of the business.

In order for a business to maintain its future operating capacity it must measure expenses carefully and recover them from revenues received before a profit can be recorded. Failure to recoup expenses in this way will lead to an overstatement of profit.

It is important to note that not all *outflows* are expenses. For instance, if a new machine is purchased for cash an outflow occurs but no expense is incurred. An asset, cash, has simply been exchanged for an asset, machinery, which has service potential to the entity. However, as the machinery is used, its service potential is utilised. Accountants explain this loss of service potential and associated loss of value as the conversion of an asset into an expense. The name given to this expense is *depreciation*. Normally the cost of assets is allocated as an expense over their useful life rather than trying to estimate the value of the asset at any point in time. Similarly not all *inflows* are revenues. Only items received as a result of normal business activity are referred to as revenues.

It may now be useful to examine the nature and role of the most commonly encountered accounting statements.

Bank reconciliation statement

For obvious reasons it is important to keep careful control of cash. A fundamental element of this control procedure is to require all business receipts to be banked intact and all payments to be made by cheque, except for minor payments out of petty cash which are recorded on vouchers.

One of the results of this process is to ensure that two records are kept of all transactions involving cash. One is kept by the business from its point of view and the other by the bank from its point of view and for its own purposes. Cash deposited at bank is an asset to the business but it is a

liability from the point of view of the bank, as the bank owes it to its customers.

The bank statement issued to customers provides access to the bank records. When this is compared with the business record of cash the two frequently do not agree. Three reasons for this are:

1. Some cash transactions have been recorded by the bank but have not yet been recorded by the business. Examples of these include bank charges and deposits made directly to the bank on behalf of the business.
2. Some cash transactions have been recorded by the business but have not yet been recorded by the bank. Examples of these include cheques that have been issued by the business but not yet presented to the bank for payment, and deposits that have not yet been recorded by the bank.
3. Errors, either by the business or the bank.

In order to satisfy yourself that cash has been correctly accounted for, it is necessary to prepare a statement which explains any difference between the record kept by the business and the record kept by the bank. Such a statement is called a bank reconciliation statement. The procedure for preparing a bank reconciliation statement is indicated in the illustrative example at the end of the chapter.

The profit and loss or income and expenditure statement

This records the effect on the owner's capital of the trading activities of the business over a period of time. The statement is normally divided into two distinct sections. It is useful to ascertain the gross profit, which is the difference between the cost of the goods sold and the sales for the period. However, it is necessary for a business to charge all other expenses incurred against the gross profit in order to ascertain the net profit for the period, as indicated in the illustrative example. While the income and expenditure statement deals with flows of resources over a period of time, the balance sheet records the financial position of the firm at any one time. It includes what a business owns (assets) and what it owes (liabilities) at a point in time. A balance sheet also reveals the owner's capital, which is essentially the owner's stake in the business.

Cash flow budget

All the above statements have a historical perspective in that they record what has happened. Although it is useful for a business manager to know what has happened in the past, it is also essential that some effort be made to estimate what might happen in the future. Rather than have a haphazard situation it is usual to plan all phases of the future activities of a business

and to coordinate these plans by preparing budgets. One of the most important budgets is the cash flow budget. This document identifies in advance the periods when cash will be short, and enables arrangements to be made in advance to tide the business over difficult periods. Cash flow analysis and the construction of a cash flow budget is demonstrated in Chapter 10 on *Cash Flow Calculation*.

Both historical statements and forecast statements help management to control their business. They are also used by banks and other lending authorities to asses creditworthiness and by potential investors to assess the potential of an opportunity.

Example

A. Potter commenced business on 1st May 1987. She intends to make and sell pots to the public from her workshop. The following transactions occurred during the first two weeks of operations.

May 1 Deposited £2000 with bank as capital.
Purchased clay £80 with cheque 001.
Paid rent for fortnight £240 with cheque 002.
2 Purchased potter's wheel £480 on credit from A. Turner.
Purchased table and storage unit for clay £150 with cheque 003.
Purchased clay and glazes from Craft Supplies on credit for £120.
3 Arranged a loan from bank £2000.
Purchased pottery kiln £2650 with cheque 004.
4 Purchased used display unit £180 with cheque 005.
5 Purchased sales dockets and accounting record books £18 with cheque 006.
6 Cash sales £29.
7 Purchased clay on credit from Craft Supplies for £180.
8 Cash sales £140.
Credit sales to I. Trustim £368.
9 Paid advertising £33 with cheque 007.
Purchased cleaning materials £16 with cheque 008.
10 Cash sales £130.
12 Credit sales to A. Nother £210.
Paid Craft Supplies £120 with cheque 009.
13 Received cheque from I. Trustim in part payment £84.
Cash sales £90.
Drew out £100 for own use with cheque 010.
14 Paid wages to A. Casual for minding the shop £140 with cheque 011.
Cash sales £204.

An inspection on May 14th revealed unused clay to the value of £180 and unsold pots that had cost £136 to make.

A bank statement obtained on 14th May was as follows:

		ACCOUNT CURRENT WITH A. POTTER			
			Dr.	Cr.	
May	1	Cash		2000	2000 CR
		Charges	6		1994 CR
	2	Cheque 001	80		1914 CR
		Cheque 002	240		1674 CR
	3	Loan		2000	3674 CR
		Charges	16		3658 CR
	4	Cheque 003	150		3508 CR
	7	Cheque 004	2650		858 CR
		Cash		29	887 CR
		Cheque 005	180		707 CR
	8	Cash		140	847 CR
	10	Cash		130	977 CR
		Cheque 007	33		944 CR
		Cheque 008	16		928 CR
	14	Cash		174	1102 CR
		Cheque 006	18		1084 CR
		Cheque 010	100		984 CR

You are required to record these transactions and prepare summary statements.

Things to remember:

- the system must be simple but adequate
- when preparing summary statements, the manufacturing activity must be separated from the selling activity.

Procedure to follow:

1 Record the transactions in the books of the business.
2 Compare the business records of cash transactions with the record in the bank statement.
3 Record in the business cash records any cash transaction not previously recorded e.g. bank charges revealed by the bank statement.
4 Prepare a bank reconciliation statement by adjusting the balance on the bank statement for any cash transaction not yet recorded. The adjusted business cash balance should agree with the adjusted balance on the bank statement.
5 Prepare summary statements.

Four separate books of entry would be necessary to record this information:

1 Cash receipts
2 Cash payments
3 Accounts receivable
4 Accounts payable.

CASH RECEIPTS BOOK

Date 1987	Description	Cash Sales £	Accounts Receivable £	Sundries £	Bank £
May 1	Capital			2000	2000
3	Loan from bank			2000	2000
6	Sales for day	29			29
8	Sales for day	140			140
10	Sales for day	130			130
13	I. Trustim		84		
	Sales for day	90			174
14	Sales for day	204			204
		593	84	4000	4677

CASH PAYMENTS BOOK

Date 1987	Ch.	Description	Cash Purchases £	Accounts Payable £	Sundries £	Bank £
May 1	001	Clay	80			80
	002	Rent			240	240
2	003	Table & storage unit			150	150
3	004	Pottery kiln			2650	2650
4	005	Display unit			180	180
5	006	Stationery			18	18
9	007	Advertising			33	33
	008	Cleaning materials			16	16
12	009	Craft supplies		120		120
13	010	Drawings			100	100
14	011	Wages			140	140
			80	120	3527	3727
May 1		Bank charges			6	6
3		Bank charges			16	16
			80	120	3549	3749

Notes: 1 There is no set format for setting out these books. You may have one column or as many as 36. Convenience is the criterion to be guided by.

2 All four 'books' of entry may be kept in different sections of one book.

ACCOUNTS RECEIVABLE BOOK

Date 1987	Name of Debtor	Amount	Received Payment	Date
May 8	I. Trustim (sales)	368	84	13/5
12	A. Nother (sales)	210		
		578	84	

ACCOUNTS PAYABLE BOOK

Date 1987	Name of Creditor	Amount	Payment Made	Date
May 2	A. Turner (wheel)	480		
	Craft supplies (clay)	120	120	12/5
7	Craft supplies (clay)	180		
		780	120	

BANK RECONCILIATION STATEMENT AT 14TH MAY

Balance as per bank statement			984
add deposit not yet recorded			204
			1188
less cheques not yet presented:	009	120	
	011	140	260
Adjusted balance			928
Balance as per cash books:			
Receipts for period		4677	
Less payments for period		3749	928

SUMMARY STATEMENTS

1 Performance statements

(a) *Manufacturing Statement:*

Direct material costs:	Purchases	380		
	less unused	180	200	
Direct labour cost:	60 hrs @ £5		300	
Manufacturing overheads:	Rent (50%)	120		
	Cleaning materials	16	136	
Cost of goods manufactured			636	

(b) *Profit and Loss Statement:*

Sales for period: cash	593		
credit	578	1171	
Less cost of goods sold:			
Cost of goods transferred from manufacturing	636		
less finished goods not sold	136	500	
Gross profit		671	
Less operating expenses			
Advertising	33		
Rent (50%)	120		
Shop wages	140		
Stationery	18		
Bank charges	22	333	
Net profit for period		338	

2 Position statement

Balance Sheet of A. Potter at 14 May 1987

Owner's Equity			*Current Assets*		
Capital	2000		Cash at bank	928	
add profit	338	2338	Stocks of raw materials	180	
			Stocks of finished goods	136	
less drawings		100	Accounts receivable	494	1738
		2238			
Long term liabilities			*Non Current Assets*		
Loan from bank		2000	Furniture and fittings	330	
			Pottery kiln	2650	
Current Liabilities			Pottery wheel	480	3460
Accounts payable	660				
Wages due to owner	300	960			
		5198			5198

9 Financial Management

Sufficient financial resources are essential to the survival and success of any business, regardless of its size and the reputation of its products. There is an alarming failure rate of young businesses, over 50% failing in the first three years of their existence. The inability to mobilise and utilise funds skilfully is a prime cause of these failures. Experience shows that financial difficulties have a few common causes. The failure to differentiate between the short and the long-term needs well in advance and lack of knowledge of available sources of funds are two important causes. The inability to present a convincing application for financial assistance and the poor financial management of funds available to the business are others. It is to these problems that this chapter is addressed.

Specifically this chapter aims to:

- identify the need for business funds and their potential source, and suggest principles that should guide their use
- explain the concept of cash flow and the technique of the cash flow budget
- develop an understanding of interest rates
- suggest guidelines to follow in preparing a loan application

The need for funds

Initially, funds will be needed to buy an existing business or to set up a new business. As the business grows, further funds will be needed to finance its expansion through the purchase of new and better equipment and premises. Funds used to purchase fixed assets such as production equipment, fittings, motor vehicles and kilns should be of a long-term nature. These are funds borrowed for a long period of time, e.g. five or more years. It is customary, however, for the loan to be paid back on an instalment basis over the period of the loan. The important point is that a proprietor would not normally be asked to liquidate the entire loan before the expiration of the period of loan. Examples of long-term finance include term loans from banks, mortgages and contribution of equity funds by the owners.

Funds are also required for the day-to-day operation of the business: the purchase of stock, materials, power, wages, advertising etc. These funds are referred to as working capital; if financing is required it can be of a short-term nature, e.g. a bank overdraft. Working capital is generated within the

51

firm to the extent that inflows of revenue collected from sales are greater than the amounts paid out to cover the cost of the goods sold and the cost of selling of these goods. The relationship is illustrated in Figure 1.

Fig. 1 The flow of working capital

Outflows of funds occur as they are used to:

- purchase raw materials on a cash basis
- make payments to creditors for goods supplied previously on credit
- pay for labour and other services to process the materials, make them ready for sale and sell them

Inflows of funds arise through:

- cash sales
- collection of debts resulting from credit sales

Working capital is measured by determining the difference between a business's current assets, i.e. items that represent cash or that can be expected to be converted to cash in the near future, and current liabilities, i.e. debts which must be satisfied in the near future. Working capital = cash + stock on hand + debtors − (creditors + any bank o/d)

It should be apparent that good inventory control and a sensible credit policy are essential to the maintenance of adequate working capital. It is

possible to have an excess of working capital and to have too much of a business's funds tied up in current assets. In such a case, the excess of funds over and above that needed to facilitate the efficient functioning of the firm is unproductive. Sound management would anticipate such a position and would siphon off the excess funds, placing them in a short-term interest-bearing security. In the case of chronic excess, long-term securities or the purchase of fixed assets can be contemplated.

A business can expect to increase its working capital needs as time passes. As it prospers and grows, so will the necessary inventories and debtors. Even without growth, continued inflation will guarantee that a firm must have increased working capital (in money terms at least) to finance its operation.

Determining requirements: start-up funds

A business is generally faced with three types of financial need: the need for start-up capital, sometimes referred to as 'seed' capital, working capital once the business is functioning, and capital for any projected expansion. Start-up capital includes the working capital necessary to service the initial period of business.

Estimates of the start-up funds necessary should not be limited to those associated with the business per se. They should also take your personal costs into account. It cannot be assumed that the business will be able to provide you with regular income for several months. Likewise, estimates should include operating expenses for the first three months of operation, since it will take that time for work to be made and sold and for funds to start flowing back to the firm. It takes time to build up sales and even an immediate sale, if on credit, may not produce a cash flow until two or more months after the sale, which might be five or more months after the goods were produced and most costs incurred.

Schedule of starting expenses

Personal living expenses _____
Inventory _____
Fixtures and equipment _____
Workshop/studio alterations _____
Opening promotions _____
Legal and professional fees _____
Deposits and licences _____
Operating expenses (3 months) _____

Notes on schedule

A sales forecast is fundamental to the estimation of necessary production levels. These in turn will enable you to predict the inventory of raw materials required for three months' operation.

An estimate of your needs for fixtures and equipment will be conditioned by how you buy them. Hire purchase with a deposit and regular instalments conserves capital while leasing plans (see below) can conserve capital further.

It is very likely that the premises you select for your studio/workshop will require alterations to conform to personal and statutory requirements. These could include division of floor space, installation of equipment, ventilation fans and safety equipment, provision of power points, painting and decorating.

Promotional expenses could include advertising copy, exterior signs and new stationery, brochures, letterheads and necessary forms and business documents.

It will be necessary to consult a solicitor and an accountant and their fees should be included together with amounts associated with compliance with government regulations, e.g. registration of workshop as a factory and registration of business name.

The final component of start-up costs, operating expenses for the first three months, will be taken from your cash budget. This is another important schedule necessary to determine financial requirements. Steps in the construction of a cash budget are discussed below in the section on raising money.

Determining requirements once a business is established

The central problem of financial management is an appreciation of the importance of cash flow. Most people are familiar with the concept of profit and see continued profitability as the cornerstone of business viability, but cash flow analysis is foreign to many. To rely on profit to the exclusion of a consideration of cash flow is to invite financial disaster. Certainly many businesses are wrecked on the rocks of unprofitability, but others are wound up not long after they have reported substantial profits for the previous accounting period. Let us try to unravel this paradox.

Money introduced into a business by the contributions of its owners or by borrowing can be used in two ways. It can be used to buy things that the company intends to keep (its fixed assets), and also things that it intends to sell. Money tied up in the latter – in raw materials, goods in process, and finished goods awaiting sale – is called working capital. Neither of these sums is immediately available to spend on further requirements, although the working capital element will be freed in the future when the goods are sold. As we will see when examining costing, the cost of a product equals the value of the raw materials plus the direct labour required to make it and the proportion of overheads assigned to it. When the goods are sold the cash used to pay for these elements is retrieved (preferably with some profit). As this inflow of cash occurs, it is used to restart the cycle by purchasing

more materials, labour and services (overheads), thereby creating a further outflow of cash. For a business to succeed in the long term, the inflows must be greater than the outflows. It must make a profit.

This process can be summarised as follows:

profit = value of sales made − expenses incurred

However, to rely solely on such a calculation is to neglect the influence of time. Time delays are introduced because of the gap between the purchase of materials and labour, and the sale of products. It takes time to purchase, make, distribute, and sell. Sales on credit extend this delay further. The creation of debtors and accounts receivable produces the certainty of delay between the recording of a sale and the actual receipt of cash; cash which is urgently needed to buy more materials, pay more wages to process these materials, and to pay the overheads on them.

Against this delay in receipt of cash owing there is a compensating factor. Because many of the firm's inputs are purchased on credit, there is a delay between the incurring of an expense and the actual outgoing payment. For some expenditure the gap may be several weeks, while for others the gap is very small − wages, for instance, are paid on a weekly basis.

To expand on this: suppose the management of a small firm has forecast the sales and expenses for the three months ending 31st December.

Sales		14400
Less cost of goods sold		
Opening Stock	3500	
Production	9800	
	13300	
Less Closing Stock	4900	
	8400	8400
Gross Profit		6000
Less Operating Exps.		2100
Net Profit		3900

If the firm's management or owners were to rely solely on this profit figure as an indicator of business health, they could well be satisfied. £3900 might represent a good quarterly result. They would be most unwise, however, not to calculate further to allow for the following factors.

1. Sales, of which a proportion is on credit, do not represent the receipt of cash. A considerable time may elapse between sale and receipt. In the above example it is conceivable that little cash from the sales of £14400 made in November and December − and even in October − will be received inside that period. If so, what matters to the cash level is the sales during the previous quarter.
2. Many goods and services purchased by the firm do not have to be paid

for immediately, so the payments made in any one month will represent expenses incurred in previous months. In addition, some outgoings are very large. Consider the firm's insurance bill. If the annual premium were £360 this would represent a monthly charge of £30 or £90 per quarter against profit. Insurance, however, is usually paid annually, and thus the firm must anticipate a payment of £360 in one particular month. *On no account* can you assume that the delays in income and outgoings will balance. They must be worked out and apportioned to the correct month.

3 Only those outgoings that actually have to be paid enter into cash flow analysis. The depreciation of furniture and machinery, for example, would be included in operating expenses (and therefore in overhead calculation) but does not result in the flow of actual cash out of the firm.

4 The cash flow must include amounts which, while forming part of normal business activity, do not represent a charge against profit and therefore do not appear in the simple position statement above. For example, the purchase and sale of assets (a new machine), loans and their repayment, and the payment of income tax, all represent cash flows, but do not affect profitability. The non-payment of loans and taxes, however, or the injudicious purchase of an asset, could result in insolvency, despite the apparent profitability of the firm.

5 The same profit figure (£3900) could have been achieved with quite different stock levels. Suppose the firm had projected the following:

Sales		14400
Less cost of goods sold		
Opening Stock	7500	
Production	9800	
	17300	
Less Closing Stock	8900	
	8400	8400
Gross Profit		6000
Less operating exps.		2100
Net Profit		3900

Should the management be just as happy with this result? No. The same result has been achieved with much higher stock levels. The firm has an extra £4000 working capital tied up in stock. This cash could have been released to help pay more urgent commitments.

It is available cash alone that keeps you in business: that pays for raw materials, wages, fuel and power, freight, postage, phone bills, and interest on money borrowed; that repays loans and keeps the tax man away. It is access to cash, and not your firm's profit prospects, that saves you from insolvency.

A profit projection cannot foretell a crisis period when there is likely to be a shortfall in the cash required. Only a cash flow budget can give you advance warning in time to work out your strategy: to arrange finance at favourable terms, to seek variations in loan repayments, to alter the method of acquiring assets (perhaps leasing in place of buying).

It is axiomatic that all small businesses are short of money. If they had more, they would be larger. All entrepreneurs, either by accident or design, tend to build their operation rather larger than they can really afford. Over half of all new businesses fail within two years of opening. Most of these collapse because they run out of cash. Cash flow is like water in a bath with the taps on and the plug out. If more goes down the drain (outgoings) than comes in through the taps (income) the bath will empty, someone (usually the bank) will turn the taps off, and you will be left shivering in an empty bath.

Perhaps it is now clear why profitable firms become insolvent and close down; why success measured purely in terms of prospective profit can be an illusion; why a firm must restrict working capital tied up in stock, by astute credit and inventory control.

Do not fall into the attitude of a complacent participant at a crafts council workshop, who wrote on the evaluation sheet, 'Cash flow analysis is too complicated for most craftspeople . . . interesting to know about, but realistically I would never use it.' Cash flow analysis is a firm's crystal ball. It is worth looking into. (See Chapter 10 on *Cash Flow Calculation*.)

Equity capital versus debt finance

Equity capital represents funds contributed by the owners of the business. It is therefore the amount that the business, as a separate entity, owes you, the owner. If you are a sole trader, you alone supply the equity capital, presumably from your savings. If you are a member of a partnership, you will contribute according to the agreed basis. If you are a shareholder of a company, your contribution will be proportional to your shareholding.

Recent studies have shown that when a small business is first established, the main source of finance is the equity capital contributed by the owner and his family. Raising additional equity funds involves selling part of your business, with the contributors having a right to participate in the after-tax profits of the business. Equity funds are therefore not (as is often held) costless funds. The alternative to equity finance is debt finance.

The creation and existence of debt is a commercial fact of life. The ability to extract advantages out of debt lies not in the size of the debt but rather in your ability to service the debt. Debt finance conveys substantial advantages and you should not dismiss it as a source simply because you do not want to get into debt. Advantages of debt finance include:

- you do not have to surrender to others a share of your equity, or control of your business

- interest paid to service debt capital is tax deductible.
- debt finance can be retired whenever it suits the objectives of the firm. After the initial start-up period has been successfully negotiated, it is likely that working capital levels may be above that necessary for the continued operation of the business. If there has been a strong bias towards equity capital it will be found difficult to dismiss. This is particularly so if it has been contributed by people outside the family circle.
- borrowed funds confer flexibility. This advantage was approached in the last point. If your business is one in which sales fluctuate seasonally, then borrowed funds will be a better form of financing. They will ensure that adequate provision can be made in times of need without the predicament of having substantial funds idle during busy periods.

The disadvantages include two obvious features. Obvious though they are, it does not follow that they are always fully considered and their implications understood:

- debt finance must eventually be returned to its owners, whereas equity funds are virtually retained within the business for the duration of its life
- interest payments, like the retirement of the loan, must be made irrespective of the profitability level. Failure to fulfil either obligation could result in bankruptcy.

In summary, therefore, you should strive for a balance between the higher cost equity capital and the lower cost borrowed funds, ensuring that the returns on the latter are at least equal to the net after-tax rate of interest.

Interest rates

While the cost of borrowing money at any time is dependent on the interest rate payable, there is no fixed interest rate. Movements in these rates, like movements in the bank rate in the UK, will produce sympathetic movements in all other interest rates working through the competitive forces. The higher or lower cost of obtaining funds from lending institutions is reflected in the rates they charge borrowers such as yourself.

Reducible and flat rates of interest

The implication of these terms is poorly understood. Misunderstandings cost money. Reducible interest is calculated on the outstanding balance of the loan at the end of each day, month, quarter or other agreed period. The term 'rests' indicates the frequency at which interest is calculated on the outstanding loan. A loan stipulating quarterly rests requires interest to be calculated on the balance owing at the end of each quarter.

Flat interest is calculated by applying the relevant interest rate to the total amount of the loan for the full loan period.

Regardless of the type of interest charged, most arrangements require the borrower to make regular repayments (usually monthly repayments of principal plus interest). In conjunction with a flat rate of interest, this requirement means that a borrower is paying interest on the full amount borrowed right up to the time when he makes his last repayment.

Example

Assume you have entered into a purchase agreement for the supply of equipment costing £1600, agreeing to:

- make a deposit of 25%
- pay interest of 12% flat over 2 years.

Your monthly instalment could be calculated as follows:

	£
Full price	= 1600
Deposit	= 400
Amount borrowed	= 1200
Interest on £1200 @ 12% for 2 yrs.	= 288
Total amount due	= 1488
Monthly instal.	= 1488 ÷ 24
	= £62

i.e. each month you will repay £50 principal plus £12 interest.

After say, 20 months, you would have repaid 20 × £50 = £1000 and thus only owe £200. But since your terms stipulate a flat rate of interest you are really paying interest on the full amount borrowed, i.e. £1200. Understanding the above you should be able to appreciate the savings associated with the introduction of rests. They allow the amount on which interest is being paid to equal the sum actually owed at that time. Another way of stating this is to say that the interest charged is equal to the true rate of interest.

Calculation of the true rate of interest

The true rate of interest is defined as the cost of a loan expressed as a simple percentage of the actual amount borrowed (on an annual basis). It can be calculated using the following formula.

$$I = \frac{2YC}{P(N+1)} \times 100\%$$

where: I = the true rate of interest
 Y = the number of repayments in any one year. If repayments are weekly there will be 52 per year, if monthly there will be 12 per year
 C = total cost of the loan in pounds
 P = the principal of the loan, i.e. the amount borrowed
 N = total amount of repayments to be made

The advantages of being able to apply this formula are clear. All lending transactions can be compared on the same basis, helping you to discriminate between potential lenders.

Example

You wish to borrow £2400 for 3 years. Bank A offers you a term loan (see below) at 12.00% p. a. with half-yearly rests but monthly instalments. Bank B offers you a personal loan at 9.00% p. a. (flat). Which offer should you select? All other things being equal, you would select the offer with the lowest rate of true interest.

Do not get bogged down in the calculations! Understanding the principle is the important objective.

Bank A's offer

Six-monthly Period	Principal £	Interest @ 12% £
1	2400	144
2	2000	120
3	1600	96
4	1200	72
5	800	48
6	400	24
		504

$$I = \frac{2YC}{P(N+1)} \times 100\%$$

$$= \frac{2 \times 12 \times 504}{2400 \times 37} \times 100\%$$

$$= 13.62\% \text{ p.a.}$$

Bank B's offer

$$\text{Amount of Interest} = \frac{2400 \times 9 \times 3}{100}$$

$$= £648$$

(At this stage you can see which is the best deal by the amount of interest payable, but press on so that you can compare interest rates.)

$$I = \frac{2YC}{P(N+1)} \times 100\%$$

$$= \frac{2 \times 12 \times 648}{2400 \times 37} \times 100\%$$

$$= 17.5\% \text{ p.a.}$$

What appeared to be a good deal because of the lower interest rate is actually a poor one when the time rates of interest are calculated. A rule of thumb: to find the time rate with monthly repayments (the usual terms) double the flat rate of interest.

Sources of borrowed funds

Bank overdraft

Normally this would be your first choice for finance. Since interest is charged on a daily reducible basis, bank overdrafts represent the cheapest source of borrowed funds. In particular, they represent the best way of augmenting working capital, but are an inappropriate source of long-term finance. An overdraft advance allows you to overdraw your current account up to a limit determined by the bank. Conditions are usually imposed requiring you to reduce this limit systematically. Of prime concern to the bank is the security offered by you. Banks would basically be interested in only two types of security offered by artists and craftspersons.

- a mortgage over real estate. The lending margin can be very much lower than your valuation. Advances are limited to 75% of the bank's valuation
- a guarantee by a third party.

Bank term loans

Banks also make finance available for fixed periods. Terms range from three to ten years and the funds may be restricted to a specific purpose, e.g. the purchase of equipment or land. In this regard they differ from an overdraft which can be generally applied to supplementing a firm's working capital. The full amount is drawn at purchase and is repaid at regular intervals.

Hire purchase

Funds made available by finance firms are more expensive and tend to be more short-term than trading bank finance. Nevertheless they represent the second most important source of finance for very small firms, providing funds for the purchase of specific assets such as equipment and motor vehicles. With the payment of the deposit the asset can be used by you while the balance is repaid, usually on a monthly basis. However, the finance

house remains the legal owner for the duration of the repayment period, having the right of repossession in the event of your default. But you can depreciate the asset and set this against your pre-tax income. Likewise all interest and other charges are fully tax deductible.

Lease financing

Lease financing has developed rapidly since 1960. A firm in need of equipment approaches a finance company; if the response is favourable, the latter will purchase the asset and lease it back to the firm.

The financial lease is a non-cancellable contract in which you as the lessee undertake to make a series of payments to the lessor (the finance company) for the use of the asset. With the signing of the agreement you acquire most of the economic benefits associated with outright ownership, although the lessor remains the owner of the asset. The lease period usually corresponds to the economic life of the asset. For example, a vehicle lease is a short-term lease, usually two or four years. Equipment leases can be for longer periods, but lessors are reluctant to extend beyond five years. The rapid growth of leasing arrangements reflects the advantages they offer:

- 100% financing. Lease financing permits you to acquire the use of an asset and so generate income without even having made a deposit. Working capital is thus not depleted
- Taxation. Lease payments are fully tax deductible, but, unlike hire purchase arrangements, depreciation charges cannot be set against income by the lessee
- Repayments can be structured to suit your seasonal cash flow variations
- Leasing rates are lower than hire purchase rates. The different taxation treatments tend to equalise overall cost and there may be little difference between the net cost of both arrangements

Sale and lease-back

An alternative to mortgage finance uses the principle of leasing and enjoys the advantages associated with that method of finance. Owning the freehold property in which your studio or workshop is located gives security to your business, but you may be better off not tying up scarce capital resources in fixed assets. An alternative is to sell it to a financial institution and take a long-term lease of the property. The institutional investor assumes all financial obligations and all you pay is rent, which is fully tax deductible. The real test is whether the funds released from the investment in fixed assets can be put to a more profitable use. The advantages have to be such to compensate you for the loss of the potential capital gain that would have been associated with a future sale of the property.

Personal loans

These are available from both trading banks and finance companies, though the latter prefer other means of financing and this is reflected in the interest rates payable. There is usually no specific limit on the amount of the loan or the term of the loan, both being negotiable. They can be used to purchase a wide variety of equipment for personal and business use.

Trade creditors

Trade creditors are always a potential source of short-term credit, as the traditional credit period is 30 days. This allows you to use your purchases to generate income before the creditors have to be paid. As a source of funds, trade credit tends to be unreliable for planning purposes, fluctuating as it does with variations in purchases. Attempts to increase reliance on it can result in reduced goodwill and such attempts have a low success rate. Moreover, there is a hidden cost if a discount is offered for prompt cash payment. Assume that the credit terms are 2.5%/10 net 30, i.e. pay for the goods within 10 days and you will receive 2.5% discount on the total. A decision to delay payment until after 30 days means that in not taking advantage of the discount you are in effect borrowing for 20 days. The cost of the credit is the discount foregone and on a regular monthly purchase basis the effective cost of the borrowing is equal to 45% p. a. – a significant cost.

Internal sources of funds

Even with growth of external financing, internal sources are still of major importance. For small businesses this is particularly true since they can experience difficulties in acquiring low-cost external finance. Three sources can be identified.

Retained profits A widely held rule of thumb asserts that a company should retain (i.e. not distribute as dividends) at least 30% of its annual profits. These can be made available to supplement working capital needed due to inflationary increases and also for growth and expansion.

Credit control Extension of credit facilities represents a considerable investment in working capital. If you extend credit it is very likely that you will have excess funds tied up in slow and doubtful debts. Continually monitor your turnover of debts. Changes in credit procedures could produce a useful pool of funds. Keep books up to date and ensure credit terms are observed.

Stock control Excessive inventories are a source of idle funds. Continually appraise the age of your stock and be prepared to vary products and production schedules to eliminate slow-moving items. Reduce the amount of raw materials purchased at any one time, provided there is no loss of discount.

10 Cash Flow Calculation

For reasons of financial management (Chapter 9) and to help you to raise money, from whatever source, you will need to forecast your cash flow in the form of a budget showing the amounts you expect to spend and to receive, and your levels of indebtedness or profit, month by month.

It may be difficult to assess in advance your level of sales or the costs of premises and materials, but if you do not have any idea of these amounts it is certain that nobody else will. An attitude of 'how can I possibly know that?' will not inspire confidence in your bank manager if you are asking for a business loan. You must make the attempt. (There is an example at the end of this section. Cash flow programs for the BBC Microcomputer can be seen in the Appendix.)

The cash flow budget shows how much you will need and how much you will earn, month by month, with running totals.

Section A. A list of outgoings and the months in which they will be paid.

R + R	rent, rates and maintenance
HLPT	heat/light/power/telephone
M/E	machinery and equipment
	In the example, £1500 is paid for purchased items and £60/month for rented equipment.
PROF	professional services
	legal/accountancy/insurance
TRAV	travelling and postage
	local travel at £60/month
	the cost of a trade fair stand in September
MATS	raw materials (wood/clay/yarn/etc.)
	consumables (packaging/nails/Nescafé/etc.)
SUBC	subcontractors paid for bought-in components, specialist work, polishing, finishing etc.
WAGE	wages paid to others. Note that a part-time assistant starts in June.
L/EX	living expenses: what you pay yourself out of the business.

Section B. The total, month by month, of all money paid out of the business.

Section C. Sales, or money coming in to the business.

DESN	sales of designs to other manufacturers
	may be outright sale or royalty

Cash Flow Calculation

PROD sales of goods produced by you.
FEES income from other sources, or input of capital by you or by others. (In the example, £1000 has been put in and the owner is receiving a New Enterprise Grant of £40/week, or £160/month.) Income from, say, teaching would show here.

Section D. Monthly totals of money received in *Section C.*

Section E. The loss or gain each month. (Totals in *D* minus totals in *B*.) In January £2460 is paid out and £1160 is received: therefore E shows minus £1300.

Section F. A cumulative total produced by adding across *Section E*. This is what your bank statement would look like at the end of each month if all the bills were paid on time. It shows a maximum deficit in year 1 of £2570, and a loss at the end of the year of £830. In year 2, the increased sales produce a profit of £2890, despite the ending of the New Enterprise Grant, and the increase in living expenses.

Note

1. The cash flow does not include repayments of the loan you would need to cover the deficit, nor of the interest, both of which would be due monthly throughout the period of the loan. These will increase the monthly outgoings and therefore the level of deficit, and hence the length of time for which the loan would be required. It is better to discuss the amount and duration of the loan with your bank manager. Indicate that you have presented the facts from your side as accurately as you can, and that you now rely on his professional advice. Methods of paying interest and their spread over time can also vary; here, too, you need his expertise.
2. If you do not produce a cash flow of this sort, you will have no clear idea of how much you need to survive, nor for how long. Uncertainty on your part will worry your bank manager: a clear, well presented statement, even if partly wrong, will put him on your side.
3. Keep a copy of your cash flow and use it to compare with your actual results through the year. If any item in your outgoings or income is widely different, try to find out why – it may help to highlight and correct problems before they become critical.

Cash flow: Year 1

	Factors	J	F	M	A	M	J	J	A	S	O	N	D
A	R+R	200	200	200	200	200	200	200	200	200	200	200	200
	HLPT	0	0	180	0	0	180	0	0	180	0	0	180
	M/C	1500	60	60	60	60	60	60	60	60	60	60	60
	PROF	200	0	0	0	0	150	0	0	0	0	0	0
	TRAV	60	60	60	60	60	60	60	60	60	60	60	60
	MATS	200	100	100	150	150	200	200	200	200	200	200	200
	SUBC	0	0	0	0	0	0	0	0	0	0	0	0
	WAGE	0	0	0	0	0	200	200	200	200	200	200	200
	L.Ex	300	300	300	300	300	300	300	300	300	300	300	300
B	TOT	−2460	−720	−900	−770	−770	−1350	−1020	−1020	−1700	−1020	−1020	−1200
C	DESN	0	0	0	0	0	0	0	0	0	0	0	0
	PROD	0	300	500	500	700	700	1000	1000	1000	1500	1500	1500
	FEES	1160	160	160	160	160	160	160	160	160	160	160	160
D	TOT	1160	460	660	660	860	860	1160	1160	1160	1660	1660	1660
E	MTOT	−1300	−260	−240	−110	90	−490	140	140	−540	640	640	460
F	CUMU	−1300	−1560	−1800	−1910	−1820	−2310	−2170	−2030	−2570	−1930	−1290	−830

Cash flow: Year 2

	Factors	J	F	M	A	M	J	J	A	S	O	N	D
A	R+R	200	200	200	200	200	200	200	200	200	200	200	200
	HLPT	0	0	180	0	0	180	0	0	180	0	0	180
	M/C	60	60	60	60	60	60	60	60	60	60	60	60
	PROF	200	0	0	0	0	150	0	0	0	0	0	0
	TRAV	60	60	60	60	60	60	60	60	560	60	60	60
	MATS	200	200	200	200	300	300	300	400	400	400	400	400
	SUBC	100	100	100	100	100	100	100	100	100	100	100	100
	WAGE	400	400	400	400	400	400	400	400	400	400	400	400
	L.Ex	500	500	500	500	500	500	500	500	500	500	500	500
B	TOT	−1720	−1520	−1700	−1520	−1620	−1950	−1620	−1720	−2400	−1720	−1720	−1900
C	DESN	0	0	0	0	0	0	0	0	0	0	0	0
	PROD	1500	1500	1500	2000	2000	2000	2000	2000	2000	2500	2500	2500
	FEES	0	0	0	0	0	0	0	0	0	0	0	0
D	TOT	1500	1500	1500	2000	2000	2000	2000	2000	2000	2500	2500	2500
E	MTOT	−220	−20	−200	480	380	50	380	280	−400	780	780	600
F	CUMU	−220	−240	−440	40	420	470	850	1130	730	1510	2290	2890

11 Raising Money

Most people starting in business are short of money. If you fall into this majority you must prepare a campaign to borrow enough to start up and to continue through the first difficult months. Whether you are lucky enough to have friends or relatives willing to lend capital, or if you have to approach a bank, the process should be the same.

1 Calculate your needs and expectations, and present as full a picture as possible to the lender.
2 Make a businesslike arrangement that is fully understood on both sides, covering the repayment of capital and of interest.
3 Keep the lender fully informed on progress and problems both before and after the starting date.

If you wish to accumulate capital of your own before starting up, plan to keep working or find work and calculate how much you can save in, say, eighteen months.

Approaching a bank

Going for the first time to ask a bank manager for money to start a business is a little unnerving. But remember that lending money is their job; they do it every day. It is not a momentous occasion for them, so try and keep the emotional level down, and concentrate on the facts you have prepared. The same, of course, applies to the tax man and Customs and Excise for VAT. They are paid professionals and are there to help you.

Financial institutions have a split-minded attitude to design and craft operations. They wish to support them as adding colour and beauty to an otherwise drab world, but they have an ingrained fear that they are unbusinesslike and unreliable. The would-be borrower must therefore reinforce the wish and allay the fear by emphasising the business's potential and by adopting a businesslike approach.

When companies need to raise money they circulate a prospectus and you must do the same. Prepare your information in advance, to give the bank manager time to read it. Do not turn up unexpectedly to discuss a loan. Ring for an appointment and confirm it by letter with a typed presentation. (See Fig. 2a.)

However well you present yourself, no bank is going to lend you money

Ros Mackie Ceramist
17 Tomlins Grove, Bow, London E3 01-980 4237

14 July 1987

The Manager
Lloyds Bank Ltd
23 Clerkenwell Road
London EC2

Dear Mr Thompson

Following today's telephone conversation, could I confirm that I will call in and see you next Wednesday at 11 o' clock.

I am enclosing some notes of my proposed operation, to give you time to read them before our discussion.

Yours sincerely

Ros Mackie

ROS MACKIE

Fig. 2a A business proposal

ROS MACKIE Ceramist
17 Tomlins Grove
Bow
London E3

ROS MACKIE
AGE 24

1979-80 Gloucestershire College of Art & Design, Foundation
1980-83 Camberwell School of Art, BA Hons
1984-86 Royal College of Art, London, MA

1984- Two-man show Sutton College of Further Education.
1986- Work sold to Liberty One-off Shop.
 Work in the collection of John Catleaugh.
1987- Forthcoming ' New Craftsmen 87 ' Exhibition at the
 Oxford Gallery

PROPOSAL

To establish a studio at 17 Tomlins Grove, Bow, to design and produce unique pots in china and porcelain for sale direct to the public and to trade outlets.

A lease of the premises at the above address has been obtained. This lease runs from 1 January 1980 to 1 January 1990 at £1000 per annum, guaranteed by John Mackie (my father).

I have been engaged to teach two days a week at Farnham School of Art, and further additional teaching dates are under negotiation, potentially totalling £2500 pa. These fees are paid at the end of each academic term.

Fig. 2b

unless *you* stand to lose if things go wrong. The manager will want to know what your stake is. Take with you details of capital you have already raised or saved, and a suggestion for the security which will almost certainly be required. This might take the form of freehold or leasehold property, or an insurance policy with a higher cash-in value than the amount of the proposed loan; or it could be a personal guarantee from an outsider who has the means and is prepared to support you in this way. (See Fig 2b.) It may well be worth consulting your accountant on the preparation of your application. If you are successful in obtaining an overdraft, remember that it may be called in on demand, or restricted in times of credit restraint; so avoid relying on it excessively.

The Department of Trade and Industry is currently operating a Loan Guarantee Scheme, under which it will guarantee up to 80% of a bank loan to approved small businesses. You can get further information from your bank manager or an area office of the Industrial and Commercial Finance Corporation.

Other sources of finance

A loan or grant may be obtainable from:
Your local Regional Arts Association
(except the Greater London Arts Association)

Crafts Council
12 Waterloo Place
London SW1Y 4AU
(in England and Wales only)

Council for Small Industries in Rural Areas (CoSIRA)
141 Castle Street
Salisbury
Wiltshire SP1 3TB
(rural areas in England only)

Scottish Development Agency
Small Business Division
102 Telford Road
Edinburgh EH4 2NP
(Scotland only; also has offices in Glasgow and Aberdeen)

Welsh Development Agency
Small Business Unit
Box 6, Ladywell House
Park Street,
Newtown
Powys SY16 1JB

Welsh Arts Council
Craft Department
Holst House
9 Museum Place
Cardiff
(Wales only)

All these agencies have different schemes, so write to the ones in your area for full details. Remember that businesslike presentation is as important to these agencies as it is to the bank.

The cash flow statement opposite shows a maximum debt of £1970 (in February) and clearance of the debt in 19 months.
Note, however that it does not include repayments of the loan, which will be due monthly throughout the period. This will increase the monthly amount, and extend the period needed to clear the loan. Let the bank manager calculate this, and then agree the amount and duration of the loan.

Cash Flow Year 1	Aug	Sept	Oct	Nov	Dec	Jan	Feb	Mar	Apr	May	Jun	July
Rent (+ rates)	250			250			250			250		
Services (H/L/P + Ph)			150			150			150			150
Insurance	180											
Postage & stat.	30	10	10	10	10	10	10	10	10	10	10	10
Travel & parking	50	50	50	50	50	50	50	50	50	50	50	50
Consumable materials	25			25						25		
Photographs		25			25			25			25	
Accountant						75						
Machinery	600											
Materials	300	200			200	300						
Living expenses	200	200	200	200	200	200	200	200	200	200	200	200
Monthly Total Out	1635	485	410	535	485	785	535	285	410	535	485	410
CC Support Grant	500											
Sales		400	200	500	100			400			300	
Teaching Fees					1200			2000			1600	
Monthly Total In	500	400	200	500	1300			2400			1900	
Monthly Balance	−1135	−85	−210	−35	−815	−785	−535	2115	−410	−535	−1415	−410
Cumulative Balance	−1135	−1220	−1430	−1465	−650	−1435	−1970	−145	−265	−800	−615	−205
Projected Year 2 Out	835	485	410	535	485	685	535	285	410	535	485	410
Projected Year 2 In	400	400	300	500	1700			2700			2100	
Monthly Balance	−435	−85	−110	−35	1215	−685	−535	2415	−410	−535	1615	−410
Cum Balance b/f −205	−640	−725	−835	−870	−345	−340	−875	1540	1130	595	2210	1800

12 Taxation

Income tax

Everyone who receives an income is liable to pay tax on it. Tax rates are set at a certain percentage of your *taxable income* and are altered from time to time in the Budget. Your taxable income consists of everything you earn (or receive from investments) less:

- personal allowance (a flat amount which varies according to whether you are single or married)
- allowances for such things as mortgage interest, life-insurance premiums etc.
- various other allowances for dependent relatives, assistance for some disabled people etc.
- for the self-employed, business expenditure (see below).

So if you earn £7000 per annum, and the allowances above add up to £5000, you will pay tax (at the rate in force) on the remaining £2000.

If you are an employee, you will normally be taxed at source – that is, your employer will deduct tax from your wages (the PAYE, pay-as-you-earn, system); but the self-employed are taxed under a different system in respect of business profits.

As a self-employed individual you will be assessed in one year (say April 1987) on the profits shown in your accounts ending in the previous (chargeable) year (1986/87) and the tax will be payable in two equal instalments in 1987.

So you work for a year, get assessed at the end of that year, and pay your tax in two equal instalments during the next year. (There are special rules for a new business in its first three years, and for a business that is sold or permanently discontinued in its final year of trading.)

Note: any person setting up in a self-employed capacity, or as a newly formed small business, is now required by law to inform the Inland Revenue (local Income Tax Office) within three months of starting to trade. Failure to do so is an offence, and attracts financial penalties and excessive tax demands.

You may claim normal business expenditure as a deduction from your gross profits. You cannot however, pay yourself a wage and deduct this amount from the profits. Instead, you make drawings from the business, which are in fact advances on the profit you expect to make. Income tax is

not deducted from these drawings, but your liability for tax is calculated on your profits before the drawings are made.

Business expenditure falls under two main headings: *revenue expenditure*, which includes the running costs of the business (overheads, goods for resale, salaries, and allowable business expenses) and *capital expenditure* on the purchase of business assets (motor vehicle, furniture, equipment etc.) which is taxed differently and where you will need your accountant's advice. In simple terms, you will have total income, less revenue expenditure and capital expenditure allowances, to give a net profit. After tax has been deducted this represents the net personal income for the year.

Value Added Tax

Vat is in principle a comprehensive tax, chargeable on the supply of goods and services in the United Kingdom, and on the importation of goods into the United Kingdom.

If you are not registered as a taxable person for VAT, you cannot claim back the VAT that you have paid in the course of your business, nor can you charge VAT to your customers or clients.

If your annual turnover (*not* your profit or personal income) is above or likely to be above a declared level (currently £21,300) you are legally *required* to register with the local VAT office of the Customs and Excise, who will provide a certificate showing your VAT number, which must thereafter be quoted on all invoices and statements. You must also on these documents show clearly and separately the rate of VAT (currently 15%) and the amount charged.

Thus:

```
                    INVOICE
   10 items @ £10                    £100.00
   VAT @ 15%                         £  15.00
                                     £115.00
   VAT No. 394280762
```

If you are registered for VAT you must keep VAT accounts and records. You wil have a record of the amount of VAT paid by you (input tax) and the amount of VAT charged by you (output tax). At regular intervals (currently quarterly but extending to annually in 1988) you will have to send your VAT returns to Customs and Excise, showing the net amount of VAT payable by you or repayable to you. You will have to account for and pay tax due from the date you first become liable to be registered.

Commercial stationers sell easy-to-follow registers for recording VAT transactions. The Simplex VAT Register (W H Smith or John Menzies) is straightforward.

If your business is newly set up and you are registering for VAT, you will most likely have already paid out money for equipment and machinery. Provided you have kept the bills, showing the amounts of VAT you have paid out, you can claim these amounts in your first VAT return even though they were paid before registration. This concession applies *only* to capital goods or vehicles, *not* to services. You can retrospectively claim back the VAT on a machine, but not on the cost of installing it.

Contact
The Collector, Customs and Excise VAT Office (local office)
Your accountant

National Insurance contributions

Almost everyone who works pays National Insurance contributions. There are four classes of contributions.

If you are employed, you and your employer pay Class 1 contributions; these are usually deducted at source when earnings are paid.

If you are not gainfully employed in Great Britain you may pay a voluntary contribution, called Class 3 contributions, in order to qualify for National Insurance benefits.

If you are self-employed you are liable to pay Class 2 and Class 4 National Insurance contributions.

The Class 2 contributions are collected by the Department of Health and Social Security, either by direct debit of a bank or giro account or by stamps on a card, and this is a weekly flat rate.

The Class 4 contributions are normally calculated, assessed, and collected by the Inland Revenue at the same time as income tax on the business profits.

If you are employed as an employee, and also part-time or full-time self-employed, you are liable to pay Class 1, Class 2, and Class 4 Contributions.

If you have employees, you must deduct their Class 1 contributions from their pay, *and* pay an 'employer's contribution' yourself, unless their wages are below a specified limit.

Pensions

Among the benefits you pay for is the retirement pension. Remember that the self-employed receive only the basic pension. If you want any more than this you must make private arrangements; probably a retirement annuity from an insurance company. There is tax relief on the payments, subject to a maximum.

Contact
Department of Health and Social Security (local office).
HM Inspector of Taxes (local office).
Your accountant.

Read
Starting in Business, HM Inspector of Taxes (free)
Employer's Guide to National Insurance Contributions, Leaflet NP15, DHSS, or HM Inspector of Taxes (free).
National Insurance Guidance for the Self-employed, Leaflet N1 41, DHSS (free)
Class 4 National Insurance Contributions, Leaflet IR 24, HM Inspector of Taxes (free).

13 Insurance – Protecting your Livelihood

The nature and meaning of risk

Risk, simply defined, means the possibility of loss or injury. To the businessman, that loss means the chance of financial loss. Hence, when we talk about risk we are talking about the chance of financial loss. This is the type that could be reflected in reduced production or sales, increased costs, reduced assets or increased liabilities. These could arise because plant has been destroyed, stock has been stolen or destroyed, or people have been injured.

Two different categories of risk can be identified. Pure risks are those that contain no possibility of gain; a loss is the only possible result. The chance of a fire in your studio or workshop or the risk of personal injury while working in your studio are examples of pure risk. They cannot be predicted. They exist whether you like it or not and cannot be entirely avoided.

Speculative risks, on the other hand, involve elements of both loss and gain. Investment in real estate, mining and oil stocks are of this nature. In the course of your business dealings you are exposed to speculative risk. The establishment of a business itself is a speculative risk. Decisions by you to vary product design, to produce in anticipation of consumer demand for your products or to open up new markets, involve speculative risks. In these cases you exercise some control of the risk. Fate is not the sole determinant. Your decisions are now an element of the risk and, as such, you cannot insure against it. Otherwise, no matter how inefficiently you operated a business, you would have no worries because your failures could always be covered by insurance. In this case everyone would wish to be in business; any business, that is, except insurance.

Planning risk management
Principles of protection

- Identify common business risks. Some insurance coverage is required by law (e.g. third party car insurance and workers' compensation). Other risks are required to be covered by contract, for example, the insurance of artworks being transported to and from galleries and while on exhibition or consignment. Your balance sheet indicates assets upon whose existence the production of the business is based.

You should ask yourself, 'what would happen if . . .' Don't leave yourself out of such considerations. Sickness, injury or death can jeopardise the stability of a business and the welfare of people dependent on its successful operation.
- Consider the odds of the chance occurring. High probability does not necessarily mean that coverage should be affected. Quite the contrary. It could mean that the risk can be absorbed as a business cost. The chance of bad debts or shoplifting are both subject to control measures and can be allowed for in your costing and pricing decisions. As such a chance becomes more and more probable, premiums may rise to an extent that makes insurance cover impractical. In general, insurance cover becomes increasingly feasible as losses become more improbable and hence premium rates lower.
- Major potential losses should always be covered. Don't put a lot at stake for the sake of paying a small premium. Analyse those losses which you could carry without taxing your financial resources. By all means restrict coverage to those potential losses which exceed a minimum amount, but don't underestimate the severity of potential losses.

Types of insurance

Loss or destruction of property

- Fire and other perils. A building and its contents can be insured against fire and all the usual perils including storm and tempest, rainwater, water leakage, explosion, malicious damage and impact by vehicles. Most policies will pay up to the cost of rebuilding as new (called reinstatement) to comply with statutory regulations or local government bylaws. Costs of demolition, removal of debris, architects', surveyors' and legal fees are also usually included. Contents includes stock, plant, furniture, fixtures and fittings. Some policies automatically increase the cover of stock (e.g. by 25%) during peak trading periods. You must be certain to inform the insurance company if you increase the hazards of insurance. For example, if you change the basic nature of your business or even if you introduce a new process, say, involving a highly volatile solvent. If you are in the slightest doubt, check with your insurance company or broker.
- Burglary. Stock, plant, furniture, fixtures and fittings can be covered if the theft occurs as the result of forcible entry or by persons concealed on your premises. The potential loss through crime should not be underestimated. The chances of being a victim of crime are greater than those of being a fire casualty. Non-protection in either area could lead to bankruptcy.
- Money. Loss of money from business premises or in transit is an insurable risk. The cover available is usually subject to limits for any one loss.

Consequential loss

While you may be fully compensated for losses caused by fire or other hazards your business may suffer indirect losses as a result of the fire. Destruction of plant or theft of stock and equipment will almost certainly interrupt your pattern of production and sales. Losses thus sustained as a consequence of fire etc. are an insurable risk. Business interruption cover will insure against loss of trading profit for a definite period up to 12 months, although you may select a longer period of protection if you wish. Other features may include the payment of fixed charges which must be met even though business has been suspended.

Liability insurance

Liability insurance contracts protect you against injury and property damages sustained by third parties. Two types are of particular concern to artists and craftspersons.

- product liability insurance. Such a policy protects you against any losses or damages occasioned by the defective nature of your goods, for example, lead poisoning from raku glazes.
- public liability insurance. A public liability policy protects you against personal injury or property damage caused to third parties as a result of your operations. For example, a customer may slip on your doorstep or members of the public admitted to your studio or workshop may be injured by equipment. All businesses should effect public liability insurance, as should organisations dealing with the public through exhibitions, shows, fairs etc.

Personal insurance

Weekly income benefits are payable if you are prevented by sickness or accident from carrying on your business. However, the amount of compensation is determined by the benefits paid for as stated on the policy rather than the actual loss sustained by you. Benefits may be payable for as long a period as two years. If injury results in loss of life, sight or limbs the usual type of policy provides for lump sum or capital payments.

Selecting the insurer

Never be reluctant to consult an expert. Your bank manager, solicitor or accountant will be able to provide you with the names of suitable insurance brokers. A broker doesn't deal with only one insurance company. He shops around. His volume of transactions enables him to achieve substantial discounts from insurance companies, which can be passed on to his clients. An insurance broker can tailor a programme to suit your exact requirements.

Your insurance problems become a single problem. Consolidation of all insurances into one programme eliminates the paperwork and loss of time associated with a piecemeal approach while at the same time decreasing the risk of underinsurance.

If you prefer to approach insurance companies directly, recent innovations have eliminated the need for a separate policy for each insurable risk. Most insurance companies now offer a package policy with separate proposal forms for each type of business. For example, a standard shop policy may have nine sections covering buildings, contents, business interruption, burglary, money, personal accident, public liability, breakage of glass and breakdown of machinery. By combining all coverages in one policy there is a substantial saving in handling costs, resulting in lower premiums. At the same time the prospect of an increased volume of business provides an incentive for the insurer to extend to you his most favourable rates. Although there may not be a standard proposal form for artists and craftspeople it would be a simple matter for an insurance company to draw one up.

Whether you deal through a broker or select a package direct from an insurance company, be prepared to shop around. Standardise your requirements and seek competitive quotes. The time and effort will be justified.

The Marketing Framework

14 The Concept of Marketing

Every business must concern itself with marketing if it is to survive. A marketing approach should not be equated with crass, razzmatazz, gimmicky activities. It simply requires an acceptance of the view that the main task of business is to determine what a chosen group of customers' needs, wants and values are, and to put all one's efforts into satisfying those perceived needs.

Marketing can be a very complex subject, as any first perusal of a marketing text will demonstrate. However, it need not be. There are certain fundamental concepts which are extremely useful and easily understood. These will be examined here and will provide a simple framework for further study.

To use the terms 'craft market' or 'art market' is to oversimplify the nature of the market. Car manufacturers, for instance, do not direct their efforts towards the needs of the car market as a whole. Instead they practise market segmentation, which means they split up the total market into smaller, more homogeneous groups and aim their production and selling strategies at these target markets. Thus the marketing strategies used to sell roomy and comfortable four-door family sedans differ markedly from those adopted to market nifty sports cars and rugged off-road vehicles.

Markets can be segmented using *geographic, demographic* and *psychographic* criteria.

Geographic. Division of the total market into different locations e.g. neighbourhoods, suburbs, cities, counties.

Demographic. Segmentation on the basis of such factors as age, sex, family size, income, occupation, education, family life cycle, religion, nationality or social class.

Psychographic. These factors refer to the individual. For example, life style ('trendy', straight, yuppie, status-seeker, etc.), personality, i.e the self-image people have (masculine, authoritarian, ambitious, independent),

user status (non-, ex-, potential, first-time, regular users), usage rate (light, medium, heavy) etc.

The main conclusion that can be drawn from a knowledge of market segmentation and target marketing is that opportunities increase when an artist or craftsperson recognises that a market is composed of customer groups, not all of whom are likely to be receiving complete satisfaction from current market offerings. Having chosen his method of segmentation based on those differences which he thinks are most crucial, he can proceed in two ways. He can attempt to cover the whole market range by marketing appropriately to each segment or he can concentrate his efforts by going after a large share of one or more of the sub-markets or segments.

Identifying the target market(s) is only part of the task. The other basic element in any total marketing programme is the determination of the marketing mix, the so-called four Ps of marketing. Determining the product(s), setting their prices, promoting them to customers and placing them with sales outlets are the components of marketing strategy which together make up the marketing mix.

Business firms are constantly appraising the attractiveness of the products they sell. They recognise the limited lifespan of products due to increased competition and changes in consumer preferences and hence the necessity to develop new products. Craftspeople should likewise be prepared to innovate with their product mix, introducing new products or new features (design, materials, colours, glazes etc.)

Pricing decisions are a major element in the marketing of a product. Large firms have different motives for raising or lowering prices. High prices may accompany the introduction of a new innovation in an attempt to skim the market before competitors enter to force prices down. (Does anyone remember the introduction of the Biro brand ball point pen at 55 shillings, thirty odd years ago?) Equally, the price can be set relatively low to achieve mass acceptance quickly. There are, in fact, many bases for the determination of price. The pricing of arts and crafts is subject to a number of constraints which are not felt in major industries. These constraints and pricing policy generally are discussed in Chapter 17.

While pricing is the subject of a whole chapter, it is appropriate to sound a warning here. Pricing is frequently made the scapegoat for other marketing failures as many business people accept a simple relationship between sales volume, sales revenue and price. Pricing should be seen as only one element in a marketing package or mix. A downturn in sales can be met by attention to product strategy and design, increased promotion and variation in the efficiency of sales outlets as well as by price variations.

Attention to marketing matters requires time. Many will baulk at the loss of production time necessary for collecting, analysing and acting on marketing information. The benefits must be set against the costs. Ultimately the appraisal of these will depend on the person's aims and objectives, which in turn will reflect their attitudes and values.

Study brief: Michael Darlow – why is making a living by craft so difficult?

Michael Darlow combines high academic qualifications with great technical excellence and flair. A qualified engineer with a bachelor's degree in civil engineering and a master's degree in construction management, he has also completed trade certificates in both cabinetmaking and woodturning at Sydney College of TAFE. He worked as a civil engineer in England and in Australia after his arrival in 1969, before becoming a full-time woodturner in 1978.

Michael shares a workshop, the Sydney Woodworking Centre, with his two apprentices and three other woodworkers in Chippendale, an inner-Sydney suburb. The centre is not a cooperative but they do sometimes use each other's equipment and work for each other. There has been no attempt to set up a retail outlet at the centre because they feel that the total volume produced for retail sale would not justify the establishment and running costs. Additionally, they are adamant that specialised retail outlets with their better locations and established clientele have significant advantages over the workshop, despite its central position.

Michael specialises in a large range of work including giftware, presentation items for industry and governments, jobbing work for architecture and antique restoration, as well as a wide variety of gallery and exhibition work. Three recent commissions demonstrate. Michael's ability and versatility:

- turned legs for a full size replica of a lunar landing module to be displayed in Centrepoint, Sydney
- turned picture frames for the Australian National Gallery
- storey–height classical columns to be used as patterns for casting replicas in sandstone

His work has been exhibited widely and is represented in museum collections in both England and Australia. It has been the subject of articles and photos in major newspapers and interior design magazines. Recently, examples were selected for inclusion in a prestigous new American design book. A committed craftsperson, Michael is a writer and critic of woodworking, especially in woodturning publications. His own book, *The Practice of Woodturning*, is to be published in both Australia and the USA.

Instead of attempting to present a formula for success he examines those factors which he feels makes living from crafts difficult. Not all the problems cited are founded in the simple ignorance of business techniques and practices. Many quite obviously arise because of attitudinal difficulties and conflicts on the part of the craftsperson. Therein lies the problem. The understanding and adoption of good procedures require fundamental changes in the attitudes artists and craftspeople have towards the many aspects of business. Paralleling such changes should be initiatives by individuals and art organisations to induce attitudinal change in the buying public. Attitudes prevent artists and craftspeople from appreciating

the value of business procedures, just as attitudes prevent the public from appreciating the value of artwork. Education is the key to any solution.

Michael writes:

There is certainly as much need for sound management practices in craft as in any other business. However, the reasons for craft being of doubtful viability is not due to a lack of management expertise which is peculiar to craftspeople, it is because most craftspeople find it impossible to sell a sufficient volume of work at a worthwhile price, and this in turn does not enable them to employ professional management services or allow them sufficient time fully to develop their own management skills or potential.

Professional craftspeople fall into two categories: those who live by selling what they produce and those who derive a significant and often the major part of their income from craft-related activities such as teaching, craft administration, craft retailing, etc. The majority belong to the second category.

Why is living by making craft impossible or at best borderline for so many? Below I list and discuss some of the reasons:

- Lack of artistic talent. This is more widespread than we realise or care to admit
- Being unwilling to give up one's own ego trip. Certainly history has shown that the contemporaries of Van Gogh and Modigliani were wrong not to appreciate the original and the new, but how many people have the singlemindedness to sacrifice all for craft? Perhaps in craft our chance of success is higher than in the fine arts because much of our work is functional, but correspondingly the rewards for success will be lower
- The smallness of our potential market. We do not face the fact that only a small percentage of the population is interested in good design and workmanship. Certainly there is a proportion of the population who have an undeveloped potential for craft appreciation, but we had better realise that the norm is abysmally low
- Competition from imported and mass produced alternatives. The obvious alternative is not to compete. The positive alternative is to create things which are distinctly different and make it clear by promotion that they are
- Poor selection of outlets. Many craft retail outlets are badly located, under-capitalised, even badly managed. For many of the successful outlets the name of the game is to buy cheaply so that the retail price is low enough to ensure sufficient volume of sales. The retailer's first duty is quite properly to himself, and this duty is often at variance with the desires of the creative craftsperson. There are many other ways of selling, but a true appraisal of markets, charity shows, etc. will usually show that they are not worthwhile.

- Lack of capital. Setting up and running a business requires considerable capital. Few of us realise how much, and flounder in consequence
- The low status of craft. Its status is low because craftspeople have made it so. Instead of bringing craft down to the 'everyone can do it' level, fine craft needs to separate and raise itself above the common herd. This may be at variance with the ideas of some of our more egalitarian craftspeople, but the rest of us have to live in the real world
- Undermining by other craftspeople. Amateurs are often happy to sell for little more than the cost of the materials; can we really blame the retailer who takes advantage of this? However, this all too common scenario is a major factor in keeping artwork prices at too low a level
- Craftwork is a luxury and as such is in competition with many other expensively promoted goods and services seeking the discretionary pound. Is your craftwork innovative enough, attractive enough etc. to hold its own?
- More craftwork is bought by individuals than by organisations. People tend to be more selective when spending their very own hard-earned money. The negligible second-hand value of much craft is a factor which will tend to make the conservative public go for the safe antique rather than the contemporary craftwork
- The situation is not all gloom and doom. A fair number of craftspeople are properly viable, in a variety of working situations and with a variety of craft philosophies. Furthermore, the climate for craft is improving year by year, largely because of imaginative efforts in marketing by some craftspeople, retailers and craft organisations. However, there is still a tendency to emphasise production volume at the expense of marketing

15 Range Building

Range building is the process of determining the variety of objects offered to the customer. Its significance to a business in terms of increased sales and profitability is often insufficiently appreciated even by medium and large firms. For the small studio or workshop it is vital.

In order to survive, the crucial element is *added value*, the process of increasing the gap between the cost of producing an article and its perceived value to the purchaser. The wider you can make that gap, the more freedom of action you will have, and the more satisfaction you will get from what you make.

If from 10p worth of clay you make an article worth 20p, the increase of only 10p will have to pay for your time, the firing, the decorating and your selling costs. If you continue to make this product there will be no time to design and plan and experiment. You will be tied to the bench and be unable to progress. The skill of the artist lies partly in being able to produce from the 10p worth of clay an object worth 200p or 2000p without using up the gap of 190p or 1990p in time or materials employed.

Students and those artists who have not previously needed to husband their time for motives of profit, too often make things in a complicated way. They use methods and techniques that are time-consuming but which do not in themselves add to the value of the finished piece of work. The aim should be for simplicity. Go and look at work produced by the masters in your field and note the economy of their designs.

A deliberate process of constructing a range of goods to be offered at a specific time will aid this process of simplification: it will also give certain commercial advantages.

1. It will improve the attractiveness and therefore the profitability of the offering by a controlled variation, to give an element of choice to the buyer, either retailer or consumer.
2. It will augment the perceived value of individual items in the range with the plus features of the others – a process of supportive relationships.
3. It will restrict the offering and avoid loss of profit from excessive tooling, surplus raw materials or dead stock by signalling the cut-off point for old lines before they decay below the profit level.
4. It will present a clearer picture to customers on repeat selling occasions.

To expand the above four points, in plainer language:

Controlled variation. Every buyer likes to be offered a choice: for many consumers the selection of items for their home or to wear is their only creative activity. For retailers it is their personal, professional contribution to the process of supplying consumer needs. An infinite choice, however, is merely confusing. To tell a buyer that he can have what you make in any size and any colour will seldom lead to a sale. Buyers like to hear your recommendations and to see what you think is best before making up their minds. You should therefore have a reason for every inclusion in your range.

Supportive relationship. In the studio, the shop window or inside the gallery, a group of articles with some family relationship but still retaining individual status will have more appeal than a selection of unrelated items. A range fixes itself in the mind more clearly if the customer is browsing or going from shop to shop and simplifies the essential first decision: 'I don't know yet what I shall finally buy, but it will be one of these.' If a customer buys only one from a range, he still carries away some of the excitement generated by the total look. He is also more likely to increase his purchase to two or more. A retail buyer can more easily visualise the grouping of a range within his shop and is therefore likely to place larger orders.

Restricted offering. To all goods where sales depend on visual appeal the 80/20 rule applies. This states that 80% of the sales will probably fall on 20% of the range, and that the tail-end of the range, the other 80%, will produce only 20% of the income. This wasteful process could, of course, be prevented if one knew in advance which were going to form the tail, and cut them out before starting the expensive and time-consuming effort of producing samples, tooling-up and carting them around to buyers. A logically planned range in which every item has a reason for existence (and about which you have prepared something to say when making your sales pitch) will help to spread sales more evenly across your offering. This approach will also assist decisions when considering what items to retain and what to discontinue in your next range.

Repeat Selling. When meeting customers on a continuing basis it gives them added confidence if you can explain clearly what is continuing in your offering, what is new (and why) and even to give them some forecast of what you will be offering next (in the form of samples, drawings, prototypes). This gives them some involvement, provides you with market research material, and makes your next offering more immediately acceptable to them when you show them the finished product.

The range building process
The craftsperson as designer

It may seem over-obvious to state that you need to know who your customers are. Marketing sources describe their consumers in terms of size, geography, age, socio-economic groupings (this last term is an amalgam of income, education, status and – although the word is never mentioned – class). These divisions are useful general categories, but are of little direct assistance when setting out to design and make a product.

The unprofessional designer designs for himself; in other words, he is subjective. The professional analyses a need and provides a solution which may not be to his personal taste. This is in no way a lowering of standards, but a correct, objective attitude to one's profession. A designer of classic clothes may dress like a ragbag. A producer of simple, traditional tableware may be an avid collector of kitsch.

Consumer profiles

It is essential, therefore, to have in mind a clear picture of the sort of person who will buy what you intend to make. This will help to determine the design itself, the quantity you might expect to sell, and the type of shop or gallery best suited to display your goods.

To achieve this, the consumer must be given identity. (If you hope to sell 100 items and try to visualise 100 people all happily clutching your product, they become a faceless blur.) You must design for an individual who epitomises your market, and construct a profile, preferably written down or in pictorial form, showing your customer in terms of:

- environment
- family
- age
- income
- status
- culture
- needs
- work
- leisure

In other words, a complete person, in depth.

This character – 'Mary' – is now your typical customer, at whom the centre of your offering is aimed, and for whom your first product will be made. There is a limit to the variety that will appeal to Mary and that it will be economic for you to produce for her – say, three bowls and two vases, all in two sizes and three colours.

Range building

When you wish to expand your offering, devise two further consumer profiles, standing, as it were, each side of Mary: George, a straighter, less adventurous buyer, and Tracy, the trendy, streetwise one. You can now design equivalent varieties (or sub-ranges) for George and Tracy with the elements of shape, pattern and colour that will appeal to them.

This process will help to clarify your mind in developing new products. It will provide a clearer story to tell when selling to a retailer, as you will be able to describe the sort of person at whom you are aiming each part of your range and the reasons for including each item. It will reduce the effect of the 80/20 rule on your sales.

Lastly, when you come to overhaul your offering for the next show or selling trip, a quick analysis of your sales to each section (George, Mary or Tracy) will indicate successes to be followed up, non-profitable areas to be dropped, and potential markets to be encouraged.

Range overlap

This process of division into distinct sub-ranges appears at first sight in conflict with the normal marketing requirement for a continuum of offering, but in practice the principle of a complete range is maintained. In selling the sub-ranges to a retailer, considerable distortion occurs both in your selling story and in the buyer's perception. Confusion also exists in the retail stocking and selling activity, and finally, the consumer buys, at will, goods intended for totally different purposes and different customers. By the time the goods are ready to sell, the set of sub-ranges are not only a continuum, but in practice are beginning to overlap.

16 Promotion

Nowhere is the uneasiness that artists feel for business more obvious than in their attitude to promotion. Why do artists spend so little time and money promoting themselves and their work? It is probably because misconceptions about the nature of promotion triggers hard-sell connotations in the mind of the artist. Artists, like other professionals, typically feel great dedication and duty towards their work. This feeling probably engenders the belief that the integrity and dedication reflected in the work should be sufficient to ensure its sale. In other words, artwork should sell as a result of its intrinsic qualities and not because of a lot of hype generated about it or its creator. Work should be bought, not sold.

Many artists have realised the significance and importance of promotion and as a result have become well known and financially successful. Some have been labelled 'too commercial'. However, these artists would insist that they have balanced their need for personal satisfaction and integrity with the realistic appraisal that, viewed correctly, promotion can sit comfortably with the ethos of art. Professionals in fields other than art, for example medicine, law and accounting, have also discovered this fact and have become aggressive in promoting their professional practices. Like many other facets of good business, such as accounting and financial management, the acceptance of promotion as a professional tool is often inhibited by misunderstandings. The aim of this chapter is to clear away these misunderstandings by demonstrating the commonsense nature of promotion.

Professional image

Clients and customers have a real need to feel confidence in the supplier of goods and services, and in his products. Much advertising is devoted not to selling a product, but rather to promoting the image of the selling firm. Such advertising is called institutional advertising. Although institutional promotion does not seek to sell a particular product, the foundation of the image is the same: reassurance to the customer/client based on a perception of creditability. Similarly, it is possible to create a professional image, i.e. the way in which a professional and his or her work is perceived in the mind of the client/customer.

Three points need to be made in explaining the concept of professional

image. First, the emphasis is on consumer perception. It doesn't really matter how we are or even how we think we are. What really counts in the business sense is what the customer or client thinks of us and the work we do.

Secondly, the development of an image depends on both functional and emotional perceptions. When contemplating purchasing the services or the work of a professional, clients will be reassured by their perception of the technical aspects of the work as well as how they feel about the work and about the professional.

Thirdly, the development of an image is not entirely a conscious affair. People respond unconsciously to cues which arise in the many elements of personal interaction and communication, for example dress, speech, mannerisms and acquaintances. Equally, written communications will provide the same opportunities and, together with administrative procedures, are powerful determinants of image development. Thus there is a necessity to evaluate the image projected by all communications, to make certain that it is consistent with the desired overall professional image.

If a person does not actively pursue image development, one will be derived by default and he or she may be unhappy with the result. The correct image will result in a growing customer base and increased customer loyalty by enhancing the effectiveness of the practitioner at all levels. A negative image will detract from all levels of practice regardless of the actual worthiness of the person and his or her work. Therefore professional image is one of the greatest potential enhancers of communication and, correspondingly, can be one of its most dangerous detractors. If you take pride in your artistic profession and have confidence in your ability as an artist, why be secretive about it?

Promotional tools

The array of promotional tools available to the artist is illustrated in Figure 3. Within the classification of written communications, institutional elements consist of those communications which are concerned with creating a favourable overall image of the professional artist. Since their primary task is informative, and not persuasive, they do not have a direct or immediate sales objective and their use should present no ethical problems to the artist. On the other hand, competitive communications, because they are primarily persuasive, have a specific sales objective and always fall within the category of advertising.

Administrative communications are the written materials and documents necessary to run a business efficiently. While some are intended for customers, others are sent to non-customers, for example suppliers, banks, sales outlets, galleries, funding agencies, art organisations. The image developed by these non-customer groups is just as important as the image of the artist held by clients, commissioners and collectors.

```
                          ┌─ Institutional
                          │     Business cards
                          │     Tags and labels
                          │     Postcards
                          │     Editorial reportage
                          │     Brochures
                          │     C.V.
                          │     Portfolio
PROMOTIONAL ──────────────┤     Publicity
TOOLS                     │
                          ├─ Competitive
                          │     Advertising
                          │     Promotion
                          │
                          ├─ Administrative
                          │     Invoices
                          │     Letterheads
                          │     Order forms
                          │     Catalogues
                          │
                          └─ Personal
                                Lectures
                                Demonstrations
                                Workshops
```

Fig. 3 An artist's promotional tools

The communication job to be done can be summarised by the VIP approach. The basic tasks of communication for the artist are to establish visibility (V), provide useful and needed information (I) and persuade prospective customers to become customers while persuading existing clients to remain (P). At the same time there must be an integration of all elements to achieve a consistent image.

Institutional communications

While it is true that all professional communications provide information, some, particularly the résumé or CV, the brochure and the portfolio, serve two specific marketing functions:

- They have a pre-selling objective. A client may not purchase solely on the strength of receiving, say, a brochure. However, it is reasonable to assume that the person would be more disposed to purchase having first received it
- They alleviate post-purchase doubt. People often experience doubt and anxiety after making a significant outlay. Did they make the right choice? Did they pay too much? Will the article keep its value? Since the purchase of any artwork represents a significant outlay, the study

of a résumé and a brochure supports the professional creditability of the artist and reinforces the reasons why the purchase was made. In this way they can reduce and even eliminate post-purchase doubt

These functions must be considered when designing each piece of institutional communication.

Business cards and letterheads

Although these are acknowledged as the most basic of promotional tools, they are greatly neglected by artists. Their layout should reflect their purpose. As business communications they should convey a conservative, businesslike, professional image. It seems more reasonable to allow your artwork to communicate your artistic talents rather than allow your artistic expression to intrude into the business aspects of your profession. The stationery should be typeset with no fancy calligraphy and be easy to read. Refrain from using bright colours or pure white. Instead, consider pale pastels and earth tones and ensure that all stationery is the same colour. Uniformity is more effective in terms of promotional impact and may also mean some savings on design and printing.

Tags and labels

No artwork should be sold without some identifying tag upon it. When people purchase artwork they want to know who made the work. It would be marketing madness not at least to indicate your name, address and telephone number. Notes on care and maintenance (fibre) and capacity (ceramics) or other properties such as dishwasher compatibility would be appropriate.

Postcards

As tourists and travellers we have all sent postcards depicting sights with which we identify to people who have significance in our lives. Why not use the same idea in your promotions? A card with provision for name, address and a short message on one side with a high quality example of their work, preferably in colour, on the reverse is seldom used by artists. However, when used in communications with past collectors, commissioners and gallery directors to, say, acknowledge an enquiry, postcards give an opportunity for work to be viewed and your professional image strengthened.

Newspaper reprints

Newspaper or magazine articles about an artist and his or her work help significantly in the development of credibility and image. Articles can be photographed or photocopied to make composite pages of several articles. Make certain that the name of the publication and the publication date are

prominently featured on each article. There is a strong positive reaction when these are read in conjunction with a brochure. Information in the brochure is reinforced if evidence is presented that people are writing about you and are interested in what you're doing, i.e. if you are newsworthy.

Brochures

For most artists, brochures are pre-selling aids designed to achieve attendance at exhibitions and other functions or to act as companions to letters soliciting business from galleries, collectors and commissioners. If the artist is offering specific products for sale, the brochure takes on the characteristics of a catalogue. We will concern ourselves only with the former type.

The brochure is used to feature the artist's work. It is a mistake to include a complete curriculum vitae listing education, exhibitions, collections and professional history. Such biographical notes make tedious promotional copy. It is far better to have a couple of well-written, complete sentences detailing career highlights and leave the emphasis on the work you do, e.g. type of work, how you sell it (direct sales, commissions, limited editions), media, techniques, scale, materials and important influences.

One or two photographs should be included; one of the artist either at work or appraising a finished article, with a caption including a short comment from a review would be most appropriate. Don't overlook black and white prints; they are much cheaper to reproduce.

All aspects of the brochure should be legible and neat and should display taste and an appreciation of quality. For convenience, they should fit into your usual business envelope. A well-produced brochure has a long life. If it is attractively presented, the recipient will tend to keep it, and it will thus have the potential to assist future sales.

The curriculum vitae

If the brochure is a tool for selling your art, the CV is a tool for selling yourself. You should contemplate its use when seeking employment, participation in art shows, exhibitions and competitions and when soliciting business from architects, interior designers and collectors. (See the section on curriculum vitae in Chapter 3.)

Your portfolio

Your portfolio is your major selling tool. In addition to several of the promotional devices already mentioned, it will contain slides and photographs of your work. It therefore represents the first opportunity for prospective clients or customers to view your work in order to gauge its scope and development as well as providing them with visual evidence of how you can satisfy their needs.

Although books and folders are frequently used, three-ring, loose-leaf binders are very suitable for the purpose. A binder is a relatively inexpensive and flexible way of protecting and displaying the contents of your portfolio. Since material can be added, deleted and rearranged, this is a convenient method of maintaining an up-to-date presentation of your work. Have at least two copies of your portfolio and keep one copy in a safe place at all times.

The portfolio should contain the following:

- Title page. Perhaps a photograph of the artist working or of a piece of his work. Name of artist, address(es), telephone number(s). Table of contents
- CV
- Set of slides. Plastic pages with twenty slots are an ideal way of holding and displaying slides. Twenty slides is a suggested maximum. Slides should be clearly identified with name of artist, name of piece, size, medium and price (if appropriate). Type this information on to an adhesive label and attach it to the slide mount. When preparing slides, consider the following points:
 — While your actual work may not be rejected if it could be viewed, it could well be rejected if the slides taken of the work are poorly done.
 — If you do not feel confident about achieving a high enough quality yourself, engage a professional photographer. Being able to photograph your artwork is a basic professional skill; it is much more convenient and certainly cheaper if you can do your own. Treat the acquisition of this skill as part of your professional development; start with Chapter 23 on *Photographing Artwork*.
 — Emphasise the work itself by using neutral backgrounds.
 — Be prepared to vary the slides according to the purpose of your appointment. For example, when soliciting a commission you may wish to demonstrate techniques and special processes by showing semi-finished work, whereas the slides you would use to gain an exhibition would be of finished work. Again, different market locations and different types of outlet may dictate a change in the emphasis of your slides.
- Six to ten colour prints, say 5 × 4 inch of representative work. It is convenient to introduce the location of previously sold work through these photographs. Location photographs will show how your work looks and integrates with a typical setting and will also emphasise that your work is professionally accepted
- Brochure
- Reprints of reviews, articles, gallery catalogues. Include several of the most significant, consolidated on to one or two pages. These, together with the brochure, can be left with the customer or client for future reference

Every aspect of your portfolio should receive special attention. It is created to make a visual impression, so make certain that the impression it creates conforms with the image you wish to promote. Finally, you should follow up your sales call. Anyone with whom you have had an appointment and who has shown interest in your portfolio should be added to your mailing list. As the pace and direction of other businesses alter, so new opportunities can open up for you. Hence an initially unsuccessful call may eventually provide a new opportunity.

Publicity

Publicity is the promotion of a person or product by planting commercially significant news about them in the media. In effect, the person and his or her work come to the attention of the public by becoming newsworthy.

There are three distinctive features of publicity gained in this way:

- News stories and features appear to most readers to be authentic media reports collected by objective, paid reporters
- Being news-oriented instead of sales-oriented, the publicity reaches buyers who would otherwise avoid direct promotion
- News stories about a person's professional life enhances his or her reputation and confirms credibility in the minds of customers and clients

To develop publicity, an artist must get into the habit of thinking about his or her professional practice in terms of what is newsworthy.

For example, a craftsperson might have discovered a new use for a local raw material. A weaver/designer might have introduced computer technology into his or her design work. A potter might have revived and refined a centuries-old potting technique. The introduction of some handicraft may produce great benefits in the work of the local occupational therapy unit. What might appear humdrum to you may have great appeal to others. Every story has several approaches or angles. Write down a simple statement of the news item and then put yourself in the position of the reader to determine whether what you have written will attract enough attention for a person to say 'I'd better read this'.

New stories are released to the media in the form of a media release. When writing a release observe the following guidelines:

- Keep it simple. Use short sentence and short paragraphs: one idea per sentence, one main point per paragraph
- Suggest a headline
- Tell the important point first. The introduction or lead is the selling point of the story. It should be no more than 25 words long
- The following paragraphs should ensure that the what, where, who, why, when and how of the item is answered
- Include a quotable quotation attributed to the artist or some other

authority. Quotations are picked up and used. Avoid unattributable opinions
- Avoid clichés, jargon and elegant variations. Check for tautologies and ambiguities. Ask someone to read the final draft before typing or printing it
- Write in the past tense
- Include a name, address and telephone number at the bottom of the release, so that a journalist can follow up the story if necessary
- Attach a black and white glossy print to make recognition easier and to increase the chance of publication
- Know the media deadlines and send in material in plenty of time. Address the release to a particular person, for example the social editor, or art editor. Indicate the time and date when news can be released
- After you have submitted your release, follow it up with a telephone call. A short personal note expressing thanks should follow the printing of any article

Certain guidelines should be followed in setting out a new release:
- all material should be typed, double spaced
- leave at least 3 cm margins on both sides to accommodate sub-editorial comment
- type on only one side of the page
- staple multiple pages together

Finally, compose a list of publications and other media outlets that represent likely prospects for your news. For each outlet detail its name, address, telephone number, circulation, frequency of use, deadlines, art or social editor's name. Contacts could include daily and weekly newspapers, local free newspapers, suburban shopping guides, entertainment guides, craft or art magazines and newsletters, radio and television.

Format for media release

- First Paragraph: Short, succinct statement of the newsworthy event (new process, novel work, commission, award etc.)
 Example
 'A two-metre high sculpture was presented to the Mayor, Alderman Ward, this afternoon by local woodcraftsman, Allen Knott.'
- Second Paragraph: Further explanation of newsworthy item.
 Example
 ' "Mutuality", which was crafted in local red cedar, took two months to sculpt. It represents the ties between the town (name) and the local timber industry.'
- Third Paragraph: Details of the artist and his skills.

Example
' "Mutuality" is the latest sculpture from local craftsman Allen Knott, who said that he enjoys creating pieces for the local community from local materials.'

- Fourth Paragraph: Quotation from the artist (or from the Mayor).
 Example
 ' "There is nothing more rewarding than forming a piece of solid timber into a significant sculpture", Allen said.'

- Fifth Paragraph: Details of the availability of the artist's work to the readers.
 Example
 'Allen displays and offers for sale his sculptures and functional pieces, mirrors and jewellery boxes at the local art gallery (name) and at his workshop at Timbertown, which is open every Tuesday and Thursday afternoon and all day on Saturdays.'

Advertising

Paid advertising with direct selling as its priority objective is the promotional device least used by artists. Perhaps artists, like many other small business people, have serious doubts about whether advertising pays off or not. Unfortunately persistent cash flow problems reinforce the belief that the cost of advertising is too high for the business to support, particularly as benefits take some time to materialise. Artists also experience great difficulty in identifying themselves with the conceptual basis of advertising. It is small wonder, then, that the small amount undertaken is sporadic and lacks the characteristics of a planned strategy.

In some countries, particularly the USA, product advertising, involving the testing and displaying of several handcrafted products, their price and ordering instructions, is becoming normal business practice. Many craft businesses are being built on the basis of mail order catalogue ordering from consumers and wholesalers. On a more general level are advertisements which, by illustrating one or two products, stimulate enquiries from new clients. Many commissions are negotiated in this fashion.

There is the possibility of a good return but there is also a risk that vital working capital can be committed with little hope of return. There are real traps awaiting the uninformed. You should clearly define your target market(s) and have more than a meagre knowledge of writing advertising copy before initiating any significant scheme. You should also be prepared to pre-test any advertising campaign. This can be done in several ways:

- Place small advertisements first. If the response is good, increase their size
- Place the advertisement once in a cheaper newspaper or periodical and then expand

- Place a code in each advertisement to ascertain its effectiveness. Perhaps use a different PO or box number.

There are substantial benefits to be gained, but they will not be immediate. Allowance must be made for the fact that, in many ways, advertising resembles an investment, as funds to initiate the investment are spent well in advance of any expected impact. Similarly, the benefits of advertising expenditures may be spread over a long period of time. It is understandable that some small businesses curtail or even cease advertising campaigns because of an alleged lack of success. It may be helpful to know that the average small business spends about 3% of sales revenue on product advertising.

Some fundamental points can be listed to guide your future research, should paid advertising have an attraction for you:

- List the marketing objective that you hope to achieve through advertising. It must be precise and achievable otherwise it cannot be evaluated. An aim to double sales by next year is too general. Be more specific. An aim to show a sample of your work to 100 members of your target market (e.g. architects) in a certain geographical area in the next six months is much more helpful. Being finely focused enables you to direct your efforts to a definite group in a definite area for a definite period of time.
- At the heart of the first point is the assumption that you can define your target market. Who are they? What are they? Where are they? As an exercise, write down the characteristics of your best customers. If you can fix in your mind the type of people they are, you are far more likely to write an advertisement which appeals to them and place it so that they will read it. On the other hand, if you do not understand the concepts of market segmentation, target markets and market positioning, you will very likely adopt a shotgun approach to advertising; lots of pellets, few hits and very expensive.
- Assuming you have identified your target market, is paid advertising the most cost effective way of reaching it? What about direct mail, personal contact, booths and displays at gatherings and conferences?
- Do not consider yourself an expert in composing advertising copy simply because, as a consumer, you have been subjected to thousands of hours of advertising. There is a lot to learn, but it is well documented and freely available.
- Advertising is a powerful tool, but it cannot replace the quality of your product, your reputation, your personal selling abilities and your ability to sniff out publicity opportunities.

Some pointers to writing advertising copy:

- Keep it simple. Use a single idea, short sentences and short words.
- Create believability, use testimonials e.g. collections.
- Use a photograph. Photographs are better than drawings. A good advertising photograph should tell a story about your product.

- Photo captions have top readership, so put your main selling point in them.
- Stress benefits to the reader. Even if they are obvious, stress and explain them.
- Five times as many people read a headline as read the advertisement proper. Therefore headlines should promise benefits, contain maximum news and force the reader to go on to the body of the release.
- Don't be too formal. Be guided by your concept of your target market.
- Invite action; don't hide information such as prices.
- Be persistent and consistent. Successful advertisers don't run advertisements; they run campaigns.

Administrative communications

Administrative communications are the written material essential in running a professional practice efficiently – invoices, bills of sale, receipts, purchase orders, cheques and credit notes. Some will never be seen by clients and customers, but non-client parties, such as suppliers of art materials, are an important audience. The two aspects of professional practice, technical and aesthetic expertise on the one hand and business expertise on the other, are interrelated. Commissioners, gallery directors and show organisers will want to do business with an efficient businessperson as well as a skilled practitioner. All communications, regardless of their function, should mirror the same image of you. It would be futile to be at pains to have a high quality brochure and portfolio and yet be serviced by a disjointed and scrappy system of record-keeping. All documents contribute to your image; design and use them accordingly. (See also page 110, following.)

Personal promotions

Lectures, demonstrations and workshops are other ways of promoting your professional image. They are vehicles for gaining a wider awareness of your work and style, and provide opportunities for increasing the public's appreciation of artistic work generally. Make a list of local community organisations and service groups and send a letter, enclosing a brochure, to the president or secretary, offering to appear at a future meeting. Do not forget that some groups may appreciate a series of classes. Seek out these opportunities. Once you have arranged to speak to the group you must tactfully ensure that you derive the maximum value from the event. Some points to consider:

- Advance publicity is vital. Check with the group's publicity officer well before the event. Will a press release be written? Who will write it? Who will receive it? Offer your services if necessary.

- Provide the group with a glossy black and white print and a résumé to be used in their newsletter and other publicity.
- Business cards and brochures should be available at the venue.
- Advise the organisers of any special facilities you will require, such as a slide projector.
- The audience should be made aware of local galleries and shops where your work is displayed and available for purchase.
- Work may be sold or orders taken after the demonstration. This should be cleared with the organiser beforehand.
- Ensure that the group is aware of your willingness to create presentation items on a commission basis.

Many demonstrations and lecutres by well-known professionals of undoubted expertise fail because they cannot communicate their ideas. Unless you plan carefully the strategies you will use, the demonstration risks being a failure and a promotional lemon. The audience will forget your work and identify you with a boring, ineffectual demonstration. The likelihood of such a disaster can be minimised by good planning.

- First and most important, write down what you hope the audience will achieve from your lecture. You should be able to identify three or four objectives. If you have no objectives, your lecture/demonstration may well start in a blaze of interest but fizzle out because of confusion and lack of direction. To guide your list of objectives, start with the statement, 'at the end of the lecture/demonstration the audience will be able to: 1) 2) 3) etc.'
- Find out as much as you can about the audience. Projections about their interests and abilities will condition your objectives.
- Keep it simple. The success of any demonstration rests with the ability of the demonstrator to break up what appears to be a complex process into a number of simple operations. Plan your demonstration as a series of stages to be reached to achieve your objectives.
- Straight, 'stand and deliver' lectures have a high failure rate. Aim to introduce a variety of activities into the lecture; for example, intersperse your talk with slides, demonstrations, questions and even participation by members of the group.
- The use of slides and other aids should, however, conform with your overall objectives. Do not treat the exercise primarily as an entertainment; think of it as a learning situation. It is far better to show three or four slides and analyse them to drive home a point than to show so many slides that the audience is left with only general impressions. Do not be too serious though, remember, that learning can be fun.
- Part of your overall strategy should be to provide an opportunity for you to interact with the group and establish a rapport with them, so don't make the demonstration 'one-way traffic'. Ask and invite questions as you go. Leave time for questions and discussions at the end.

Make certain you have some questions in reserve to stimulate discussion and to help you evaluate your effectiveness.
- Spend time evaluating the exercise, seek feedback and be critical of your presentation. A valid evaluation is impossible without realistic objectives. Write down your evaluation and file it for the next time.

17 Pricing, Costing and Paperwork

How much to charge

This is one of the most important questions you will face but for which, unfortunately, there is no one method of determining the appropriate answer. Obviously, you must charge 'enough' or eventually you will go out of business. The problem is universal; all sellers face the same problem and their response varies with many factors – the type of industry, product, location, volume of production, degree of competition, market conditions etc.

To charge enough means at least to cover your costs of production. Costing and pricing form an important nexus, even if occasions arise when prices appear to be set more by reference to market conditions than to cost factors. In such a situation you must be aware of your costs of production; even if you cannot use a simple pricing formula based on cost information, knowledge of the relationship between costs and prices is an essential element in devising any business strategy. Attempting to conduct business in ignorance of cost conditions invites financial disaster and eventual insolvency.

An unsophisticated pricing policy is to set a price which accords with estimates of what the market will bear. Such a procedure in attempting to set the 'going rate', which has been established by artists and craftspeople in the market, is not related to costs of production and other important marketing considerations. Finding out what the competition is charging is an important step in determining your own price. However, continued reliance on the going rate method, while acknowledging the general importance of market forces, is far too naïve, since it ignores the importance of cost factors.

Similarly, it is possible to place too much reliance on cost factors. Costing by itself cannot provide the right price because in a competitive situation, in which most artists and craftspeople will find themselves, prices are determined by the interaction of the forces of supply (cost factors) and demand (consumer preferences). A sensible policy must be flexible enough to take account of both sets of forces.

Within product markets, there are usually two types of producer. The price-maker, because of the differentiation of his product (by advertising etc.), can exercise a degree of control over the pricing for his work by charging prices substantially in excess of the going rate. The price-taker, on

the other hand, has no such power and must accept the structure of prices operating in the market. His prices will more usually reflect the going rate.

Three factors influence the pricing of artwork:

- Cost influences relating to the costs incurred in producing and marketing the work.
- Intrinsic influences, which relate to the technical and aesthetic properties of the artwork.
- Extrinsic influences, which relate to the reputation of the artist, the galleries where he or she exhibits and the scarcity of the artist's work.

The marketing of the work of established artists and craftspeople can reflect all three factors. The higher the reputation, the greater the perceived technical and aesthetic characteristics and the greater the artist's ability to influence prices. They are price-makers. Prices set would be substantially in excess of costs of production as conventionally defined. People in such a position may even consider a knowledge of costs irrelevant.

On the other hand, newly emerging artists and craftspeople, would be more in the nature of price-takers. The price of their work reflects the market demand for artwork generally, with some allowance for the intrinsic nature of the work. With growing reputation and technical expertise the person can set prices which mirror the market's growing acceptance of his or her work and hence can more reasonably be expected to cover all costs of production.

In developing a marketing policy it is important that you view price as only one part of a marketing package. It should not be viewed as your sole marketing weapon, nor as a substitute for good product design, sales promotion and distribution channels.

If, by a comparison of costs and prices, you discover that your profit margins are low, your profitability can be increased by lowering costs as well as by increasing revenues. Efficiency, so necessary for successful operation, cannot be improved if you have no knowledge of inefficiencies. The provision of costing information helps to reveal them. Remedial action, e.g. a reduction in labour time (and hence cost), could be achieved by altering production schedules, deleting some products or rearranging workspace. Material costs could be reduced by a critical analysis of the production process to cut waste etc., by seeking new materials or new sources of supply.

These, together with the preparation of cash flows and budgets, are too often the neglected orphans of small businesses. But they are essential for survival. Learn to cope with them right at the beginning, and keep them simple and systematic.

Costing

Costing is the process of putting together all the financial ingredients of making a product to ensure that it is sold profitably.

These ingredients are: materials
labour
overhead
profit

First work out the overhead (or fixed costs). This is the total of all the expenses of running the workshop apart from those directly related to individual products. Raw materials and the time spent making items are directly related to the quantity and type of product and will vary accordingly. On the other hand, rent and rates, telephone bills and travelling costs, for instance, will have to be paid whether you have any work or not, and are therefore fixed costs, and part of the overhead.

List all expenses not directly related to the product incurred over a period of time. This may be done for a week, a month or a year. In the examples, the ceramics overhead (page 108) is for a year and the textiles (page 110) for a week, but both amounts are reduced to a cost per hour.

Remember that you are unlikely to work the full 52 weeks in any year; you must allow for holidays, Christmas (when your suppliers and customers won't be working, even if you are) and so on. The maximum you are likely to work in a normal year is 48 weeks; but when starting up you may prefer to calculate on a basis of 50 weeks – it makes the sums easier, and at first you may not have much time for holidays anyway.

Most items are self-explanatory, but note:

1 If the total cost of machinery is charged for one year it will inflate the total and set your prices too high. It is usual to spread the cost of machinery over its expected trouble-free life. If you have second-hand machinery you may prefer to spread it over only five or even two years.
2 Make sure that the amounts for, say, electricity relate to the correct period of time. Do not put a quarter's bill into a week's costing.
3 If you keep stocks of raw materials, they cost you money just sitting on the shelf: in rent, in heat, and, more important, in tied–up capital that is probably borrowed and attracting increasing interest charges. If the stock is precious metal or expensive components this may amount to a lot of money. At least 20% of average stock value should be added to the overhead. Even if the amount is small (60p per week for the textile workshop), put it in, as a reminder to keep your materials stocks as low as possible.
4 The overhead rate of £1.50 per hour is for each hour that the workshop is open during a week (40 hours). If you work alone, the rate is £1.50 per man/hour. If you work with a partner or an assistant, together you work 80 hours per week and the rate is therefore halved to £0.75p per man/hour.

The product costing is made up of *materials, labour* and the *overhead* rate, with profit added.

Materials are those directly used for the product, whether it be 150 pieces

of stoneware or a yard of 18oz wool cloth. Allowance is made in both cases for wastage. *Labour* cost is calculated from the number of hours taken to do the job × the cost per hour. Note that labour on the ceramics invoice is split into *professional* and *labouring* hours charged at different rates. This is a useful procedure for the small workshop. As a skilled potter you may be worth £4.00 per hour when exercising your skill, but not when sweeping the studio, making coffee, or going down to the post. These are jobs that anyone can do. If the whole week is charged at £4.00, the final selling price will be too high and sales will suffer. Keep a day-by-day record of professional and labouring hours worked. If you are working 70 hours a week, of which 30 are labouring, trade is good and it may be time to employ a junior to leave you time for more professional work. If you are working 40 hours a week, of which 30 are labouring, it is time to think again or find other regular employment.

Overhead cost has already been worked out. The number of hours under labour × the overhead rate per man/hour provides the figure.

Cost (ex-factory) price is the sum of materials, labour and overhead costs.

Profit is the extra amount you charge for setting up and running the business and for the risks you take. The percentage charged is a personal decision, governed by trade practice and the state of the market. If your goods are in demand, profit can be high. If trade is bad, profit may have to be reduced. *But never sell at a loss.*

Discount (see textile costing) is a reduction in price offered to encourage the buyer to pay quickly. The more quickly you are paid, the more money you will have for further production. A discount offered for early payment will encourage your customer to pay promptly, as it will save him money. Although the value of a discount may be small, even large customers tend, at the end of the month, to pay out first on invoices that carry a discount. The inclusion of one on your invoice will prevent it being put at the end of the queue. But *never* offer a discount unless you have already added the amount into your costing, otherwise the discount will come out of your profit, and you will be working for nothing.

For example, if you price an article at £9 and you intend to offer a 10% discount for early payment, you must add £1 to make the selling price £10. If the customer pays quickly he will deduct 10% and you will receive £9 which is the price you require. If he is slow in paying, he will pay £10, an extra £1 to compensate you for the delay.

There is a further bonus in the inclusion of a discount. Customers with accounts offices who pay monthly start with the discounted invoices. (Do this when paying your own bills!) If cash is short it may run out before they get to the undiscounted pile which will be put back till the next month or later.

VAT (see ceramic costing) currently 15%, is assessed on the final selling price. The operation of VAT is discussed separately on page 75.

Having completed a costing and arrived at a price it must be compared with the price of similar goods available in the market. It is necessary to add

a retail mark-up to make a true comparison with shop prices. If your prices seem low, you can consider raising your profit. If which is more likely, your prices seem high, you must carefully consider your costs and try to improve them, or try to add value to justify your higher price. Then work right through the costing again, incorporating any revised figures.

Ceramic workshop costing producing hand thrown domestic stoneware with one employee + owner

Overhead/fixed costs

	£ per Year
Rent	800
Repairs and maintenance	200
Heat/light/power	600
Telephone	120
Insurance	180
Post and stationery	100
Travel/parking	200
Trade fairs/conferences	150
Accountant	150
Consumable materials	200
Machinery and plant (£3000 over 10 years)	300

£3000 per year
£60.00 per week of 40 hrs
£1.50 per hour = overhead Rate

Therefore, with two people working, the overhead rate per man/hour worked = 75p

Product costing based on 150 pieces good from the kiln (= 200 into kiln) weekly output.

	£
Materials per week (including wastage)	40.00
Labour: professional hours 20 × £4.00	80.00
labouring hours 60 × £1.00	60.00
Overhead 80 Hours @ 75p	60.00
	240.00
Manuf. profit 50%	120.00
	360.00
VAT @ 15%	54.00
	414.00

Estimated retail price 80% Markup £745.00

Product costing – Slip-cast porcelain pot, limited edition of 12 overhead rate = £1.50 per hour

	£
Materials (including wastage)	15.00
Model & mould 1/12 materials and labour	7.00
Labour: professional hours 10 × £4.00	40.00
Overheads 10 hours @ £1.50	15.00
	77.00
Manuf. profit 20%	15.40
	92.40
VAT @ 15%	13.86
	106.26

Estimated Retail Markup between 60% and 100% – £170 to £215
For a private (direct) sale price should be between £110 and £160.

Textile workshop costing

Small owner-managed workshop producing plain wool men's suiting.

Calculation of Overhead (fixed or indirect costs)

Stock 50lbs yarn @ £3 = £150
20% interest on stock costs = £30 per yr
Therefore weekly cost is 30 ÷ 50 (wks per yr)

	Per Week
(yarn interest)	.60
Premises	30.00
Heat/light/power	10.00
Phone	3.00
Machinery (cost £1000, depreciating over ten years, therefore £100 per year)	2.00
Consumable materials	2.00
Insurance	5.00
Postage/Stationery etc.	5.00
Travelling	3.00
	£60.60

One worker totals 40 hours per week. Therefore overhead is 60 ÷ 40 = 1.50 per hour worked.

Variable costs per yard (direct costs)

	£
Materials 18oz Yarn @ £3/lb	3.30
Wastage 5%	.15
Labour 2 hrs @ £2 per hour	4.00
Overhead 2 hrs @ £1.50 per hour	3.00
Cost (ex-factory) price	10.45
Profit 10%	1.05
Discount 10% at 14 days (add 1/9th)	1.28
Selling Price	£12.78

This is above the market price for a plain wool 18 oz cloth, which should be nearer £9 or £10. Therefore costs must be cut somewhere, by cheaper yarn, faster working or cheaper labour, *or* the market price must be enhanced, perhaps by more design content or use of exotic yarns (silk, mohair etc.), which are more expensive per lb but, if skilfully used may add more value than their cost. And if any changes are made to material, labour or other figures, the whole costing must of course be worked out again.

Paperwork

As a professional trader you must present a professional face to your customers: by your products, you yourself, and your paperwork. The last of these, your paperwork, is the area where you may be least confident.

Stationers sell pads of invoices and delivery notes to which you can add your name and address, but this creates an amateur impression. You need a simple, appropriate letterheading that says who you are, what you do, and where you do it. This, and a business card, are all you require initially. The headings for invoices etc. can then be typed on.

Printing is cheap, but preparing the original artwork is expensive, so prepare your own. Letraset on plain white paper of a standard size, such as A4, will provide a satisfactory master from which any 'instant printer' can produce good quality printed paper. If you have no experience of this you should get the *Design and Print Production Workbook* by David Plumb, which will tell you, in easy stages, all you need to know.

Using this letterhead as a base, there are five documents you will use in your trading:

1 Order
2 Delivery note
3 Invoice
4 Credit note
5 Statement

In each case take a carbon copy and file it, as firms do not return invoices with payment, but keep them for their own records; include a date (day of posting); number each category consecutively to help in your bookkeeping and to guard against loss. Do not start numbering at 1 (one) – it has an amateur look. Start at 100 or 200, to give substance to your operation.

1. *Order.* For purchasing goods or raw materials. It should state quantity, description of goods, price and delivery details (where applicable).
2. *Delivery note.* This accompanies the goods, whether despatched or delivered. It quotes the customer's name, his order number and the quantity and description of goods delivered. If you deliver personally, always get a signature for the delivery on the carbon copy which you keep: disputes at a later date can be difficult to resolve if the goods have meanwhile been sold by your customer.
3. *Invoice.* This is a request for payment, and should be sent separately from the goods when supplying a firm, although with private clients it may be handed over with the goods. It carries the same information as the delivery note with the addition of:
 the delivery note number
 the price per article
 the total cost

any discounts
the amount of VAT, where applicable
your VAT number, where applicable.

4 *Credit note.* If goods are returned for any reason – quality, wrong specification or colour – there is a temptation to replace them as quickly as possible and hope for the best. If there is no document to record the transaction there will be argument at a later date as to whether the correct goods have been delivered or not. When returned goods are received, send the customer a *credit note* stating his order number, quantity, type and value of goods and the reason for return.

This tells the customer that he does not have to pay the amount quoted. If and when the goods are replaced, a new invoice is then sent to ask for payment for the replacement.

5 *Statement.* This is a reminder to the customer that he has not yet paid for goods received. It quotes any unpaid invoices and totals them and also deducts any credit notes issued during the period covered.

Pricing, Costing and Paperwork 113

a

```
Wootton Glass   Station Rd  Wootton
                Hants (0476) 5578

        DELIVERY NOTE 107        12 Mar 8-

The Gift Shop        Order No 236D
Harpenden
Herts

Bubble Glass.   White

Qty 6 Bowls 4"
    12 Ashtrays
    4 Bowls 8"

Delivered by Wootton Glass

            Received
            B. Sando.

        Chris Reid  MDesRCA
```

b

```
Wootton Glass   Station Rd  Wootton
                Hants (0476) 5578

        INVOICE No 021          21 Mar 8-

The Gift Shop        Order No 236D
Harpenden            D / N No 107
Herts

Bubble Glass.   White

Qty 6 Bowls 4"   @ £2.83        16.98
    12 Ashtrays  @ £3.82        45.84
    4 Bowls 8"   @ £5.33        21.32
                                ─────
                                84.14
VAT @ 15%                       12.61
                               ──────
                               £96.75

Discount: 10% @ 14 days from Invoice
VAT No. 394280762

        Chris Reid  MDesRCA
```

c

```
Wootton Glass   Station Rd  Wootton
                Hants (0476) 5578

        CREDIT NOTE No 562       28 Mar 8-

The Gift Shop      Returns Note No 43
Harpenden
Herts

Bubble Glass.   White

Qty 2 Ashtrays returned faulty.

            @ £4.41        £8.82

        Inclusive of VAT @ 15%

        Chris Reid  MDesRCA
```

d

```
Wootton Glass   Station Rd  Wootton
                Hants (0476) 5578

         STATEMENT No 065        31 MAR 8-

The Gift Shop
Harpenden
Herts

        Invoice No 006 of 3 Mar 8_      27.45
        Invoice No 021 of 21 Mar 8_     96.75
                                       ──────
                                       124.20
        Credit Note No 562 of 28 Mar 8_  8.82
                                       ──────
                                      £115.38

        VAT No. 394280762

        Chris Reid  MDesRCA
```

Fig. 4 A delivery note, invoice, credit note and statement

18 Selling your Work

There are several channels through which you may choose to sell:

- wholesale, through art/craft shops, boutiques, gift shops, galleries and department stores
- on sale or return through these retail outlets (except department stores, which seldom operate in this way)
- direct sale to the public from your studio, or at shows and fairs
- through commissions.

You cannot decide either the best method of selling or the most appropriate stores until you locate and identify the outlets that it is possible to service. In your early days a suitable strategy might be to aim for what marketeers call the 'roll out'. This is a technique by which a seller in a regional market extends his distribution to a much wider geographical area, like ripples in a pond spreading progressively over a larger area. Having made a decision initially to confine your distribution points to a restricted area, say within a radius of 50 miles from your studio or base, you can then enlarge your market area, to capitalise on your increased marketing knowledge, when you are confident that you have the capacity to service the larger market. Initially, you can economise on time and other resources by servicing a small local area but later, as you refine the knowledge of your market, you can identify markets in more distant areas which you can justify servicing from your studio/base.

Your first task, therefore, is to compile a catalogue of all outlets you consider to be potential markets for your work. Don't be confined to a small area. You should aim to have your work widely distributed. It makes little marketing sense to have outlets featuring your work located in close proximity to each other.

The personal element is fundamental to the next stage of your research, when you examine the potential of the outlets you have isolated. Only a visit can produce a worthwhile evaluation. Spend time in each store appraising its size, its customers and its stock. How will your work appeal when placed alongside other stock? Remember that it detracts from quality items to be displayed with shoddy work. Does the store's marketing strategy appear compatible with your aspirations and the image you wish to promote? Will the store generate sufficient business to justify your servicing the outlet? Size in terms of floor space can be deceptive, so it is better to look at the space devoted to arts and crafts and better still to look at

the number of sales personnel. Talk to the sales personnel, shoppers and neighbouring storekeepers and seek the advice of established professionals.

The end product of your first piece of market research should be a list of outlets, ranked in order of sales potential. Your next task is to approach the management of selected outlets to lay the foundation of a mutually satisfying professional and business relationship.

Making contact

The approach should be formalised by ringing or writing for an appointment; don't just 'pop in' seeking a 'few minutes' of the proprietor's time. If you ring, choose a time when the person may be best able to give you a good reception; early afternoon or late morning is probably the best time. If you write, make certain you write under your own letterhead and send a well thought out CV so that it can be determined how well your work will fit in with other work being sold or exhibited. A CV is a most important promotional instrument, so think carefully about its layout and the information it conveys. See page 9 for the preparation of the CV.

In keeping an appointment you should aim to create a good businesslike image as well as a good professional image. As a businessperson, the proprietor or manager will be probably more interested in the former than the latter, although he or she will value both. A business card is a must, enabling quick recall of past approaches as well as providing a future reference point. Take along a sample(s) of your work. Don't overdo this; take those pieces most representative of your style or with the greatest appeal to the particular type of outlet; you won't necessarily wish to sell the same work through a gift shop as you would through a gallery. Actual pieces of your work can be supported by slides (take a small viewer with you, just in case . . .), but don't rely entirely on slides – they can be misleading in conveying proportions and may not adequately portray important properties such as texture. A well-designed brochure appropriate to your estimated level of sales to be given to each customer would be a useful supplement. Attach tags to your samples, one to indicate wholesale price and another to indicate your name, address etc. (see pages 94–5).

Wholesaling

The output of the individual artworker is limited by the labour-intensive nature of his craft. As an individual he may find it difficult to service a mass market. However, as an employer or as a member of a cooperative enterprise, this may be possible. Some artworkers have wholesale-type relationships with a limited number of retailers who agree to buy much of a person's product at mutually determined prices. Several problems confront the individual entering a true wholesale market. These relate to the need for

increased documentation and correspondence, packing and despatching and the necessity to gear production to the needs of the retailer.

On receipt of an order and on estimating that the order can be supplied within the specified delivery time, an order acknowledgement should be sent, advising the retailer of the order number and the method and approximate time of delivery. If there is likely to be any dispute about price changes, include details so that the retailer has the opportunity to change his order: it is much simpler to amend or abort the order at this stage than waiting until the goods arrive at their destination.

Small firms are often criticised, rightly, for late deliveries or for complete failure to deliver. In many cases this is due to the inability to lift production levels sufficiently to supply large orders. It is also often due to inefficiency in making promises that cannot be kept. You must offer firm delivery dates and keep to them, or your orders may be cancelled.

When taking an order and agreeing to supply on a certain date it is essential to know not only how long it will take to make the order itself, but also how much work is in the pipeline ahead of it. In other words, when can you start it?

On a selling trip or at a trade fair, you need a chart of the weeks or months ahead, and a clear knowledge of your capacity – how much you can make in a day or a week. Every order you take, or promise you make, must be entered immediately, and each will push further into the future the date you could start a new order and therefore the possible completion or delivery date. Never promise what you cannot achieve. Most customers will accept a later delivery date suggested when placing the order: No customer will accept late or non-delivery.

As a wholesaler, you must appreciate that a retailer plans his inventory levels to ensure that he is adequately stocked in time to take advantage of peak periods of demand. The art/craft market is strongly seasonal in character, being geared heavily to the gift and tourist market, and retailers will attempt to increase their stock levels well before the holiday or summer months. An acknowledgement of an order, by reassuring a retailer that he will have adequate stock, builds up goodwill and strengthens the partnership element of the supplier-seller relationship.

If you have problems meeting commitments consider setting a minimum order, since small orders require almost as much paperwork and attention as large orders. Further, you need to ensure that the retailer buys enough to make a good display and to supply customers with a suitable range of your work. One way of doing this is to set a limit on the initial order (say £200) and reduce the limit for subsequent orders. Alternatively, you could consider imposing a surcharge in the form of a handling fee on quantities less than the minimum order.

Sale or return

Fine art galleries almost invariably operate a process of sale or return: they agree to display an artist's work, either as a one-off exhibition or as a part of their current stock, and to pay the artist a specified proportion of the sale price when the piece is sold. This is a standard practice, and the terms of agreement are discussed in Chapter 19 on *The Artist/Gallery Relationship*.

Sale or return is a much-abused system when imposed by retailers on craftspeople who are eager to start selling or to dispose of stock in order to survive.

Goods are left with the retailer, without payment, and reimbursement is made only when the goods are sold by the retailer. This process has several disadvantages:

- The craftsperson must wait to be paid – which adversely affects cash flow
- The retailer has no incentive to promote and sell the goods, as his money is not invested in them
- The craftsperson may, after a considerable time, be required to take the goods back, and be left with unsaleable stock.

If you are just starting in business, or if there is a retail outlet in which you would particularly like to place your goods – either for geographic coverage of the market, or for reasons of prestige – it may be necessary to agree to supplying on a sale or return basis. It is essential, however:

- To make it clear that it is for an initial, stated, period of time, after which you expect to be paid as a normal wholesaler
- To agree that, should the goods not sell, you are entitled to remove them (and to transfer them to a more profitable outlet)
- To try to obtain some preferential conditions such as a display of your range, using your name and promotional material or a different division of the retail price between the retail and wholesale markups.

When a retail shop has bought goods at the wholesale price, it obtains ownership, and may add any markup it desires. This may be anything from 80% to 200% or more, depending on its costs, rents and turnover. This is a retailer's right, and it is, in fact, illegal for a supplier to impose a strict retail price on the retailer. Where the goods are not to be paid for, as in sale or return, the supplier has every right to negotiate the retail price with his customer, the retailer. The supplier, however, as a struggling beginner, may not be in a strong bargaining position, and sloppy or nonexistent agreements made in these conditions have brought the sale or return system into disrepute.

In other countries, particularly the United States, the process is more formalised and can work profitably for both sides. It is termed selling 'on consignment', a phrase used in the UK mainly in large-scale wholesaling operations. It is worth considering the adoption of the term and the use of

the system for the small-scale artist/craftsperson. The paperwork, described below, should be prepared in advance, and suggestions by retailers of their taking work on sale or return should be countered with the proposition of supplying goods on consignment. (This may dazzle them with your efficiency, and make them more amenable to the terms of the agreement.)

Note

There is an area of confusion in the setting of percentages for profit, markup, or commission.

If you sell to a retailer for £2, and he sells to a customer for £4, he has added a markup of 100%. At one time, retailers calculated a profit figure on their *selling* price, and some traditional ones still do. Namely, if the item is sold for £4, that gives £2 profit, which is only 50%.

It is essential when discussing prices with a retailer that you know whether any percentage mentioned is calculated against his buying price or his selling price. It is best to ask which he uses, even at the risk of appearing stupid.

In the consignment process below, the commission taken by the retailer for selling your work is calculated on the final retail selling price.

Selling on consignment

If you consign work to a gallery or store you enter into a contractual relationship with its proprietor. Your offer (as the consignor), to leave work with the outlet (the consignee), pending sale and the proprietor's acceptance of it, together with his agreement to send sale proceeds less commission, ensures that a valid contract exists.

While consignment is a very common transaction for many artists and craftspeople, there is seldom any attempt to agree on anything beyond the bare essentials, let alone formalise the arrangement by a written agreement. In most cases there is no attempt even to identify the artwork which is consigned, and few artworkers can display a receipt for work left. Without a receipt, how can they support an insurance claim in the event of fire in the gallery or store? How can they prove ownership in the event of the gallery or store's bankruptcy? Tags, signatures, marks and signs can identify authorship and may point to a consignment arrangement, but a written agreement will clarify the nature of the relationship and hence establish ownership.

If you consign regularly you should consider using a standard document. If you find the idea of written agreements distasteful or think they will harm your relationship with other parties, at least discuss the various issues involved and reach verbal agreement on each of the conditions which will apply.

It is difficult to draft a contract to suit the needs of all artworkers, since the circumstances of each relationship will vary. The following outline is an example to aid understanding of the idea of a written contract. It should

be amended to suit particular circumstances, e.g. extensions to this agreement to accommodate more complex transactions such as the consignment of major artworks are considered in the next chapter on *The Artist/Gallery Relationship*.

Simple consignment agreement
Artist's logo, letterhead, address, phone number(s)
............ (the consignee) of acknowledges the receipt from (the consignor) of the following works on consignment.

Number	Description of Item	Retail Price	Total
......
......
......

The consigned work will be sold under the following conditions:

1. The work shall be sold at the stated retail price.
2. The consignee will pay the consignor the retail price less ... % commission on any work sold. Notice of all sales together with all monies due will be sent to the artist by the fourteenth of each month for work sold the previous month.
3. During the term of the agreement the consignee shall be responsible for the insurance of all consigned work to the benefit of the consignor to an amount equal to the consignor's portion of the retail price.
4. After one month from the date below the consignee may notify the consignor to remove work for any reason. The consignor may also remove any unsold goods after one month and after giving the consignee five days' notice of his intent.

....................
consignor date

....................
consignee date

The first section of the agreement identifies the parties to the agreement and acts as a receipt for the delivery of the works. Clauses 1 and 2 detail the price to be charged, the commission payable and the procedures to be adopted following sales. Clause 3 identifies the responsibility for the safety of the goods while detailing the extent of the indemnity involved. The last clause ensures that the responsibility for the removal of work rests with the artist but confers on him the right to remove work for any reason, e.g. dissatisfaction with their promotion or a wish to withdraw them so that they can be used in an exhibition.

Consignment records

Be prepared to support your decision to consign work with thorough record-keeping. Unfortunately, the nature of the selling method with possible distribution to numerous outlets of a large number of pieces of work which may be sold, damaged and returned makes a lot of paperwork inevitable. Keep a consignment book or card system in which each outlet has its own page or section. By recording under suitable headings the number and description of items left, sold and returned, you can determine the balance of work held by each outlet at any time.

Selling direct from your studio

Using your studio for the dual purposes of making and selling brings many of the advantages associated with shows and fairs, viz. selling at retail price (but don't undercut your other retail outlets), identifying artwork with the maker and educating the public. Additionally, you could probably have a greater selection of work available. However, there are many disadvantages, the most obvious of which stem from the effect of your selling on your work rate and work pattern. It seems inevitable that conflicts will arise, since admitting the public to your studio will affect your work routine, require structural alteration involving extra expense and a restriction on work space, and having to conform to government safety requirements.

A compromise can eliminate the main disadvantages. Instead of selling from the studio as a continuous activity, promote special studio days or private showings at convenient times throughout the year. Use your mailing list to invite people to inspect your studio, view and buy your latest work. If you share accommodation with others, a joint venture would add variety and increase market potential. Even if you do not share studio space, the same effect could be gained by having a joint exhibition and sale at one studio with the venue rotating on each occasion.

Shows, fairs and other happenings

Shows are a way of testing yourself against the competition; you are one of many artworkers representing different art forms, in different price ranges, displayed in contrasting ways. If business seems to be booming around other stalls and you are barely paying your way you will have to ask yourself serious questions about your promotion and selling strategies, as well as what you are trying to sell. A moment's reflection will show why this is true. Because of the transient nature of a show, few people when they come have any idea of what they will buy, they probably have £x to spend (more if they have a credit card) and are only waiting for the right stimuli (good display, products or promotion or a combination of these) to make their purchase(s).

While attending your stall you must talk to people, tell them about your craft and your approach to it, feed in a few technicalities and seek their ideas regarding product and the design. Have some of your virtuosic pieces on display to show your range and talents: these might even invite a commission. It is important that you be identified with your work. If two items have a fairly equal appeal, a customer naturally chooses one in preference to the other because he is aware of the maker's background and personality. People want to know who made a work and how it was made, so do not sit back and read a book while potential customers drift past your booth.

Your involvement with customers has a spin-off in addition to personal gain; your interaction with them represents an educational exercise. You are giving them an insight into the skills and philosophy required to be an artist or craftsperson. You should:

- Tell people something about yourself and your work, so that they can identify your craft with you.
- Be punctual and allow about an hour for preparation before trading. Make certain your booth is attended at all times. Arrange with relations or friends for relief where necessary.
- Check out other displays and talk to fellow participants. Seek out the organisers to compliment them on good aspects, to make suggestions for future shows and to find out valuable marketing information, e.g. attendance, opinions of the other stall holders.
- Keep a lookout for shoplifters.
- Perhaps demonstrate your skills or some selected skills while still having your stall fully attended. There are sound promotional and educational reasons for doing this.
- If your craft is functional or wearable, promote it by using items in your display or wearing them yourself.

After the show is over . . .

Your first job will be the processing of all commitments contracted at the show: outstanding orders, requests for further information and adding new entries to your customer inventory.

Your second task will be the evaluation of the show as a worthwhile selling strategy. The basic question is, did results justify participation? Compare costs and sales, compute your cost per sale, cost per person and average sale. Compare with previous year's figures and those from alternative venues. How well do actual figures compare with predictions? How much time was taken up by the show, its preparations and follow-up? Translate this time spent into units of production lost and set the show profit against the lost production. Was it worth it? Only you can set the objective criteria against the subjective benefits derived from the show as a recreational, social and professional exercise.

Packing and despatching

Lack of attention to packaging poses problems for the sender and the outlet. When goods arrive in a damaged state it is not only the sender who is disadvantaged. The store is without stock at a critical time and the whole process of claiming damages from the transporting agency takes time and effort better expended elsewhere. Anyway, whose responsibility was it to insure the goods while in transit? Spend some time working out the best way to pack your work. No matter what you are packing, make certain that the contents of a carton do not have room to rattle around. Old newspapers can provide good protection. When packing such items as ceramics, it is best to wet the newspaper first. It will then mould itself around the work. You can buy new shipping materials, including polystyrene packing, straw, etc., but you will have to weigh up the particular advantages relative to your own art or craft and the extra expense involved. A glassworker, for example, might even choose to deliver items personally.

The despatch of an order requires formal documentation. A packing slip itemising the goods despatched should be included with the order so that the contents can be checked immediately on receipt and you can be notified of any discrepancies or breakages. At the same time, an invoice with freight charges included should be forwarded under separate cover, with a copy kept for your records. Use some well designed labels and stickers on each despatch; never lose an opportunity for promotion.

Fees and royalty payments

A manufacturer may wish to buy your designs for mass production, or may commission you to produce designs specifically for him. This can be very useful in spreading your reputation, and also very profitable. Payment may be in one of three ways:

1. A contract where the manufacturer gives regular (monthly or quarterly) payments, in exchange for a clear commitment to produce a given quantity of design work on your part.
2. A flat design fee for each piece of work completed.
3. Royalties on goods produced: a system where the designer is paid an agreed percentage of the manufacturer's sales income.

The first type of contract is self-explanatory; it is a long-term relationship between the two parties. The other two are alternative methods of paying for a single design or group of designs. There are advantages and disadvantages to both. The flat fee ensures that you get a certain sum of money for the work, but will limit the total *potential* profit. With a royalty, the designer takes on more of a risk; if the product does not sell well you may never earn

enough from it to repay the design time. But if it is a success, the profit will be high.

Royalties are usually within the range of 1% to 5% net sales invoice value (the price paid by the customer – who may be retailer or consumer – less any discount and not including VAT). They may be calculated as an unchanging percentage through the life of the product, or they may be a decreasing percentage as the total volume increases.

Before agreement is reached, the designer must work out how much money he would receive under the proposed system, taking into account expected quantities of production. Mental calculation of percentages is very confusing.

Example Royalty on a product with net invoice value £100
(a) 3% flat royalty on expected sales of 1000 units
= £3000

(b) decreasing royalty of 5% on
first 300 units £1500
3% on next 300 units £ 900
1% thereafter 400 units £ 400
 £2800

(b) sounds better with 5% on 300 units, but produces less cash. But (a) has a higher risk if sales are less then expected.
A total sale of 400 units will produce:
 £1200 in (a)
 £1800in (b)
If sales exceed the expected 1000 units, system (a) is still more profitable.

There are some further points to watch with royalties. Designers often assume that any design accepted will be produced, but about 80% of designs never emerge as finished products. You should therefore try to negotiate an 'advance', an irrevocable payment against royalties. This should be about one-third of the value of the design work, say £700 on a £2000 design job. This £700 will be deducted from the royalties as they accrue. The royalty may continue for the life of the product, or it may stop after a fixed time limit. Remember that sales may not reach full volume during this period. Also, any time limit should run from the start of sales, not from completion of the design work; otherwise you could lose money through manufacturing delays outside your control.

If your design incorporates some significant technical innovation, it is important that this new method is seen as part of the design, and is specifically mentioned as such in the contract. This ensures that you will receive royalties if your innovation is applied to a product slightly different in pattern or shape.

Whether (if offered the choice) you should take a flat fee or royalties for a particular piece of work is a matter of calculating the risk. Only the designer

can do this, bearing in mind the specific case. But always compare estimated royalties with the cost of producing the design on a flat fee basis.

The Chartered Society of Designers has produced an outline contract for royalty payments, which covers all likely questions. Copies are available from the CSD, 27 Bedford Square, London WC1, price £1.25 to members.

19 The Artist/Gallery Relationship

Artists and craftspeople will vary in their acceptance of the various market outlets as avenues for sales. The fine artist or craftsperson in particular will probably reject any notion of selling through retail stores, boutiques and fairs. For them, the gallery acts as a focus for marketing efforts.

The search for a suitable gallery

The procedure to adopt was discussed in the previous chapter. It is sufficient here to emphasise the importance of personal visits to determine compatibility. Secondary sources of evaluation are important, but only through a personal visit can you appreciate the aims and philosophy of the gallery. The primary evaluative resource is your appraisal of the type of artwork handled, price range, layout, decor, motivation of staff and exhibition policy. Arrange to be placed on the mailing list and attend a few openings. In this way you can also make judgements about the clientele of the gallery.

A personal approach, seeking an appointment to show one's expertise is better than an impersonal phone call. Even if the owner or the gallery director is not present when an appointment is sought, all is not lost. The gallery assistant could well be an important adviser to the absent chief in addition to being a valuable source to you of background information.

The owner or director will appraise the suitability of your work by reference to slides, photographs, original work (two or three representative pieces) and other evidence presented. Concurrently, he will be appraising you personally as a potential party to a business agreement. Your attention to detail, businesslike approach and personality will be important variables in his decision.

Likewise you should try to assess the gallery director. After all, you are an equal party to any arrangement. How knowledgeable is he about arts and crafts in general and yours in particular? Does he appeal to you as a concerned and enthusiastic supporter of art or is he a retired used car salesman who has moved into a more up-market mode of business?

If the initial introduction reveals work of a sufficient interest and standard, the director could well respond to an invitation to see a greater quantity of work in your studio. Understandably, it is impossible for a gallery director to go to a studio 'on spec'.

Given a favourable impression, he can offer you two alternatives, in

addition to the alternative, already discussed, of consignment selling on a more or less ad hoc basis:

- an offer of a solo exhibition
- an offer of gallery representation

An offer of exhibition

This is an offer for you to place a significant amount of work with a gallery for exhibition and sale on a consignment basis. The offer could entail a solo exhibition or perhaps an exhibition in conjunction with another artist(s) whose medium(s) would not compete with yours.

Since work is consigned, you should keep in mind the points raised in Chapter 10. However, the offer of an exhibition raises more issues than those associated with the ad hoc consignment of works mentioned above. Unless there is a clear definition of these issues, and an agreement made, there can be no equitable allocation of responsibilities with respect to these areas.

You may hesitate to introduce documentation, but you would be well advised to do so. Documentation will ensure that your rights are protected, without placing any strain on the artist-gallery relationship through misunderstanding, since the gallery owner will receive the same protection. There is much evidence to suggest that gallery owners and directors welcome the use of written agreements, so do not think that your suggestion of 'something in writing' will jeopardise any newly negotiated deal.

In negotiating an exhibition deal artists and craftspeople will find the following checklist valuable. However, every artist and gallery representative, as parties to an agreement, must decide for themselves the terms of the agreement best suiting their needs.

Checklist for exhibition agreement

1. Description of parties, names and addresses.
2. Identification of works to be exhibited. Description and prices. Inventory can be in the form of an attached list signed by both parties.
3. Venue, Address, gallery hours, exhibition space.
4. Duration of exhibition.
5. Publicity. Responsibility for promotion and associated costs, e.g. advertising, postage, catalogues, photographs.
6. Provision of promotional material by artist, e.g. biographical notes, photographs, description of each work, personal mailing list of invitees.
7. Packing, freight and insurance in transit from studio to gallery and gallery to studio. Amount and nature of insurance cover, type of transport, delivery dates.
8. Insurance of exhibition works. Responsibility for safety of works on exhibition.

9 Framing and hanging.
10 Exhibition preview. Date, time and responsibility for costs.
11 Conditions of sale. Whether all goods are for sale, responsibility for determination of prices, need for deposits, use of artist's bill of sale.
12 Commission on exhibited works sold at the exhibition, on orders for work taken at the exhibition, on work sold from the studio during the stated period.
13 Payment of artist/craftsperson. Timing of payments, statement of expenses.
14 Arrangements for unsold work.
15 Other exhibitions. Limitations in time and area on artist participating in other exhibitions.
16 Copyright. Are reproduction rights reserved for the artist or are they negotiable? How will purchasers be informed?
17 Signatures, date.

An offer of gallery representation

The continuous nature of this type of relationship contrasts with the one-off nature of the exhibition offer. Success associated with an exhibition could well lead to an offer of gallery representation and it is likely that one exhibition or more would precede such an offer.

A gallery's offer of representation is an offer to act as manager/agent for the purpose of promoting, exhibiting and selling the artist's work. It is often said that the gallery has 'taken on' the artist or the artist has joined the 'gallery's stable of artists'.

In accepting the gallery's offer you capitalise on the reputation that the gallery has built up over the years. Your stature and prestige will be enhanced by this and by the reputation of other artists who are represented by the gallery. In such circumstances your work is guaranteed a more serious and more widespread response than would otherwise be the case. If this were not so you surely would not accept representation.

Gallery owners and directors would be certain to point out that the artist-gallery representation system is a mutually dependent system. It depends essentially on the sale of artists' work. They would maintain that an artist may be only partially dependent on the sale of work but galleries are almost exclusively dependent on the sale of artists' work. Thus they would argue that, once an artist chooses to become a part of the system, no work should change hands without commission being payable to the artist-gallery system. Artists and craftspeople should be aware of this attitude.

The gallery agreement

If there appears a chance that a gallery will be your representative or agent, there are many issues on which agreement might be sought. The points below, though not an exhaustive inventory, represent major areas where

obligations must be defined and allocated. Once consensus has been reached, the agreement should be written down. It is left to individuals to devise their own form of agreement but expert advice should be sought.

1. Description of the parties to the agreement.
2. A statement detailing the nature of the gallery's representation. For example, the gallery will act as agent for the artist for the purposes of promotion, exhibition, renting and sale of works under the following conditions: (points 3 to 17).
3. Definition of agency area: town/county/country/international area.
4. Duration of agreement and method of termination.
5. Description of goods. Will they include all works created or only those selected by the gallery? Will there be an annual minimum? Can the artist retain works for private sales?
6. Delivery. Allocation of the responsibility for arranging and paying the cost of delivery expenses including insurance.
7. Title. Agreement as to when the buyer shall be acknowledged as owner.
8. Selling prices. How are these determined? Can the gallery allow discounts? If so, who bears the cost of these discounts?
9. Payment. Arrangements for payment of the artist and policy regarding the gallery's extension of advances against future sales.
10. Commission. Determination of the rate payable for sales negotiated by the gallery and any differential which apply to ex-gallery sales and commissions.
11. Exhibition. Details of exhibitions (frequency, type, duration) to be held annually and an indication of responsibilities and cost-sharing arrangements associated with them.
12. Insurance. Responsibility for the safety of works on exhibition, in storage, in transit.
13. Copyright. See provisions of the exhibition agreement, particularly those regarding the use of the artist's own bill of sale.
14. Statement of account. Regularity with which the artist will receive a statement containing such details as:
 - works sold, leased or rented
 - dates, price and terms of above transactions
 - gallery's commission
 - details of purchaser or rentier
 - amount due to the artist.
15. Return of work. Allocation of responsibility of arranging and paying for packaging, freighting and insuring the return of work to the artist.
16. Arbitration. A commom feature of foreign contracts, particularly those of the USA, is to specify a mutually acceptable arbitrator to preside over any dispute. Such a procedure, though not free, may obviate potentially expensive litigation.
17. Governing law. Agreements have international implications. Specification of the applicable laws could save you time and money.

20 A Guide to Commissions

Historically, the commissioning of artwork was the most usual form of sale because most art was custom-made. Even today, there is still considerable scope for art and craftwork to be made to order. All levels of government regularly commission works for display in public buildings, their grounds and in parks. Churches, companies and academic institutions similarly commission works to be hung or displayed in boardrooms, foyers, libraries, dining rooms, etc. Individuals and community organisations likewise commission work for trophies, presents, posters and other illustrative advertising material. There is a large potential market for you to share in and to exploit.

Working on commission confers both advantages and disadvantages.

Advantages

- you do not have a large stock unsold or on consignment with the attendant cost of tying up working capital and storage space.
- you do your own marketing, thus avoiding consignment commissions, mark-ups, etc. This can make you more competitive.
- you do not have to produce in anticipation of demand – your artwork is presold. This leads to more accurate budgeting.
- you can create work knowing the environment in which it will be placed.

Disadvantages

- if you rely heavily on commission you won't have the stimulus of working to exhibit in galleries. This may inhibit career advancement.
- with commissioned works the artist gains a greatly enlarged body of 'clients' to satisfy, e.g. committee members, civic officials, relatives of the commissioner, etc. Dealing through other channels the artist is not exposed to discussions, debates and misunderstandings.

Negotiating a commission

In accepting an offer of a commission you enter into a contractual arrangement whether you like it or not. The sensible thing is to identify important

features of the arrangement, reach agreement on them and write them down. Perhaps you might feel that the introduction of legalities is unnecessary and inhibiting. This may be so if a long-established relationship exists between the two parties, but it is more likely that both parties will have no such firm basis of mutual understanding to provide protection of rights and allocation of responsibilities. The latter can only eventuate if both have a clear understanding of all details concerning the project. Issues apparently clear when the commission was negotiated become blurred with time and a written record is essential should any dispute arise.

The first step in negotiating a commission entails an interview in which you determine the needs of the commissioner, gain an impression of the environment in which the work will be installed or its intended use, and fully discuss the cost constraints under which you must work. On the basis of this interview(s) you should be able to put a proposal before the individual, council or committee with the aim of achieving mutual understanding of what is desired and under what conditions it will be supplied. It should be in writing and should include prices, a description of the intended work and time schedules. It may even set out a number of alternatives. Models or sketches should accompany your proposal. Once your proposal is accepted or amended with your approval, its terms should be incorporated into an agreement signed by both parties.

Commission agreements

A written agreement has obvious advantages to both the artist and the commissioner. By defining the rights and responsibilities of both it will avoid disputes and costly legal arbitration.

Legal opinion supports the idea that there are two areas where agreements are appropriate. This arises because of the separation of the act of creating the work and the act of selling the work. The two need not be coincident. The commissioner engages the artist to create a work and, while sale of the work to the commissioner would usually follow, it is not necessary. The commissioner may not wish to be the owner of the work; he may have commissioned the work on behalf of a third party.

This problem need not present difficulties for the most artists and craftspeople. The one agreement can embody both creation and sale. The first clause nominates the parties to the agreement and provides a description of the commissioned work. Here would be inserted details of the type of work, size, materials used, and reference could be made to the model(s) and sketches used. (See opposite.)

Clause 2 defines the terms of payment. It provides for partial payments, representing compensation for time expended and cost of materials used by each of the dates nominated. It therefore provides protection to the artist in the event of cancellation (see below). At the same time it ensures that cash flow problems, associated particularly with large commissions, will be avoided.

BASIC COMMISSION AND SALE AGREEMENT

1. This is an agreement between ..

 (the artist/craftsperson), of ... and

 (the commissioner), of
 for the creation and transfer of the following work

 ..

2. The commissioner shall pay the artist the total sum of

 £ as follows:

 £ on signing the agreement.

 £ on (date)

 £ when the artist advises in writing
 that the work is complete.

3. The artist undertakes to commence the work within days
 of signing this agreement and shall complete the work by

 (date) and upon delivery both parties will sign
 the artist's bill of sale.

4. The commissioner may terminate this agreement at any time. In
 the event of cancellation the artist shall be entitled to keep all
 monies paid. All rights to the work will be vested in the artist.

 Date

 Signed ..
 (artist/craftsperson)

 ..
 (commissioner)

Fig. 5 A basic commission and sale agreement

The agreement to sign the artist's bill of sale (clause 3) provides the nexus between creation and sale mentioned above. In completing the section on price in the bill of sale (see overleaf) the following or similar words would be inserted.

Price: As agreed in the commission and sale
agreement of (date).

Cancellation provisions are contained in clause 4. Cancellation would normally result from the commissioner's dissatisfaction owing to differing interpretation(s) of the work or because of apparent or perceived deviation(s) from models, sketches or designs.

The likelihood of such an event, which benefits neither party, can be minimised by complete consultation in the planning stages and a schedule providing for inspections at specified points in the creation of the work.

The creation of models, designs etc. can be the subject of a separate commission agreement.

Provisions that protect the work once it leaves the artist's possession, e.g. copyright, appear not in the commission agreement but rather in the bill of sale and contract of sale.

Other rights and responsibilities which could be the subject of special provisions but which have not been mentioned above include:

- the responsibility for freight and packing, which could be a significant expense
- protection for the artist against delays beyond his control, e.g. those caused by strikes and accidents
- ownership of preparatory artwork and models
- insurance
- protection for the artist against structural or other damage caused by the artwork's weight, size, etc.
- installation provisions. These could be the subject of a separate agreement depending on the nature of the commission.

The above examples suggest guidelines; no sample could possibly cover all situations. Adjust them to suit the occasion but don't overload your contracts. They should be positive in tone, evenhanded and written in terms that can be understood by all parties.

Bills and contracts of sale

In the sale of all goods there are a number of implied conditions. For example, that the seller has the right to sell the goods, that they correspond with their description, are of merchantable quality and are fit for their intended use.

Most sales to which we are a party in our personal and business lives are not subject to any special conditions. When you purchase a suit from your local clothes store, the proprietor or tailor is not concerned if you then cut it up for dusters or give it to the local charity shop. Once the sale has been concluded the supplier is completely indifferent about his product's welfare. Anyway, even if he or she was upset, how could it be proved that a sale to you took place?

A Guide to Commissions

```
                    BILL OF SALE

   Artist's letterhead, logo, name, address, phone number, etc.

   Date of sale _____

   Purchaser _____

   Address _____

             _____

   Title of work _____

   Description of work _____

             _____

   Price _____

   Copyright in the work will remain the property of
   the artist/craftsperson

   _____      _____
       (Artist or agent)                (Purchaser)
```

Fig. 6 A sample bill of sale

When you sell your artwork without any special conditions you are exhibiting the same indifference. The buyer can lose, damage, destroy the work, reframe it, exhibit it anywhere and anyhow while at the same time refusing to allow anyone the right to view it. In other words, while the law may protect your right to the copyright of the work, your indifference to the fate of work once sold may dictate that there is no work capable of being reproduced or even worth reproducing.

As a first step to remedying this deficiency, artworkers can use a simple bill of sale. This should detail the date and place of sale, the purchaser's name and address, the title and description of the work, price and terms of payment and should indicate which party owns the copyright. Thus the bill of sale acts not only as a receipt for the money received but also provides documentary evidence that a sale took place. Should the parties agree to specific conditions to protect the future existence and use of the work, they could embody these in a contract of sale. This would supersede the bill of sale. It would include all details contained in the bill but could also contain clauses and conditions referring to:

- Care and maintenance of the work. The purchaser could agree not to damage intentionally, destroy or even alter the work and to be responsible for routine cleaning and maintenance.
- Restoration and repairs. The parties could agree that the artist is to be consulted should repairs be necessary, so that he can supervise or even conduct the restoration (for a reasonable fee).
- Availability for exhibition. The artist may be given the right to borrow the work (perhaps biennially) for the purpose of public exhibition. Conditions of loan would be included.
- Originality. The artist or craftsperson could warrant that the work is his or her own work. The purchaser could give an undertaking to identify the artist with the work by a suitable notice whenever it is publicly displayed.

In effect, an appropriate contract of sale gives the creator of a work some say in its future welfare in the absence of specific legislation.

Commissions for design work

When you produce designs from which a manufacturer or contractor will then make either a production run or the finished artefact, the time between contract and final payment may be considerable. You may have to wait a long time for your money. If you are making prototypes or models, you may also have to lay out money for materials and subcontractors. There is a secondary risk that your client may not like the finished design work and, particularly if he has not employed designers before, he may be disinclined to pay you for the work you have already done on his behalf.

Some designers include a 'cancellation clause' in the agreement, which requires the client to pay a percentage of the fee should he wish to cancel the commission. It seems, however, a negative attitude to suggest, before you have even begun, that he may not like the finished work, and it is not one to inspire confidence.

A better method, and one that obviates both the risk of non-payment and the delay in getting paid, is to construct the agreement in clear stages, showing what you are to do (and also perhaps what he is to do), when you are to do it, how much you are to be paid and when. The sample below illustrates a typical agreement in this form.

Note

- Stage 1 includes any preliminary meeting (which may have already taken place)
- It gives a completion date and a price for that stage.
- In stage 2, the completion date is from the approval of stage 1. This is essential, as there are often factors, outside your control, which may delay the approval of the previous stage – such as the absence of a key member of the client firm.
- The final stage is at the discretion of the client, but serves two useful purposes. It indicates your professional commitment to the project,

- The requirement to pay fees in instalments is clearly stated.
- The payment (or non-payment) of expenses must be agreed before the contract is signed. You may not be over-concerned with small incidental costs, but if the work involves much travelling or accommodation you will soon lose all your profit if expenses have not been agreed and the client refuses to pay them.

It is always preferable to write such agreements yourself, rather than leave it to the client. Type out three copies and sent the client two, with a note asking him, if he approves the content, to sign one copy and return it to you.

QUOTATION

Messrs Jones and Jones 1 Nov. 19--
23 Old Street
LONDON EC1

STAGE 1. Completion: 2 weeks from contract.

Meeting to agree brief.
Preliminary design work, first working drawings.
Presentation and discussion at Luton works £400

STAGE 2. Completion: 3 weeks from agreement of stage 1.

Revision as agreed at 1.
Full working drawings. Breadboard model.
Presentation at Old Street. £650

STAGE 3. Completion: 2 weeks from agreement of stage 2.

Preparation of specifications.
Ergonomic model.
Meeting at Luton works. £300

STAGE 4. When required, by agreement.

Three one-day visits to Luton works.
Agree prototypes and production samples. (£80 per day) £240

Fees will be invoiced for payment at the completion of each stage.

Agreed travelling costs and expenses, with costs of materials, will be invoiced separately for each stage.

HUGH BAX

Please sign and return one copy of this letter to confirm agreement.

Signed
Date

(A format for costing design work of this type is as follows. It should be read in conjunction with Chapter 17 on *Pricing, Costing and Paperwork*.)

Studio Costing Product Design.

Ingredients: MATERIALS used plus
 Subcontractors paid plus
 LABOUR by the other plus
 OVERHEAD equals PRICE of commission
 (+ VAT)

MATERIALS as used or bought. If value is large, + % for handling.

LABOUR: professional rate selling time
 client contact
 research
 designing
 presentation £5 per hour

 labouring rate making models etc
 fetch and carry
 housekeeping £2.50 per hour

OVERHEAD (as product costing) £3.00 per hour

Contract costing

Materials: @		£ 15
 @		20
 @		40
	Subcontractor		80
			£155
LABOUR: professional hours	30 @ £5		150
labouring rates	20 @ £2.50		50
			200
OVERHEAD: 50 hours	@ £3.00		150
			150
	Cost Price		505
	PROFIT @ 25%		125
Query: addition for discount?			
	selling price		£630
+ VAT			

Notes for Consultancy Agreement

(D–Designer, Cl–Client

1. D will work for Cl as a consultant designer.
2. The consultancy will cover all aspects of design, product development and liaison with customers.
3. D will give Cl X days a week, but this will be flexible.

 You have, of course, to take some holiday and therefore you should contract for X × 48 days in the year.

 The days should be flexible so that at times you might work four or five days a week and at others you would put in less time.
4. The consultancy would be for two years with six months' notice being given by either side, so the minimum period of consultancy would be two years, six months.
5. You would not work for Cl's immediate competitors, but it is important that they do not make this too restrictive. It is better that they state the companies that they do not want you to work for rather than, for example, excluding the whole industry.
6. When you present a design to Cl they will have six months to evaluate it and if, after six months, they have not started any development work, you will have the right to withdraw the design. If development work has started, Cl will have two years to put the design into production. If they do not do this, then, again, you should have the right to withdraw the design.

 This clause does require some careful thought as obviously you can't withdraw a design simply because Cl have taken two years and one month to put it into production. It is, however, important for a designer that you do not have work indefinitely held by manufacturers who have no intention of using it.
7. Any design of D that Cl put into production will be theirs absolutely and D will assign all copyright to Cl.
8. Cl will not develop design concepts emanating from D with other freelance designers but they may do so with their inhouse team.
9. D's work will be marketed by Cl with your name.
10. D will give Cl help in promoting all products with which you are associated.
11. D will treat as confidential all information that you may gain through your association with Cl.
12. D will be prepared to travel at the request of Cl and it is understood that the consultancy will require frequent visits to the factory. All travelling and hotel expenses will be reimbursed. Motoring expenses will be at an agreed mileage rate suggested by the AA.

Study brief: Mary and Larry Beeston, a designer-weaver team

Larry Beeston was a hobby weaver for many years and is largely self-taught although he has attended short courses in Finland, France, England and Kathmandu, and a two-year course at Sydney College of Textiles.

Mary studied painting and design at the National Art School, Newcastle (New South Wales, Australia), and has been painting and exhibiting regularly in one-person shows and major exhibitions since 1960. She attended a short course in textile design in Finland and in tapestry weaving in France.

They have been working as a full-time designer–weaver team for about eleven years. During this time they have taken part in major invitation exhibitions and numerous group shows in New South Wales, Victoria, South Australia, Australian Capital Territory, Northern Territory and have held solo exhibitions in Australia, Scotland and Holland. They do occasional freelance teaching in Australia and overseas and find this refreshing and stimulating as well as financially supportive.

Mary says:
As the designer my responsibility is to conceive the idea, develop it, and transform it into a workable design. I then select colours and yarns, decide on texture and weight of the piece, and draw a full-sized cartoon for Larry to pin under the warp. If I am breaking new ground that might involve technical problems, there will probably be long discussions with Larry about pros and cons, why and how, which sometimes result in a modification of design. Sometimes this leads to further extension of technique for Larry. Once a decision is reached, and the cartoon completed there is no going back. Larry weaves from the back on a low warp four shaft loom, so we see only four to five inches at any time until the work comes off the loom. When the piece is large, involving months of work, this makes for a certain amount of tension.

Larry says:
Once the cartoon has been completed and the colours and texture decided, it is then my responsibility to transpose all this to a woven product. Since Mary is constantly exploring new design avenues and experimenting with shapes and colour, I must extend my knowledge and experience of the technical side to cope with her ideas.

This is a wonderful challenge to me, and I look forward to each encounter with a new cartoon with a feeling of excitement and adventure. When the weaving is finally taken off the loom I feel proud that we have between us produced this piece. I am always conscious of the need to reproduce the design to the best of my ability.'

We are totally interdependent in producing our work and have a strong sense of responsibility to one another in standards of workmanship, economic use of resources, and honest individual effort. This mutual dependence means that we are equally concerned not only with the quality of our

work but also with the success of the business aspects. This leads us into a shared interest in the possibilities of new initiatives, expanding markets, widening the scope of concepts and broadening the range of products.

We enjoy working together, supporting and stimulating one another, sharing the 'downs' as well as the 'ups' and finding mutual confidence in tackling something new or very large. Our objective is to make works that have some timeless lasting quality, that are more beautiful, more adventurous, more meaningful than previous work. This is an open-ended goal. Achievement becomes one small step in the right direction. Unfortunately, there never seems to be enough time to stop, think, feel, listen and experiment because we need to keep producing for economic reasons.

We live on the shores of Lake Macquarrie about 30 kilometres from Newcastle and 2 hours' drive from Sydney. This has the advantage that we are distant enough from major centres for visitors to want to telephone before coming and this gives us the opportunity to arrange times to suit ourselves. We have been forced to discourage 'droppers in', particularly the Sunday-afternoon-drive variety, as we were losing too many man-hours with no recompense. However, being isolated from fellow professional fibre workers, when artist friends do visit, it is an occasion, and we welcome the break from routine and the opportunity to talk 'shop'. Visits to exhibitions are major excursions and very time-consuming so they are necessarily more limited than we would like.

We are isolated from clients by being so far from the city and we find this is a real disadvantage in the area of architectural commissions. Most Sydney architects tend not to consider work by people outside the metropolitan area despite their willingness to go to Sydney for consultation.

As our full-time status grew out of a hobby, we found that business administration became a problem. At first we did not realise the importance of putting everything on a sound accounting system. There is nothing more distracting to an artist than being worried and confused in his business dealings. We soon turned to an accountant for advice and help in bookkeeping methods, partnership arrangements, tax and other business principles. His services and help have proved invaluable. Now we cost everything we make in detail, including materials and equipment and all overheads and indirect expenses. We keep an exact record of man-hours spent on each job and pay ourselves a flat rate per hour, which is a pittance, but our work is labour-intensive and we know what the market will stand. So far we have not achieved a built-in profit margin. Our type of weaving cannot be speeded up by mechanical means and we value the quality standard of our work more than a high return.

We contact the buying public through Craft Expo, competing in public exhibitions, group exhibitions, solo exhibitions, commissions.

- Craft Expo is an expensive exercise but has proved worthwhile for us as resulting commissions have meant that we at least break even, and through Expo we reach a wider public than is possible otherwise.

- Public exhibitions are the logical way into the craft market. To gain exhibition experience it is worth taking part in every one available.

 Gradually it is necessary to become selective about:
 1. the standard of the venue
 2. the standard of other work exhibited
 3. the standard of judging, if it is competitive
 4. the reputation and standard of the exhibition and presentation
 5. conditions of entry – read the small print! There are still some public and invitation exhibitions which demand copyright of the work as a condition of entry for a purchase or acquisitive award. Many craftspeople and artists agree to this condition not realising that they lose all control of their work. It can be duplicated, mass produced, used in advertisements, used as illustration, copied in other media for commercial purposes and so on. In correspondence with one committee, we found that what was really required was an agreement as to its uniqueness and the right to exhibit and photograph the work without restriction. In our opinion it is morally wrong to demand copyright as a condition of entry and we suggest that competitors and exhibitors make sure they understand what they are agreeing to before accepting this condition.

- Group exhibitions require a comparatively small panel of work as against solo exhibitions, so there is less preparation time and, with luck, a quicker return. The moral support and sharing of the financial burden give confidence and comparative security.

- Solo exhibitions mean a long period of concentrated work with little or no income along the way and no knowledge of what return there will be at the end. It is very necessary to know and trust the gallery, to be sure that the clientele is in tune with your type of work, to be confident that you will get adequate advertising, good PR and that the gallery will make every effort as your agent and pay you promptly. In addition of course it is important to check the usual details such as quality of invitations and their distribution, the standard of hanging, lighting, general presentation. Above all a satisfactory statement of gallery conditions or a contract concerning costs, commission, payments, advertising and general conditions must be obtained.

- Commissions are the most satisfactory financially. Provided that you have a sound contract agreeing on progress payments and all necessary commitments on both sides, you know you will be paid for work done. The idea that commissions are financially more rewarding than exhibitions is a fallacy. Commissions are just more secure. They may come to you through a gallery or your agent, who are entitled to 10% of the total price. You might win a commission competitively – then all except the winner have spent much time and effort for little or no

reward. Often commissions are given on the basis of the client knowing your work or your reputation. However it is obtained, a commission involves you in a great deal of time and effort and perhaps travel. There will be consultations with the client, maybe delays of weeks or months if a committee is making decisions. There is assessment of the requirements of the site and/or architects' preconceptions. Its necessary to prepare and present maquettes, specifications, estimates or quotes, samples of technique and materials. The cost of this part of the commission work should be accurately accounted and could amount to 20% or more of the total cost. This, combined with the agent's fee, about balances the gallery commission for exhibitions.

It is absolutely necessary to have a written agreement of commission and sale so that all parties know exactly where they stand. Agent, client and artist should each have a copy of the agreement. A verbal agreement between friends is the best way to lose a friend.

Designing for commission is interesting, for there are disciplines involved in relating the characteristics of the work to an established or planned environment. Considerations such as purpose, size, proportion, colour, lighting, architectural characteristics and financial budgets are viewed as disciplinary challenges rather than as restrictions and limitations.

To date we have not encountered any real problems with the commissioning of work. In consultation and discussion we take time to talk with the client and/or architect, to develop a rapport with them, to be sure we understand their requirements. Sometimes a client can't explain or does not know exactly what he wants until he has something in front of him. It is up to the designer to help him over this hurdle, to be patient and receptive in discussion. Photographs of earlier work may be helpful; perhaps it will be necessary to do several maquettes. Occasionally a client wants a hand in the designing to the extent that it is neither his nor your design. A clear understanding must be reached – you are willing to listen, discuss, try to understand his ideas but ultimately it must be either his or your design.

Following preliminary consultation we do our groundwork thoroughly – taking accurate measurements, checking other surfaces in the area, behind, beside, above and below the work for both colour and texture. The style of furniture, furnishing fabrics and other works of art all give some insight into the taste and thinking of the client. Where possible we acquire samples of materials used in the environment – bricks, carpets, wall colours, upholstery, and we take photographs of the site and surroundings; we enquire about additional lighting if we think it necessary.

We aim to make the piece look so integrated and in harmony with the building and so enhancing the environment that it would look incomplete without the work.

Overall, how important is our work to us?

It comes after our family, our friends and our fellowman. It is absorbing, fascinating, challenging and great fun. We enjoy every minute of it seven days and most nights every week, and look forward to continued growth in understanding, knowledge, skill and productivity.

21 Exporting

Selling to overseas buyers raises additional areas of possible difficulty. These can be divided into:

packing
transportation
pilferage
labelling
documentation
ensuring payment

Packing

How you pack your goods for export will depend on the method of transport, but in all cases you should aim at security from damage and theft, and quick delivery. All cartons and crates must be full, either with goods or added filling. Some countries require that timber crates be treated against vermin, and some forbid or restrict the use of hay or straw as filling. Some shippers refuse to accept secondhand cartons or crates, and even if accepted these can delay transit through customs (and therefore payment).

> Consult: your customer when he places the order,
> your shipping agent *before* you pack and deliver the consignment to him;
> the Export Services Division of the Department of Trade and Industry (Export House, 50 Ludgate Hill, London EC4).

Transportation

Goods can be sent by road/rail and sea ferry, sea- or airfreight. Road/sea ferry has the advantages of speed and security, but tends to concentrate on containerised bulk loads. Seafreight is cheapest for very heavy or bulky loads, but requires expensive packaging to avoid damage in loading, deterioration in transit and pilferage at the docks. It can also be very slow. Airfreight requires less substantial packing, which often offsets any additional cost.

> Consult: your shipping agent (in the yellow pages);
> ABC Freight Guide (from booksellers);
> the Export Services Division (DTI).

Pilferage

Any torn or broken packages are likely to be pilfered in transit, so make sure they are full and sufficiently robust to stand the journey. Inform customers by mail when you despatch the goods and by what route, so that they can expect them and report non-arrival if necessary.

Consult: your shipping agent for insurance.

Labelling

Most countries have legislation relating to the labelling of products imported, often requiring precise specification of materials and country of origin. Any goods not sufficiently or correctly labelled will not be admitted by customs, which will cause delay or non-delivery, and hence possible loss of orders.

Consult: your customer when he places the order;
the Export Services Division (DTI).

Documentation

This is one of the most important aspects of overseas trade. It may appear confusing at first, but it is worth mastering at an early stage. The process is repetitive, and once learned becomes straightforward. The basic documents are the export invoice, the bill of lading or equivalent (air way-bill, or surface consignment note) and the insurance policy (or certificate), plus additional documents for specific countries of destination. With your first export contracts it is essential to get expert advice on the form and completion of these documents.

Consult: the Export Services Division (DTI);
your shipping agent;
your local chamber of commerce;
your bank.

Ensuring payment

First, you need to be sure of the customer's creditworthiness. If you have an opportunity of conversation with him, you may discover other UK suppliers with whom he has dealt, and make tactful enquiries of them. Your bank should be able to check through its international links. The Export Credit Guarantees Department is a specialist government agency set up to insure and advise exporters in this area.

Secondly, the method (and currency) of payment and its timing in relation to delivery must be agreed and arranged to ensure quick and safe payment.

Consult: your customer on the method of payment;
your bank on creditworthiness and method of payment;
the Export Credit Guarantees Department, Aldermanbury House, Aldermanbury, London EC2 (telephone 01-606 6699) and regional offices in major centres. Ask for an appointment with the marketing manager.

The Supporting Framework

22 Protecting Yourself – Health Hazards

Operating a workshop or studio imposes responsibilities – to employees, to the general public, to your family and to yourself. Some aspects of health and safety are specifically covered by Acts of Parliament, see page 150 at the end of this chapter. Some aspects are matters of common sense or of professional knowledge. It is essential to be aware of all the hazards and to take suitable precautions. Remember that if you harm others you may be liable for heavy claims for compensation, quite apart from any feelings of guilt. If you harm yourself you may be unable to work (or dead).

This chapter is divided into sections containing checklists: mixed media; types of hazard; sources of information; legislation. The sections are intended to indicate areas of risk. They do not embrace all situations, and it is essential that workshop and studio operators consult the appropriate agencies and legislation. Read the whole chapter. You will find something of relevance to your activity in the sections for other trades.

Mixed media

One of the most common causes of injury in studios and workshops is working in mixed media. In carrying out experiments, in tool and jig making, or to achieve a particular effect, people use techniques and materials for which they are not professionally trained or, equally dangerously, they mix materials and chemicals in ignorance of their effect on each other. Here are some examples; there are many more.

- Potters using power tools to make jigs and moulds
- Weavers using hammer and nails to fix a loom
- Using domestic or industrial solvents at random for cleaning metals, plastics etc.

Protecting Yourself – Health Hazards 147

- Applying heat or a naked flame to chemicals and other materials used in combination
- Throwing waste, liquids, soaked rags, paper, dust and hot material into the same refuse bin, or on the floor
- Pouring or stirring together chemicals used in different trades, without knowing their possible interaction.

Remember that even the most common material can become a volatile chemical when exposed to other elements or processes. Water + heat → steam is a common domestic hazard. Chemicals + heat → fumes, or fine powder + air → dust may not be so obvious, and therefore not so easily foreseen.

Types of hazard
Machinery

This may involve:

- Sharp edges, including all cutting tools, saws and planes
- Closing movements, which may nip flesh and clothing
- Rotating parts of all descriptions, which may burn or abrade when fast-moving, or bite as with gear teeth
- Reciprocating parts such as rams, presses or levers.

All machinery must be adequately guarded, and preferably grouped and placed in workshops away from doorways and gangways. Hand tools, too, carry similar risks if improperly used. All machinery and tools should undergo regular inspection and maintenance to a laid down programme.

Electricity

It should be self-evident that all electrical installations must be professionally carried out. All equipment must be earthed and be correctly connected to the supply.

- Fixed machinery should be connected through conduit, not trailing flexes.
- There should be a clear indication, preferably a pilot light, to show when equipment is switched on.
- Portable equipment should be connected by three-pin, earthed plugs to switched sockets with pilot lights.
- Sockets should be placed at a convenient height and away from sinks, taps, radiators and damp working areas.
- Two- and three-way adaptors must never be used, and extension leads should never be used for a permanent installation, but only for maintenance or repair work. All cables must have thick rubber or plastic outer covers. Braided cable should not be used.

- Electrical equipment should never be handled with damp or wet hands, or when standing on a wet surface. (Note that concrete is often permanently damp and is a good conductor, and therefore dangerous.)
- All equipment, connections and leads should be checked each time before use, and must also be examined for faults as part of a regular maintenance programme.

Fire

A major cause of fire is rubbish. Oily rags, waste paper, sawdust and shavings that are allowed to accumulate are a constant source of danger, particularly if close to kilns, furnaces, machinery or naked flames. Keep your workshop swept and clear of rubbish.

- Portable electrical appliances, particularly soldering irons, must be switched off when not in use.
- Naked flames, such as Bunsen burners, must not be left alight (Note that many flames are invisible in strong sunlight; if you need to leave one alight in use, shield it from the sun.)
- All soldering and welding must be performed on metal, not wooden, benches.
- Welders must be provided with a secure rack or stand to hold the handpiece. They should never be placed unsecured on the bench.
- Soldering irons, similarly, must have a rack or clip to retain them safely.
- Fire extinguishers must be available *in* the workshop. They must be checked regularly, and must be of the appropriate type; non-water for electrical fires, foam for chemical and solvents.
- All gas installations must be professionally fitted. Flexible gas pipes should not be used, unless of armoured quality suitable for the purpose.
- Flammable liquids and materials must be stored in containers with close-fitting lids.
- Stock of such items should be safely stored, small quantities of ready to use material in a metal cupboard and larger quantities in a secure metal cabinet or fire-proof premises away from the workshop itself.
- Ventilation should be generous when solvents, paints and flammable materials are used. Extractor fans for removing flammable fumes must have fire-proof motors.

Airborne fumes and dust

The effect of these may be long-term. Some are physical, as with the inhalation of fine powders and dust waste; some have a chemical action and may attack the lungs, kidneys, skin or eyes.

- Fumes are best controlled by ventilation, air extraction and storage in closed containers.
- Dust should be kept down by regular cleaning. Dry sweeping with a broom can do more harm than good; damp sawdust sprinkled on the floor before sweeping will attract dust to it and prevent it rising.
- Domestic vacuum cleaners may simply discharge the dust or fine powders back into the air. Industrial vacuum cleaners have a range of outlet filters available to cope with extremely small particles.

Chemicals

Chemicals should never be used unless you know what they are and what risks are involved. Many are packaged with only trade names or code numbers, and if you are not familiar with their use you should ask the supplier. Manufacturers often produce leaflets on use and safety precautions; you must ask for them.

- Protective gloves must be worn when using corrosive chemicals, adhesives, solvents, and epoxy resin/glass fibre materials.
- Similarly, goggles for the eyes and face masks to protect the lungs should be worn. Note that most standard face masks are only marginally effective if you have a beard – so you must shave it off or get a special mask.
- Never pour fine powders (clays, dyes, chemicals) into an open container without masking the top to prevent dust exploding up into the air and into your face.
- Wash your hands and face frequently, especially after using chemicals or powders, and always before eating.

Physical stress

If you are working in a mess, or are overtired, you will do bad work and you will have accidents. If you are injured you cannot work. If you cannot work you will get behind and hurry to catch up. Hurrying causes more accidents.

- Your workshop should be warm, ventilated and well-lit. Cold muscles produce clumsiness, lack of fresh air causes tiredness, and bad light strains the eyes and induces errors.
- Take care lifting heavy weights and moving equipment or large containers.
- Safety shoes or boots should be worn where there is heavy lifting, excessive heat (foundries, kilns, furnaces), danger of sharp material (cullet, nails in woodwork), corrosive liquids, or droppable tools. Trainers should never be worn in these situations.
- Goggles, masks and protective gloves must always be available and used.
- Wearers of contact lenses can have their eyes permanently damaged

150 Art, Design and Craft

by the glare from furnaces and from welding. This can be either a sudden or a long-term effect. If you or your staff wear contact lenses, consult an optician about safe procedures. If you use such equipment, it is wise to post a clear notice warning visitors of the danger.
- Keep your workshop clear of dust, rubbish and litter to avoid the risk of slipping or tripping.
- Have enough clear bench space to work at, with tools safely racked. Do not work or leave tools on the floor.
- If you must bring food and drink into your workshop, keep it wrapped or covered. Always wash before eating.

Sources of information

The simplest and fullest reference for workshop safety is the series published by the Department of Education and Science.
No. 2, *Safety in Science Laboratories*, HMSO
No. 3, *Safety in Practical Departments*, HMSO
Other useful publications are:
Safety Manual, UMIST, PO Box 88, Manchester, M60 1QD.
Occupational Safety, RoSPA Cannon House, The Priory, Queensway, Birmingham, B4 6BS.
Danger From Fire, HMSO
(HMSO publications are obtainable from Her Majesty's Stationery Office Bookshops in High Holborn, London, and in Belfast, Birmingham, Bristol, Cardiff, Edinburgh and Manchester.)

Legislation

Health and Safety at Work Act, 1974, HMSO
Under the Act, inspectors of the executive have right of entry to industrial premises (which includes your workshop/studio). They will also give technical advice if you require it. Addresses of local offices are in the phone book, or obtainable from the Health and Safety Executive, Baynards House, 1–13 Chepstow Place, Westbourne Grove, London W2 4TF.

Electricity supply regulations

Regulations for the Electrical Equipment of Buildings, Institution of Electrical Engineers
The Electrical Equipment (Safety) Regulations, 1975 and 1976, HMSO.

23 Photographing Artwork

Inevitably, in your vocation as a practising artist, you will need quality colour slides or prints of your work for such diverse reasons as submissions to grants authorities, to art institutions, to potential clients, for lecturing purposes or for your own records. The cost of hiring a professional photographer may prove prohibitive, so you may need to develop adequate photographic skills for what may become a recurring activity.

The following chapter, which is aimed at developing these skills, has been written by Roger Broadbent, a lecturer in Art at Newcastle College of Advanced Education. Roger had 12 years' experience in professional photography before taking up a career in art in 1976.

The choice of camera, lighting and film in reproducing the finer qualities of two-dimensional and three-dimensional art in photography are often overlooked by artists who believe that, simply because they own an automatic 35 mm camera, it is an easy matter to take quality pictures of their work. Indeed, automatic 35 mm cameras, without interchangeable lenses, manual control of aperture, and shutter speeds, place the amateur photographer at a real disadvantage.

A basic understanding of camera operation: loading and unloading film; focusing; setting the film speed (ASA, DIN, ISO) can be gained by reading the introductory chapters of the basic photography books listed in the bibliography. The object of this chapter is not to cover ground adequately contained in general photography literature, though some reference to basic techniques will inevitably be made.

At some time you may have the opportunity to process your own slides and colour prints. Alternatively, your colour slides and/or colour prints may be processed through the film manufacturers, or professional colour processing services. Some films, such as Kodachrome slide films, can only be processed by the manufacturer, and a processing charge is included in their price. Other slide films, such as Ektachrome, give you the option of manufacturer or private laboratory processing, and processing charges are not included. Special process-paid envelopes can be bought separately if you wish to send your slide film to the film manufacturer.

Independent colour laboratories offer two categories of colour prints:

- machine-made prints
- hand-made or custom-made prints

Machine-made prints are the result of automated processing equipment

151

designed to give acceptable images to amateur photographers. This process takes into account the average amateur subjects and compromises on print quality. Photographs of works of art that are not compatible with the 'normal' colour and tonal placement standard assumed for machine-made prints will exhibit poor colour balance and over- or under-printed areas of tone.

Hand-made or custom-made prints are generally superior to machine-made prints and offer the artist/photographer the opportunity to explain or demonstrate his areas of concern regarding accurate photographic reproduction of his work(s).

To assist the colour print technician in reproducing the colour balance of your original artworks accurately it is prudent to photograph a grey card and set of Kodak colour test patches at the beginning of each photography session. The printer uses this negative to calibrate his equipment to the specific colour correction filtration for accurate colour rendition.

The 35 mm single lens reflex camera (SLR) is the obvious choice for photographing works of art. Through-the-lens viewing guarantees accuracy without the parallax problems associated with the direct vision view finder camera. A wider range of interchangeable lenses and through-the-lens exposure metering help to make photography successful.

The tripod is an essential piece of equipment necessary to provide a steady support for your camera while taking long exposure photographs. The tripod is most commonly needed if you require to take photographs in a studio situation or in a poorly lit situation. Leaving your camera 'set up' on the tripod leaves you free to make innumerable adjustments to artwork, lights or surroundings. A *cable* release for off-the-camera exposures minimises the possibility of inferior image quality due to camera shake.

Other items of useful equipment include masking tape, scissors, cleaning fluid and rags.

Polarizing filters are an inexpensive means of minimising and contrasting spectacular reflections on surfaces and consequently increasing colour saturation in works of art. They are not a remedy for all such problems and because they have neutral density (no coloration) some adjustment to exposure is always necessary. The polarizing effect increases as the filter is rotated in front of the camera lens, giving the photographer control over the degree of reflection control required.

35 mm colour slide and negative films. Subtle variations in colour rendition, grain and contrast occur between the different brands of colour films. Selection of a brand of film which provides the most 'accurate' colour is found by comparing the rendition of reds and greens with reference to the colours of your art works.

Slower speed colour film generally exhibits minimal grain size, has lower tonal contrast and slightly more exposure latitude which makes it preferable to 'faster' film for most static or studio photography. However, using 'slower' films is based on the assumption that adequate light is available.

Obviously, kinetic subjects, performances or 'hand-held' photography in poor lighting situations may call for fast film and even push processing (see table explaining 'push processing') of slide film to attain 'higher' film speed ratings. Ektachrome slide film, if push processed, offers a range of film speeds up to 1600 ASA. To avail yourself of this facility you need to process the film yourself or have it processed through an independent processing laboratory to your specifications.

If you choose a laboratory to process your film do not forget to mark your re-rated ektachrome film clearly so that the laboratory staff can make the necessary processing modifications.

Films with the suffix '-chrome' are slide films. Among Kodak colour films Kodachrome is returned to a Kodak Laboratory for processing. All Ektachrome films can be processed in E6 process privately. Films ending in '-colour' are negative films from which prints must be made to get a positive image. E6 and C41 are the popular market names for Kodak processes. Other companies also market comparable processing chemistry for films designated C41.

Colour prints can also be made from 35 mm slides by a direct slide (positive) to positive print process. Ilford/Ciba Chrome market a process and print paper called Ciba Chrome AII, and Kodak's equivalent process is Ektachrome 14RC. Both processes are readily available for private or laboratory service.

Camera Exposure	First developer time increase
Normal	Normal Dev. (7 minutes)
Double ASA rating (e.g. 400–800 ASA)	Increase by 2 minutes
Double ASA again (e.g. 800–1600 ASA)	Increase by 5½ minutes

Colour temperature
Colour slide films are divided into two categories: those suitable for exposure in daylight and those suitable for artificial light exposures. This is because daylight and artificial light have different colour temperatures. Daylight is bluer (cooler) relative to most types of artificial light.

Colour temperatures of some common light sources
Photofloods	3200°K
Photolamps	3400°K
Blue photoflood lamps	4800°K
Direct sunlight	5000°K
Standard photographic daylight	5500°K
Blue flash bulbs	5500°K
Electron flash	6000°K

154 Art, Design and Craft

Colour slide films – 35 mm

Film types *Colour slide*	Process	Conversion Filter/ASA speed		
		Daylight and electronic flash	Tungsten photolamp 3400°K	Tungsten photolamp 3200°K
Agfachrome 64		None/64 ASA	80B/20 ASA	80A/16 ASA
Ektachrome 64 (Daylight) ER	E6 or Kodak	None/64 ASA	80B/20 ASA	80A/16 ASA
Ektachrome 200 (Daylight) ED	E6 or Kodak	None/200 ASA	80B/64 ASA	80A/50 ASA
Ektachrome 400 (Daylight)	E6 Kodak	None/400 ASA	80B/125 ASA	80A/100 ASA
Ektachrome 160 (Tungsten) ET	E6 or Kodak	85B/100 ASA	81A/125 ASA	None/160 ASA
Fujichrome R 100	E6	None/100 ASA	–	80A/32 ASA
Kodachrome 25	E6			
Kodachrome 11 Professional Type A	Kodak	85B/25 ASA	None/40 ASA	82A/32 ASA
Kodachrome 64		None/64 ASA	80B/20 ASA	80A/16 ASA

Colour negative films for prints – 35 mm

Film types *Colour negative*	Process	Conversion Filter/ASA speed		
		Daylight and electronic flash	Tungsten photolamp 3400°K	Tungsten photolamp 3200°K
Agfacolour 11 N21		None/80 ASA	25/80B	20/80A
Fujicolor F11	C41	None/100 ASA	–	80A/32 ASA
Fujicolor F11 400	C41	None/400 ASA	–	80A/125 ASA
Kodacolor 11	C41	None/100 ASA	80B/32 ASA	80A/25 ASA
Kodacolor 400 (CG)	C41	None/400 ASA	80B/125 ASA	80A/100 ASA
Kodak Vericolor 11 Professional, type S	C41	None/100 ASA	80B/32 ASA	80A/25 ASA

Note Avoid taking photographs of artworks in the shadows of buildings because the colour temperature of the light here is predominantly cool (blue).

Daylight colour film has a colour temperature of 5500°K and will also give normal colour when exposed with electronic flash but will exhibit a strong red-orange cast when exposed in tungsten photographic lights (colour temperature 3200°K or 3400°K). Conversely, artificial light film will exhibit a strong blue cast when exposed to daylight. Unless you are adept at mixing light sources of different colour temperature for special effects it is better to avoid mixed light sources altogether.

Conversion filters can be used to modify the colour temperature of light reaching the film so that if necessary you can convert daylight film to artificial light usage, and vice versa. However, try to buy film specifically made for the lighting you intend to use.

Information relative to various films and conversion filters for typical light sources you may encounter is contained in the colour film tables above. When using a conversion filter adjust your ASA rating to that recommended for compensation of the filter.

Fluorescent lighting in exhibition spaces creates problems for even the most competent photographer. Without filtration, fluorescent lights are reproduced with strong green casts. To add to the photographer's misery there are daylight fluorescents, white, warm white, cool white, and, if you wish to be particular, they all require different tailor-made correction filtering. Often fluorescent types are mixed and it is difficult to get close enough to check the labels. Kodak recommends CP filters for fluorescent light correction, which is explained in the table overleaf, but it should be noted that these are only starting points for testing colour correction.

Exposure determination

Hand-held exposure meters. The hand-held exposure meter has the advantage of giving 'off camera readings' when the rendition of a particular tone or light intensity reading is essential. For example, the photographer may wish to leave his camera set up and obtain a light reading closer to his subject, or read a specific tone isolated in, or surrounded by, a more dominant but less important tone, which can only be done by a separate light meter.

Another important feature of the hand-held meter is that it renders numerous combinations of possible lens apertures and shutter speeds. A suitable combination, taking into account the subject and the depth of field desired, is selected, and the camera aperture and shutter speed are adjusted accordingly.

If used properly, the exposure meter housed in your camera will provide accurate light readings for exposure determination of your artworks. However, an 'in camera exposure meter' is more appropriate for less specialised areas of photography where speed of operation is more important than consistently high quality exposure determination.

Filter recommendations for Kodak films used in fluorescent lighting

Fluorescent lamps	Daylight films		Tungsten 3200K films
	Ektachrome 200 Kodachrome 25	Ektachrome 64 Kodachrome 64 Ektachrome 400	
Daylight	40M + 40Y + 1 stop	50M + 50Y + 1⅓ stops	85B + 40M + 30Y + 1⅔ stops
White	20C + 30M + 1 stop	40M + ⅔ stop	60M + 50Y + 1⅔ stops
Warm white	40C + 40M + 1⅓ stops	20C + 40M + 1 stop	50M + 40Y + 1 stop
Warm white deluxe	60C + 30M + 2 stops	60c + 30M + 2 stops	10m + 10Y + ⅔ stop
Cool white	30M + ⅔ stop	40M + 10Y + 1 stop	60R + 1⅓ stops
Cool white deluxe	20C + 10M + ⅔ stop	20C + 10M + ⅔ stop	20M + 40Y + ⅔ stop

Reflectance meters. An exposure meter which measures the range of brightnesses reflected directly from your subject is called a reflectance meter. It integrates, or averages, the range of brightnesses. A single lens reflex, through the lens camera meter, works on a principle similar to hand-held reflectance meters. Reflectance metering generally works well when the subject brightnesses are evenly dispersed over the field of view, but if your subject has large and small areas of contrasting tones a 'general reflectance' reading will usually prove inadequate.

Incident light metering measures the intensity projected directly from the light source, usually by collecting the light through a small translucent diffusion dome placed over the photocell. The dome is engineered so that the meter takes an average reading from the light source. Incident light meters are available only as hand–held meters.

Incident light readings are perfectly suited to exposing colour slide materials since they are not as prone to being misdirected as reflectance meters can be.

Kodak grey card (18% neutral grey test card) A grey card represents middle grey irrespective of the intensity of light it is placed in. Most exposure meters are calibrated to provide information that allows you to set your camera so that the film will record a subject tone, or collection of tones, as an average or mid-tone value. An incident light meter will provide an average reading suitable for exposing slide material but most reflectance exposure meters, including TTL metering systems, only give accurate *general* readings if the subject is *average* to begin with. A grey card represents 'the average tone', so that reflectance readings taken carefully from grey cards, in the subject's lighting, help you to make the correct exposure judgements.

The cheaper exposure meters, when used with a grey card, are just as effective in their limited range as their more expensive equivalents.

Using a *grey card* is a very accurate method of determining the correct exposure for colour films. To illustrate the correct use, consider the following four different situations in which you may use the grey card.

Note: make sure there are no shadows from yourself or your exposure meter on the card, nor any harsh reflections. Meter only the card.

1. *Determining exposure for flat two-dimensional copy work*, such as paintings, photographs, drawings and collages, place the grey card on the same plane as your artwork and use your camera exposure meter or hand-held exposure meter, after selecting the correct ISO/ASA, to measure the light from the grey card. Then set your aperture/shutter speed.
2. *For daylight readings*, position the card so that it faces the camera, preferably close to your subject. Exposure determination will be accurate only while you have the card in the same light as the subject, and pointing towards the camera on the same axis as your subject.

Fig. 8 To aid your colour printer when producing an accurate reproduction of your work it is good practice to include a photograph of a Kodak grey card and Kodak colour patches on each exposed film

3 *In artificial light* with inanimate objects try to position the card close to and directly in front of your 3-D subject, aimed between the main light and the camera. Be careful not to meter your own shadow.
4 *Lighting ratios.* When photographing 3-D objects, it is important, especially when using slide film, not to have too strong a contrast between your main light and your fill-in illumination. The brightness range that human binocular vision can adjust to is enormous, compared to the tonal recording capabilities of slide film. Consequently, it is easy to choose a lighting ratio which seems acceptable but is too contrasting for film.

A suitable ratio between fill-in illumination and main light is generally about 3:1 when full textural shadow and highlight details are required with slide film.

To adjust your lighting ratio to an acceptable level:

- First, position your grey card close to the subject. At this point all your lights should be on. But be careful that your meter does not accidentally catch direct light from a backlight source. Turn the card until the meter gives its maximum reading. Record your aperture and shutter speed reading.

Fig. 9 Place the grey card on the same plane as the work of art. The exposure meter should be carefully positioned to avoid its own shadow

- Turn off the main light and record the reading while the grey card faces the fill-in light. Note the number of 'stops' difference between the fully lit and fill-in illumination reading.
- Determine your subject lighting ratio by consulting the following table.

Lighting contrast ratios	
Grey card differences in light readings	Lighting ratio
1 stop	2 : 1
1⅔ stops	3 : 1
2 stops	4 : 1
2⅔ stops	6 : 1
3 stops	8 : 1
4 stops	16 : 1
5 stops	32 : 1
6 stops	64 : 1
7 stops	128 : 1

Fig. 10 To adjust your lighting ratio take two separate exposure meter readings with the grey card in full lighting and with only fill-in illumination

Light sources

Direct sunlight or diffuse sunlight, suitably controlled, meets most of the basic lighting requirements for photographing 2-D and 3-D subjects. Using daylight type film and suitable reflectors such as large sheets of white card to provide fill-in illumination, most basic studio effects can be achieved. The quality of sunlight will change according to atmospheric conditions and the angle at which the sun rays strikes the work. Photography in the shadows of buildings should be avoided because of excessive blue light content, which will give a bluish colour balance. Frustrations occur with open-air daylight photography due to the variability of weather conditions. Good sunshine and no disturbing wind gusts creates optimum conditions. Photographs of two- and three-dimensional pieces in naturally lit exhibition spaces are often enhanced by additional fill-in illumination.

Electronic flash and daylight have compatible colour temperatures for daylight colour films. Electronic flash, for beginners, may be complicated and seemingly difficult to control. Problem frequently occur with direct bounce-back reflections on glazed surfaces. To avoid these reflections the flash should be carefully positioned in relation to the work, usually slightly to one side. Daylight and flashlight of equal intensities will over-expose

Fig. 11 All form and surface detail of this ceramic scuplture, by artist Alfred Scott, has been described by carefully arranging an overhead modelling light and fill-in illumination to create a 3:1 lighting ratio

your film. To overcome this problem, set and operate the flashlight as though the camera aperture were one stop larger than needed for normal flash exposure. For example, if your camera is set for the metered daylight exposure of, say, 1/60 at f11 then use your flash as fill-in illumination, relative to the daylight part of your exposure, by setting the flash to give perfect exposure as if the camera had been set at 1/60 at f8. With camera aperture and shutter speed you will have maintained daylight exposure to 1/60 at f11 and flash exposure will have been for 1/60 at f8. With fully computerised flash guns enough light is emitted automatically simply by setting your ASA/ISO film speeds, and then setting the flash to operate at f8. In the case of manual flash operation it is more difficult. The only adjustment of the control of flashlight intensity as it falls upon your subject is by moving the flashlight closer and further away from the work. By this method a suitable distance can be found which corresponds to the correct f/stop needed for exposure. Not all flashlights have the facility to operate independent of the camera's accessory shoe flash connector, which may present some operational restrictions.

Studio photolamps. Before using any photographic lights, ascertain their respective colour temperatures so that the availability of compatible film stock and conversion filters can be checked. Lamps with colour temperatures of 3200°K and 3400°K include incandescent tungsten lamps housed in

aluminium reflectors (the cheapest purchase) and quartz iodide and tungsten halogen lamps. The practical differences are that incandescent tungsten lamps begin to deteriorate in quality after about six hours of use and may affect colour balance. Blue or daylight photolamps are available at reasonable cost with a colour temperature of about 4800°K.

If you have studio space of your own, or access to studio space, then two 500 watt photolamps are usually adequate for photographing 2-D works of art. For 3-D works, three photolamps should suffice. Available on the photographic market are relatively cheap adaptors which permit lights to be clamped on to door jambs, doors, chairs and other articles of furniture, if proper stands are unavailable.

Lighting 2D works of art

Lighting artwork(s) skilfully and sensitively to produce accurate photographs requires an analytical approach to the problems of resolving the texture, tone and form in your works. Two-dimensional works such as paintings, drawings, embossings, collages, black and white and colour photographs can all be photographed using similar lighting arrangements. Only slight variations in approach are needed to render the different textural qualities intrinsic to separate works.

It is better to photograph paintings and their like unframed to avoid peripheral shadows which come from recessing the work in its frame. Traditionally, 2-D works are photographed on neutral backgrounds of grey or black matt surfaces of material or paper.

Daylight is suitable lighting for 2-D artworks, although difficulties are often encountered with highly glazed or glossy surfaces that reflect surrounding objects, colours and tones. Adequate control of distracting reflections, which also dull colour saturation, is effectively obtained in the studio. To photograph 2-D works of art in daylight, two approaches are worth considering:

- Position the work of art in direct sunlight so that your lighting comes from above, ideally at 45° to the surface of your work. You may wish, however, to arrange that your daylight is sympathetic to directional clues, or light effects, in your work. Carefully consider your lighting with regard to textural rendition. Lighting which is too oblique causes heightening of the shadow effect at the expense of accurate colour rendition and reproduction of the work as executed. Direct oblique sunlight will highlight textural qualities. Embossings are particularly suited to this treatment.
- Diffuse sunlight provides a softer image of textural and tonal qualities and the coloration of the work will not be impaired.

When setting up your camera to photograph 2-D works, special care should always be taken to ensure distortion-free reproduction. Geometrically square or rectangular works will appear distorted if the camera is not

parallel to the surface of the work. By ensuring that the edges of such works are parallel to the viewfinder frame, distortion can be eliminated.

For accurate exposure determination refer to the section entitled 'Determining exposure using a grey card'.

Fig. 12 To photograph two-dimensional works of art in the studio, place your photolamps at a reasonable distance from the work to ensure an even light intensity across the surface of the work. The painting, 'Overture to Chinese Rug', 1982, is reproduced by kind permission of the artist, Francis Celtlan

2-D works of art photographed in the studio

The studio space offers a controlled situation for lighting two dimensional works of art, which is an advantage when photographing glossy or glazed works. Hang the work on a suitable background, positioning your lights to the left and right and check that the illumination is visually 'even'. The distance of your lights from the work varies according to the size of the work. Lights placed too close will contribute to uneven areas of intensity across the surface of the work. Shiny reflections on the surface of the works are generally to be avoided if the angle of incidence made by the light to the flat surface is slightly more than 45°. (See Figure 13 overleaf.)

To ensure even light intensity across the surface of any work, a simple routine may be adopted as follows. First, to balance your lights, roughly use the reverse, white, side of your grey card, close to and in the centre of your work. While in this position, hold a small piece of white card (approximately 25 mm square) at right angles to the white side of the grey card. Looking

164 Art, Design and Craft

Fig. 13 Lighting a two-dimensional work of art

along the little card, compare the shadows cast by your two lights and adjust the position of your lights until they balance. Second, use your grey card and meter across the surface of your work to ensure even light intensity. Finally, check through the viewfinder for spectacular reflections.

It may be more convenient and correct, when light direction and texture are important, to photograph horizontal works positioned on their side if the light source should appear to be from the top.

2-D works of art behind glass are very prone to reflecting objects in front of them such as shining parts of your camera equipment, light clothing, walls and windows. A polarizing filter does not completely remedy this problem

Fig. 14 To eliminate reflections in glazed works of art, the basic 2-D copying arrangement is modified by suspending a large sheet of black cloth in front of the camera. A hole was cut for the lens

although it may certainly lessen it. The most effective solution is achieved if a large piece of black of black cloth can be suspended in front of the camera, and other reflective objects, with an opening cut for the lens.

Photography of 3-D works of art. Successful photography of 3-D works of art varies with your ability to solve technical problems and to provide the right mood or atmosphere to surround your works. Requirements related to purely visual aspects, such as tone control, contrast, texture, form and volume should be adjusted together with the considerations needed to depict various moods or concepts. These can be suggested through positioning, camera viewpoint, spacing and the use of light in its purely symbolic and emotive manifestations.

Lighting to enhance texture requires oblique lighting with fill-in illumination if the textural surface is too coarse. Tones and contrasts of works need to be assessed when setting your lights and adjusting lighting ratios. Form and volume are basic considerations of light source positioning.

A basic knowledge of depth of field manipulation is relatively important when staging your shots in natural surroundings away from the studio. By controlling your depth of field, the background and foreground planes can be thrown out of focus, thereby concentrating interest upon your subject. Depth of field gradually increases to a maximum area of sharp focus as the aperture is stopped down towards the smallest apertures (f16–f22). Shallowest depth of field is evident at the largest apertures. (Some 35 mm cameras are fitted with a preview bottom which allows you to view and consider your depth of field at the selected aperture for exposure.) Nearly all single lens reflex cameras have a scale on the lens barrel indicating the depth of field at any given aperture.

As mentioned previously, longer focal length lenses produce a shallower depth of field than shorter focal lengths at relative apertures. The longer focal length lenses are better for eliminating perspective distortion (which is especially noticeable with shorter focal lengths at close quarters).

Using the studio for 3-D objects. The solutions discussed here in relation to the problems of photographing 3-D works of art in the studio are equally applicable to photographing them outdoors. If you intend photographing your 3-D works in the studio a selection of background cloths or paper rolls, usually in pastel or earth colours, will be needed. Usually enough material is purchased to provide a seamless background which also covers the platform.

Lighting 3-D objects. Directional studio lighting is commonly looked upon as the basic arrangement of a modelling light with the option of adding fill-in illumination, background and accent lights. The modelling light delineates the main light/tonal patterns and masses, and also describes the form and texture in its sculptural terms. Finding the ideal position for the modelling light can be done if the light is made mobile by removing it from its stand and rotating it around the subject by hand. Once found you can

then position the stand under the light. One light by itself can create very dramatic images.

If fill-in illumination is required to ensure textural rendition in your shadows, the light or reflector will have to be suitably distanced from the subject to maintain the integrity of the main light. The safest place for a fill-in light is close to or on the same axis as your camera/subject. In such a position, shadow patterns are kept unobtrusive by not forming complex double shadows with main light shadows. However, personal aesthetic criteria should ultimately dictate your fill-in illumination position.

Background lighting and backlighting (if needed) can sometimes be engineered with one light, but it is advisable to leave enough room to control your background light without affecting your subject.

Exposure readings and the control of lighting ratios between the main light, fill-in illumination and background illumination can all be calculated with reference to the section on exposure determination.

Distracting reflections and glare on lightly glazed objects (such as ceramics), from the main lights and fill-in lights, are at best only modified by a combination of polarising filter, careful lighting and the possible use of a matt surface spray. (Take care with the latter as the nature of the surface may prohibit spraying.)

Diffuse reflections, characteristic of textured surfaces, cannot easily be identified as specular reflections because they are not always obvious. Nevertheless, they do tend slightly to obscure the colour and fine textural qualities of some works. Careful lighting and the use of a polarising filter will usually correct the problem.

To enhance textural details use, an oblique modelling light with fill-in illumination where the depression is very coarse or deep. Diffuse lighting may, if desired, destroy some textural details.

Diffuse lighting. Where soft lighting, usually referred to as diffuse or broad source lighting, is required, architect's tracing paper provides the perfect diffusing medium. The only problem is rigging it in front of the lights, which, if brought too close, may set it on fire! The architect's tracing paper will alter the intensity of light falling on your subject to a considerable degree, making the tripod more necessary. Diffuse lighting detracts from subjects which rely on sculptural contrast lighting, since it results in a lowering of image contrast.

Tent lighting is a method of providing virtually shadowless illumination for objects placed inside. Another use is in the almost total negation of distracting reflections in highly polished metalwork articles. Black strips stuck to the inside can be arranged to provide contrasting reflections to lift otherwise high key images. The 'tent' in Figure 15 was made with architect's tracing paper. It took only about 15 minutes to construct. A hole was made in one side giving access to the camera lens.

Transparent perspex and glass objects require special lighting applications. Backlighting through a suitable diffusing medium, or solely reflected

Fig. 15 The 'tent' can be used with studio lights or daylight to provide virtually shadowless illumination

from background paper will tend to create a silhouette, with full light inside the objects, as the light refracts through the outside edges. No direct illumination should reach the objects. Dark surroundings will enhance the silhouette effect.

Backlighting on to glass or perspex placed on a black background will create the reverse effect, highlighting the outermost edge and leaving the interior dark. Frontal lights and reflectors will form spectacular highlights and reflections which sparkle in the body of the glass or perspex.

Figures 16 and 17 illustrate a makeshift, shadowless light table (see pages 168 and 169). A large sheet of 'Opal' perspex formed the platform, together with a backdrop of architect's tracing paper. This made it possible to backlight an area totally to light a perspex construction by the artist Alf Scott. No frontal light was required. Calculating exposure for this type of subject is very difficult and, unless you own a spot meter which measures, telescopically, exposure information from very small areas, you should take a range of photographs around what you estimate as 'correct' and then select the best.

Mounting your slides and providing brief, descriptive titles is a simple matter. The descriptive titles are more useful when typed or written in simple script. Figure 18 illustrates an effective way of mounting and captioning colour slides. Your slides should be numbered in the bottom left-hand corner, as viewed, which leaves the numbers visible when they are in

the projector. The slide numbers can also be used to locate more specific information you may wish to include on a separate broadsheet accompanying the collection.

For submissions, slides are best placed in plastic suspension files, of the type used to store slides vertically in filing cabinets, and which can hold up to eighteen 35 mm colour slides, protect and conveniently display your photographs. Filed in this way the slides will take up a minimum of space in your submissions folder. Glass slides are not recommended since they are incompatible with some makes of projector.

Captions accompanying 10" × 8" colour prints should be typed on separate pieces of paper and squarely glued to the backs of the prints. Place them in a lightweight folder with the contents clearly labelled before including them in your submissions folder.

Fig. 16 An improvised light table to provide backlighting and shadowless illumination

Photographing Artwork 169

Fig. 17 The perspex sculpture 'Rocking Totem' by artist Alfred Scott, was photographed using the light table

Fig. 18 Information should be clear and precise with the number in the bottom left-hand corner

Bibliography

Eastman Kodak, *Kodak Colour Darkroom Dataguide* 12–19, 1980.
Angeloglou, C. (ed.), *Creative Photographic Lighting*, William Collins, 1981.
Hedgecoe, J., *The Art of Colour Photography*, Mitchell Beazley Publishers Ltd., London, 1978.
Hedgecoe, J., *The Photographer's Handbook*, Dorling Kindersley Limited, London, 1977.
Titus, W. H., *Photographing Works of Art*, Watson–Guptill Publications, New York, N. Y., 1981.

24 Getting Help

One of the key problems of small businesses is that of isolation: not geographical isolation, but isolation in the process of decision-making. It is encouraged by the perception of the individual proprietor, or a small group of proprietors, that everything depends on them, on their knowledge and on their skills. This should not be the case. Within the community, there are many individuals and organisations who can assist in all the various aspects of a business enterprise. An artworker needs to be aware of their services, know how to approach them and have the competencies necessary to implement their advice.

The aims of this chapter are:

- to review some of the sources of help available to the artist/craftsperson
- to suggest some guidelines to be followed in seeking help
- to provide a reading list of appropriate references that individuals can use to develop their knowledge and skills.

Professional services – reasons for consultation
The accountant

Formation Advice on the form of legal entity that best fits needs; tax implications.
Records Development of an initial set of records to cover debtors and creditors, cash receipts and payments, inventory, etc. Advice on their maintenance by the proprietor.
Cost and credit control Initiation of cost and credit control systems appropriate to the needs of the enterprise.
Planning Assistance with the development and implementation of budgeting procedures.
Finance Advice on the nature and source of borrowed funds; assembling financial information to support loan applications; introduction to lenders; advice on the investment of surplus short or long term funds.
Taxation Advice on responsibilities and the preparation of returns.
Changing business environment Planning is based on present knowledge. If circumstances change, particularly through new legislation, plans have to be modified to accommodate the changed business environment. For

example, changes in depreciation rates affect the relative advantages of leasing and hire purchase. Your accountant will be familiar with new developments.

The solicitor

Formation Advice on legal form and taxation implications; preparation and filing of appropriate documents.
Business law advice Assistance on the legal implications of problems involving the law of contract, consumer law, agency, insurance, finance, copyright, etc.
Estate planning Assistance to minimise tax during lifetime and on death. A solicitor can advise on wills, trusts, and valuations. An accountant's advice will also be invaluable here.

The bank manager

Financial management The bank manager can supplement the advice given by the accountant. Bank managers have the opportunity to work with a large number of businesses in a variety of fields. This experience allows them to identify a firm's financial strengths and weaknesses.
Provision of finance Banks are the major external source of funds for small business. Prepare your application well. (See Chapter 12.)
Investment of surplus funds

The insurance broker

Risk management Estimation of risks and possible losses; preparation of insurance proposals; provision of cover.
No charge for advice Possible fee on policy.

Professional advisers – guidelines when seeking help

Do not wait until there is an urgent need Prevention really is better than cure. Treat advice as a continuous process. Do not wait until the danger signals appear. Instead, keep your advisers, particularly your accountant and banker, up to date with your progress and development.
Good meetings are the result of thorough homework For your meetings, prepare a written submission which includes the background facts, statistical data, your analysis of the issue, your perception of the need and your solution(s). Such a procedure not only helps to clarify your thoughts but saves much time in providing a basis for discussion.
The benefits of advice exceed the costs Never be reluctant to seek the advice of the expert. There is a corollary to this theorem; good advice does not cost, it

Getting Help 173

pays. Remember that the quality of advice is conditioned by the ability of the receiver to comprehend and use it. Hence the need for individual research.

New initiatives This is an extension of the first guideline. Advisers are useful in circumstances other than those of gloom. Use them as a sounding board for your ideas when circumstances seem buoyant and you are optimistic about future plans. You will benefit from the objectivity and the different perspectives of each adviser.

Useful addresses

Society of Chartered Designers,
27 Bedford Square, London WC1
(01-636 1510) Offers an information service and operates index for members; runs training courses and seminars; produces number of publications related to professional practice.

Crafts Council, 12 Waterloo Place, London
SW1Y 4AU (01-930 4811)

Design Council, 28 Haymarket, London
SW1Y 4SU (01-839 8000)

Scottish Design Centre, 72 St. Vincent's Street,
Glasgow (041-221 6121)

Welsh Design Council, Pearl Assurance House,
Greyfriars Road, Cardiff CF1 3JN (0222-395811/2)

Design and Industries Association, 12 Carlton House Terrace, London
SW1Y 5AH (01-940 4925)

Arts Council of Great Britain, 105 Piccadilly, London
W1V 0AU (01-629 9495)

Scottish Arts Council, 19 Charlotte Square,
Edinburgh EH2 4DF (031-266 6051)

Arts Council of Northern Ireland, 181a Stranmillis Road, Belfast BT9 5DU
(0232-663591)

Welsh Arts Council, Holst House, Museum Place, Cardiff CF1 3NX
(0222-394711)

Arts Council in Eire, 70 Merrion Square,
Dublin 2 (0001-764695)

Regional arts associations:
Buckinghamshire Arts Association, 55 High Street,
Aylesbury, Bucks HP20 1SA (0296-34704)

Art, Design and Craft

Eastern Arts Association, 8/9 Bridge Street, Cambridge CB2 1UA (0223-67707) covers Bedfordshire, Cambridge, Essex, Herts, Norfolk and Suffolk

East Midlands Arts Association, Mountfields House, Forest Road, Loughborough, Leics LE11 3HU
(0509-218292) Derbyshire, Leics, Northants and Notts

Greater London Arts Association, 25 Tavistock Place London WC1 (01-388 2211) 32 London Boroughs & City of London

Lincolnshire and Humberside Arts, St. Hugh's, Newport, Lincoln LN1 3DN (0522-33555)

Merseyside Arts Association, Bluecoat Chambers, School Lane, Liverpool L1 3BX (051-709 0671)
County of Merseyside, West Lancs, Ellesmere Port and Halton

Northern Arts 10 Osborne Terrace, Jesmond, Newcastle upon Tyne NE2 1NZ (0632-816 334)
Cleveland, Cumbria, Durham, Northumberland, Tyne and Wear

North West Arts Association, 12 Harter Street, Manchester (061-833 9471) Greater Manchester, Peak District of Derbyshire, Lancs and Cheshire

Southern Arts Association, 19 Southgate Street, Winchester, Hants S023 9EB (0962-69422) Berks, Hants, IoW, Oxon, W. Sussex, Wilts

South East Arts, 9–10 Crescent Road, Tunbridge Wells TN1 2LU (0892-41666), Kent, Surrey, E. Sussex

South West Arts, 23 Southernhay, Exeter, Devon EX1 1QL (0392-38924) Avon, Devon, Cornwall, Glos, Somerset

West Midlands Arts, Brunswick Terrace, Stafford ST16 1BZ (0785-59231) Hereford, Worcs, Metropolitan County of W. Midlands, Shropshire, Staffs, Warwickshire

Yorkshire Arts Association, Glyde House, Glydegate, Bradford BD5 0BQ (0274-23051) North, South and West Yorks

North Wales Association of the Arts, 16 Wellfield House, Bangor, Gwynedd (0248-353248) Clwyd, Gwynedd and district of Montgomery in Powys

South East Wales Arts Association, Victoria Street, Cwmbran, Gwent NP44 3JP (06333-67530) City of Cardiff, Gwent, mid Glamorgan, S. Glamorgan, Radnor, Brecknock

West Wales Association for the Arts, Dark Gate, Red Street, Carmarthen, Dyfed SA31 1QL (0267-4248) West Glamorgan and Dyfed

Area Arts Associations:
Mid Pennine Association for the Arts, 2 Hammerton Street, Burnley BB11 1NA (0282-21986) North East Lancs and Yorkshire Border

Bury Metro Arts Association, The Derby Hall, Market Street, Bury (061-761 7107)

Fylde Arts Association, Grundy Art Gallery, Queen Street, Blackpool F11 1PX (0253-22130) Fylde, Blackpool and Wyre

Mid-Northumberland Arts Group, Wansbrook Square, Ashington, Northumberland NE63 9XL (0670-814444)

Calouste Gulbenkian Foundation, 98 Portland Place, London W1N 4ET (01-636 5313/7)

Dept. of Trade and Industry, Regional Support Inward Investment and Tourism Division, Kingsgate House, 66–74 Victoria Street, London SW1E 6SJ (01-212 7676)

Alliance of Small Firms and Self-Employed People, 42 Vine Road, East Molesey KT8 9LF

National Federation of Self-Employed, 32 St. Anne's Road West, St. Anne's on Sea FY8 1NY

Association for Business Sponsorship of the Arts, 3 Pierrepoint Place, Bath (0225-63362)

Directory of Social Change, 9 Mansfield Place, London NW3 (01-431 1412)

Design and Art Directors Association, 12 Carlton House Terrace, London SW1 (01-839 2964) Runs design concept workshops for students and graduates wanting to work in advertising, in which briefs are set and work criticised by art directors from agencies

Institute of Practitioners in Advertising, 44 Belgrave Square. London SW1X 8QS (01-235 7020) Represents ad agencies in the UK

Advertising Association, Abford House, 15 Wilton Road, London SW1V 1NJ (01-828 2771)

Association of Illustrators, 1 Colville Place, London W1P 1HN (01-636 4100) The professional organisation that protects and promotes the interests of illustrators; can offer support to members over legal issues related to their work. Runs programmes and seminars; can offer advice on folios to young professionals; sponsors competitions; has an annual open exhibition; and a gallery with a regular programme of illustrators' exhibitions; also produces house magazine

Society of Typographic Designers, c/o Mike Seaton, Brunel Technical College, Dept. of Printing and Graphic Design, Ashley Down, Bristol BS7 9BU

Society of Graphic Artists, 17 Carlton House Terrace, London SW1 (01-930 6844)

176 Art, Design and Craft

Publications

Several publications and other sources of information are mentioned in the text. In addition, the following may be helpful:
Small Firms Information Centres provide a wide range of answers to all problems concerning small firms. They have a national data bank, and if they do not have the direct answer, can tell you where to ask specialised questions. Their services are free, and they have a set of free booklets on various subjects. To contact your nearest centre, dial 100 and ask the operator for *Freefone* 2444
Croner's Reference Book for the Self-employed, a looseleaf updated easy reference to the many laws affecting the self-employed. Sections on VAT, National Insurance, Health and Safety, Sale of Goods, Debt Recovery. This publication is invaluable, since it is updated monthly and thus keeps the small operator in instant touch with changes in legislation. From Croner House, 173 Kingston Road, New Malden, Surrey.
Croner's Consumer Law and Product Liability. Croner Publications
Croner's Guide to Cost Control. Croner Publications

Crafts Council Publications:
 Grants and Loans, general leaflet on what is available and when to apply
 Setting Up Scheme
 Advanced Training Scheme
 Workshop Assistant Scheme
 Grants of Guarantees Against Loss for Special Projects
 Bursaries – conditions
 Grants and Loan Schemes – established craftspeople
 Working to Commission
 Organising Your Owns Exhibition: Exhibitions Information Sheet:
 Setting Up; Costing Your Work; Sources of Finance and Advice Series of leaflets

The Design Council: What We Do, What We Are, Why We Do It: booklet describing the work of the Design Council, available free from the Council

Chartered Society of Designers Publications:
 Protecting Your Invention: a guide to patent protection
 Protecting Your Designs: a guide to copyright and design registration
 Working Together: guidelines for designers working with other professionals
 Product Design: Part I Usual sources and methods of charging, Part II Conditions of engagement
 Interior and Graphic Design: Part I Guide to designers work, Part II Form of Agreement
 Royalty Agreements (i) commissioned work (ii) non-commissioned work
 Survey of Salaried Designers' Pay and Conditions: Issued annually

Taxation and the smaller business, CoSIRA.

Starting in Business: Inland Revenue; pamphlet explaining the financial arrangements necessary for self-employment – eg VAT, dealing with the tax office, Nl contributions, engaging an accountant etc; free from Inland Revenue offices

VAT General Guide HM Customs and Excise Notice No 700: VAT Scope and Coverage HM Customs and Excise Notice No 701 from Customs and Excise offices

Starting Your Own Business, Edith Rudlinger, Consumers' Association 1983; strong on practical and addresses of other organisations that may be able to help. Looks at various aspects of self employment from mail order to market trading and franchising; available from Consumers' Association, 14 Buckingham Street, London WC2N 6DS

Small Claims in the County Court, available from local county court; guide to procedures on how to sue and defend actions without a lawyer

The ABC of Copyright, UNESCO 1981 (available from HMSO)

Access to Local Government Information – Your Legal Rights and Some Advice on How to Get Them, R. Bailey, Local Government and Health Rights Project

Alternative Sources of Funding and Practical Assistance for Arts Organisations, A Reading List, 1982, Guide to agencies other than arts councils which may provide funds for arts projects; Arts Council (free)

Arts Council of GB – Guide to Awards and Schemes, annual publication; important to consult current edition as bias of awards alters year by year

Promotion of the Arts in Britain, Central Office of Information, HMSO, 1983

Regional Arts Associations, often have own publications related to arts activities in the area; offer grants distinct from those of the Arts Council; issue regional magazines of events

Professional Practice of Design, Dorothy Goslett, Batsford, 1978

Working in Art and Design, Peter Green, Batsford, 1983; a useful book because it is written by a practising artist who is also the Dean of Faculty of Art and Design at Middlesex Polytechnic

Guide to Courses and Careers in Art and Design, Tony Charlton, from NSEAD, 7a High Street, Corsham, Wilts SN13 0ES

Directory of Enterprise Agencies, available from Business in the Community, 227a City Road, London EC1V 1JU; listings of the agencies which exist throughout the UK to encourage new business. Largest of these is the London Enterprise Agency which offers training courses in business management

Finance for New Projects in the UK, A guide to govenmental grants; Peak, Marwick, Mitchell; available from them at 1 Puddle Dock, Blackfriars, London EC4V 3PD

Guide to the Enterprise Allowance Scheme, MSC 1983, available from Jobcentres; details of the Government scheme to encourage self-employment; in return for a £1000 investment you will receive £40 per week for one year to supplement income from receipts

A Summary of Incentives for Industry, Dept. of Trade and Industry; Government booklet outlining help available to encourage new businesses in designated 'assisted' areas

All Our Own Work, Manpower Services Commission Basic Skills Unit (COIC) 1983

Minding Your Own Business, P&C Phillips 1982, Manpower Services Commission (COIC)

Money Box Book List, Occasional supplement. Free from Money Box, BBC Broadcasting House, London W1A 1AA; send sae for useful list of books on self-employment and raising finance

National Insurance Guide for the Self-Employed, leaflet N141, DHSS or HM Inspector of Taxes (free)

Export Services Handbook, British Overseas Trade Board, Export House, 50 Ludgate Hill, London EC4M 7HU.

Association for Business Sponsorship of the Arts/WH Smith Sponsorship Manual

Fund Raising: A Comprehensive Handbook, Directory of Social Change

Raising Money for the Arts, Directory of Social Change; Aims to assist arts organisations of all kinds – museums, theatres, community arts and festival organisers on how to obtain finance from Arts Council, RAA's, local authorities, businesses etc.

Raising Money from Trusts

Raising Money from Government

Raising Money from Industry

Industrial Sponsorship and Joint Promotions, all from Directory of Social Change

Artists' Directory, Richard Layzell and Heather Waddell, Art Guide Publications; includes information on exhibiting, galleries, art supply shops, awards, studios etc. plus an international section and bibliography. Available from AGP, 28 Colville Road, London W11 2BS

Arts Review Yearbook and Directory, published by Gainsborough Ralston; annual publications listing all private galleries and the work in which they specialise.

London Art and Artists Guide, Art Guide Publications Ltd; information on galleries for contemporary art, printmaking, film and community workshops, group workshops, artists' material supplies, art courses, arts magazines and good places to eat and drink

Design and Art Director Annual, DADA of London; a useful guide to where the most creative visual work is being done within advertising

List of Advertising Agencies, Institute of Practitioners in Advertising

Artists Studio Handbook, Artic Producers, 1985; for anyone who has ever thought that setting up a group studio would be fun, this handbook shows that fun it may be, but hard work it certainly is. Those dissuaded from the idea may find comfort in the listings of established group studios

Appendix

Appendix

Cash flow program: BBC model B

```
10REM (C)COPYRIGHT:Thomas Crowe 1982
20MODE7:PROCINTRO1:CLS:PROCINTRO
30CLS:PROCMONTH
40*FX4
50TR7=0
60X%=8:Y%=2:C=0:O=0
70DIMR(12),S(12),M(12),P(12),H(12),I(12),W(12),L(12),T(12),D(12),G(12),T2(12),T3(12),T4(12),F(12),C(12)
80MODE3:VDU19,0,4,0,0,0
90VDU23;8202;0;0;0;
100PROCCHART
110PROCALTER
120MODE7:IF O=1 THEN PROCSAVE ELSE PROCINPUT
130PROCWORKOUT
140GOTO80
150DEF PROCCHART
160CLS
170IF TR7=42 THEN VDU2:TR7=0
180PRINTTAB(1);"FACTORS";TAB(40);"MONTHS"
190PRINTTAB(10);JAN$;TAB(16);FEB$;TAB(22);MAR$;
200PRINTTAB(28);APR$;TAB(34);MAY$;TAB(40);JUN$;
210PRINTTAB(46);JUL$;TAB(52);AUG$;TAB(58);SEP$;
220PRINTTAB(64);OCT$;TAB(70);NOV$;TAB(76);DEC$
230PRINTTAB(1);"R+R";:A=8:FORQW=1TO12:PRINTTAB(A);R(QW);:A=A+6:NEXT
240PRINTTAB(1);"HLPT";:A=8:FORQW=1TO12:PRINTTAB(A);S(QW);:A=A+6:NEXT
250PRINTTAB(1);"M/C";:A=8:FORQW=1TO12:PRINTTAB(A);M(QW);:A=A+6:NEXT
260PRINTTAB(1);"PROF";:A=8:FORQW=1TO12:PRINTTAB(A);P(QW);:A=A+6:NEXT
270PRINTTAB(1);"TRAV";:A=8:FORQW=1TO12:PRINTTAB(A);H(QW);:A=A+6:NEXT
280PRINTTAB(1);"MATS";:A=8:FORQW=1TO12:PRINTTAB(A);I(QW);:A=A+6:NEXT
290PRINTTAB(1);"SUBC";:A=8:FORQW=1TO12:PRINTTAB(A);C(QW);:A=A+6:NEXT
300PRINTTAB(1);"WAGE";:A=8:FORQW=1TO12:PRINTTAB(A);W(QW);:A=A+6:NEXT
310PRINTTAB(1);"L.EX";:A=8:FORQW=1TO12:PRINTTAB(A);L(QW);:A=A+6:NEXT:PRINTTAB(1)
320PRINTTAB(1);"TOT";:A=8:FORQW=1TO12:PRINTTAB(A);T(QW);:A=A+6:NEXT:PRINTTAB(1)
330PRINTTAB(1);"DESN";:A=8:FORQW=1TO12:PRINTTAB(A);D(QW);:A=A+6:NEXT
340PRINTTAB(1);"PROD";:A=8:FORQW=1TO12:PRINTTAB(A);G(QW);:A=A+6:NEXT
350PRINTTAB(1);"FEES";:A=8:FORQW=1TO12:PRINTTAB(A);F(QW);:A=A+6:NEXT
360PRINTTAB(1)
370PRINTTAB(1);"TOT";:A=8:FORQW=1TO12:PRINTTAB(A);T2(QW);:A=A+6:NEXT:PRINTTAB(1)
380PRINTTAB(1);"MTOT";:A=8:FORQW=1TO12:PRINTTAB(A);T3(QW);:A=A+6:NEXT:PRINTTAB(1)
390PRINTTAB(1);"CUMU";:A=8:FORQW=1TO12:PRINTTAB(A);T4(QW);:A=A+6:NEXT
400ENDPROC
410DEF PROCINTRO
420*FX15,1
430PRINTTAB(10,0)CHR$141"Cashflow-KEY"TAB(10,1)CHR$141"Cashflow-KEY"
440PRINTTAB(0,2)"FACTORS"
450PRINTTAB(0,4)"R+R...........RENT+RATES"
460PRINTTAB(0,5)"HLPT..........HEAT,LIGHT,POWER,TELEPHONE"
470PRINTTAB(0,6)"M/C...........MACHINERY+TOOLS"
480PRINTTAB(0,7)"PROF..........PROFESSIONAL SERVICES"
490PRINTTAB(0,8)"TRAV..........TRAVEL+TRANSPORT"
500PRINTTAB(0,9)"SUBC..........SUBCONTRACTORS,BOUGHT-IN"
510PRINTTAB(0,10)"MATS.........MATERIALS+CONSUMABLES"
520PRINTTAB(0,11)"WAGE.........WAGES TO EMPLOYEES"
530PRINTTAB(0,12)"L.EX.........LIVING EXPENSES FOR SELF"
540PRINTTAB(0,13)"DESN.........DESIGN SALES"
550PRINTTAB(0,14)"PROD.........PRODUCT SALES"
560PRINTTAB(0,15)"FEES.........FEES,TEACHING,CONSULTANCY"
570PRINTTAB(0,16)"MTOT.........MONTHLY TOTAL"
580PRINTTAB(0,17)"CUMU.........CUMULATIVE TOTAL"
590PRINTTAB(2,19)"Press 'K' to retrieve this key."
```

184 Art, Design and Craft

```
600PRINTTAB(4,21)CHR$129"ALL FIGURES X '10"
610PRINTTAB(2,23)"PRESS ANY KEY TO CONTINUE":A$=GET$
620ENDPROC
630DEF PROCASSIGN
640ON
Y%-16TO650,660,670,680,690,700,710,720,730,770,770,770,740,750,760,770,770,770,770,770
650A%=R((X%-2)/6):GOTO770
660A%=S((X%-2)/6):GOTO770
670A%=M((X%-2)/6):GOTO770
680A%=P((X%-2)/6):GOTO770
690A%=H((X%-2)/6):GOTO770
700A%=I((X%-2)/6):GOTO770
710A%=C((X%-2)/6):GOTO770
720A%=W((X%-2)/6):GOTO770
730A%=L((X%-2)/6):GOTO770
740A%=D((X%-2)/6):GOTO770
750A%=G((X%-2)/6):GOTO770
760A%=F((X%-2)/6)
770ENDPROC
780DEF PROCASSIGN2
790ON Y%-16GOTO800,810,820,830,840,850,860,870,880,920,920,920,890,900,910
800R((X%-2)/6)=A%:GOTO920
810S((X%-2)/6)=A%:GOTO920
820M((X%-2)/6)=A%:GOTO920
830P((X%-2)/6)=A%:GOTO920
840H((X%-2)/6)=A%:GOTO920
850I((X%-2)/6)=A%:GOTO920
860C((X%-2)/6)=A%:GOTO920
870W((X%-2)/6)=A%:GOTO920
880L((X%-2)/6)=A%:GOTO920
890D((X%-2)/6)=A%:GOTO920
900G((X%-2)/6)=A%:GOTO920
910F((X%-2)/6)=A%
920ENDPROC
930DEF PROCALTER
940IF INKEY(-26) AND X%<>8 THEN X%=X%-6
950IF INKEY(-122) AND X%<71 THEN X%=X%+6
960IF INKEY(-58) AND Y%<>2 THEN Y%=Y%-1
970IF INKEY(-42) AND Y%<>16 THEN Y%=Y%+1
980IF INKEY(-71) THEN CLS:PROCINTRO1:CLS:PROCINTRO:PROCCHART
990IF INKEY(-82) THEN O=1:ENDPROC
1000IF INKEY(-52) THEN O=2:ENDPROC
1010IF INKEY(-33) THEN VDU19,C,0;0;
1020IF INKEY(-114) THEN VDU19,C,1;0;
1030IF INKEY(-115) THEN VDU19,C,2;0;
1040IF INKEY(-116) THEN VDU19,C,3;0;
1050IF INKEY(-21) THEN VDU19,C,4;0;
1060IF INKEY(-117) THEN VDU19,C,5;0;
1070IF INKEY(-118) THEN VDU19,C,6;0;
1080IF INKEY(-23) THEN VDU19,C,7;0;
1090IF INKEY(-119) THEN C=C+1:IF C>1 THEN C=0
1100IF Y%=13 THEN Y%=10
1110IF Y%=11 THEN Y%=14
1120PROCASSIGN
1130COLOUR1:PRINTTAB(X%,Y%);A%:FORX=1TO200:NEXT
1140COLOUR0:PRINTTAB(X%,Y%);A%:FORX=1TO200:NEXT
1150COLOUR1:PRINTTAB(X%,Y%);A%
1160*FX15
1170IF INKEY(-83) THEN PRINTTAB(X%,Y%);:INPUT""A%:PROCASSIGN2:PROCWORKOUT:PROCCHART
1180IF INKEY(-66) THEN
PRINTTAB(X%,Y%);:INPUT""A%:PROCALL:PROCASSIGN2:PROCWORKOUT:PROCCHART
1190IF INKEY(-56) THEN PROCPRINTOUT:VDU3
1200IF INKEY(-98) THEN PROCWIPE:PROCCHART
1210GOTO940
1220ENDPROC
1230DEF PROCWORKOUT
1240FORX=1 TO 12
1250T(X)=-R(X)-S(X)-M(X)-P(X)-H(X)-I(X)-W(X)-L(X)-C(X)
1260T2(X)=D(X)+G(X)+F(X)
1270T3(X)=T(X)+T2(X)
1280NEXT
1290T4(1)=T3(1)
1300FORX=2 TO 12
1310T4(X)=T3(X)+T4(X-1)
```

```
1320NEXT
1330ENDPROC
1340DEF PROCALL
1350FORX=1TO 12
1360ON
Y%-1GOTO1370,1380,1390,1400,1410,1420,1430,1440,1450,1360,1360,1360,1460,1470,1480
1370R(X)=A%:GOTO1490
1380S(X)=A%:GOTO1490
1390M(X)=A%:GOTO1490
1400P(X)=A%:GOTO1490
1410H(X)=A%:GOTO1490
1420I(X)=A%:GOTO1490
1430C(X)=A%:GOTO1490
1440W(X)=A%:GOTO1490
1450L(X)=A%:GOTO1490
1460D(X)=A%:GOTO1490
1470G(X)=A%:GOTO1490
1480F(X)=A%
1490NEXT:ENDPROC
1500DEF PROCPRINTOUT
1510*STYLE M
1520TR7=42
1530PROCCHART
1540PRINT
1550VDU3:TR7=0
1560ENDPROC
1570DEF PROCINTRO1
1580PRINTTAB(0,0);CHR$132CHR$157TAB(0,1);CHR$132CHR$157TAB(10,0)CHR$132CHR$157CHR$13
1CHR$141"CASHFLOW"TAB(10,1)CHR$132CHR$157CHR$131CHR$141"CASHFLOW"
1590PRINTTAB(4,3)"The arrow keys are used to position"
1600PRINTTAB(1,4)"flash on the location to be changed."
1610PRINTTAB(0,5);CHR$134CHR$141"Sequence:"TAB(0,6)CHR$134CHR$141"Sequence:"
1620PRINTTAB(10,7);CHR$133"Press 'C' to stop flash."
1630PRINTTAB(10,8);CHR$133"Type in new value."
1640PRINTTAB(10,9);CHR$133"Press 'RETURN'."
1650PRINTTAB(10,11);CHR$134"To change twelve months at once:"
1660PRINTTAB(10,12);CHR$129"Press 'A' to stop flash."
1670PRINTTAB(10,13);CHR$129"Type in new value."
1680PRINTTAB(10,14);CHR$129"Press 'RETURN'."
1690PRINTTAB(0,16);CHR$134"To print out completed cashflow:"
1700PRINTTAB(10,17);CHR$130"Press 'P'"
1710PRINTTAB(10,19);CHR$134"To change colour."
1720PRINTTAB(10,20);CHR$131"Select from 'f0' to 'f7'."
1730PRINTTAB(10,21);CHR$131"Press 'f8' to switch between"
1740PRINTTAB(10,22);CHR$131"foreground and background."
1750PRINTTAB(0,24);CHR$132CHR$157CHR$131"       PRESS ANY KEY TO CONTINUE.";
1760A$=GET$:CLS
1770PRINTTAB(0,0);CHR$129CHR$157TAB(0,1);CHR$129CHR$157TAB(10,0)CHR$129CHR$157CHR$13
5CHR$141"CASHFLOW"TAB(10,1)CHR$129CHR$157CHR$135CHR$141"CASHFLOW"
1780PRINTTAB(0,5);CHR$134CHR$141"Sequence:"TAB(0,6)CHR$134CHR$141"Sequence:"
1790PRINTTAB(0,7);CHR$134"To save data on tape:"
1800PRINTTAB(10,8);CHR$130"Press 'S'"
1810PRINTTAB(0,10);CHR$134"To recall data from tape:"
1820PRINTTAB(10,11);CHR$133"Press 'R'"
1830PRINTTAB(0,13);CHR$134"To reset chart to zero:"
1840PRINTTAB(10,14);CHR$131"Press 'Z'"
1850PRINTTAB(0,24);CHR$129CHR$157CHR$135"       PRESS ANY KEY TO CONTINUE.";
1860A$=GET$:ENDPROC
1870DEF PROCWIPE
1880FORX=1TO12:R(X)=0:S(X)=0:M(X)=0:P(X)=0:H(X)=0:I(X)=0:W(X)=0:L(X)=0:D(X)=0:G(X)=0
:F(X)=0:C(X)=0:NEXT
1890PROCWORKOUT
1900ENDPROC
1910DEF PROCSAVE
1920PRINTTAB(0,0);CHR$131CHR$157TAB(0,1);CHR$131CHR$157TAB(10,0)CHR$131CHR$157CHR$13
3CHR$141"CASHFLOW-save"TAB(10,1)CHR$131CHR$157CHR$133CHR$141"CASHFLOW-save"
1930PRINTTAB(0,5);CHR$134CHR$141"Sequence:"TAB(0,6)CHR$134CHR$141"Sequence:"
1940PRINTTAB(8,7);CHR$134"1:Type in name of cashflow."
1950PRINTTAB(8,8);CHR$134"2:Press 'RETURN'."
1960PRINTTAB(8,9);CHR$134"3:Move tape to desired position."
1970PRINTTAB(8,10);CHR$134"4:Press the record button."
1980PRINTTAB(8,11);CHR$134"5:Switch tape off afterwards."
1990PRINTTAB(8,13);CHR$129"Steps 4 and 5 are unneccessary"
2000PRINTTAB(3,14);CHR$129"if the recorder has a motor control"
2010INPUTTAB(4,16)"Cashflow name",F$
```

Appendix 185

186 Art, Design and Craft

```
2020X=OPENOUT(F$)
2030FORX1=1 TO 12:PRINT£X,R(X1):NEXT
2040FORX1=1 TO 12:PRINT£X,S(X1):NEXT
2050FORX1=1 TO 12:PRINT£X,M(X1):NEXT
2060FORX1=1 TO 12:PRINT£X,P(X1):NEXT
2070FORX1=1 TO 12:PRINT£X,H(X1):NEXT
2080FORX1=1 TO 12:PRINT£X,I(X1):NEXT
2090FORX1=1 TO 12:PRINT£X,W(X1):NEXT
2100FORX1=1 TO 12:PRINT£X,L(X1):NEXT
2110FORX1=1 TO 12:PRINT£X,D(X1):NEXT
2120FORX1=1 TO 12:PRINT£X,G(X1):NEXT
2130FORX1=1 TO 12:PRINT£X,F(X1):NEXT
2140FORX1=1 TO 12:PRINT£X,C(X1):NEXT
2150CLOSE£X
2160ENDPROC
2170DEF PROCINPUT
2180PRINTTAB(0,0);CHR$131CHR$157TAB(0,1);CHR$131CHR$157TAB(10,0)CHR$131CHR$157CHR$13
3CHR$141"CASHFLOW-recall"TAB(10,1)CHR$131CHR$167CHR$133CHR$141"CASHFLOW-recall"
2190PRINTTAB(0,5);CHR$134CHR$141"Sequence:"TAB(0,6)CHR$134CHR$141"Sequence:"
2200PRINTTAB(8,7);CHR$134"1:Type in name of cashflow."
2210PRINTTAB(8,8);CHR$134"2:Press 'RETURN'."
2220PRINTTAB(8,9);CHR$134"3:Move tape to desired file."
2230PRINTTAB(8,10);CHR$134"4:Press the play button."
2240PRINTTAB(8,11);CHR$134"5:Switch tape off afterwards."
2250PRINTTAB(8,13);CHR$129"Steps 4 and 5 are unneccessary"
2260PRINTTAB(3,14);CHR$129"if the recorder has a motor control"
2270INPUTTAB(4,16)"Cashflow name",F$
2280PRINTTAB(15,20)CHR$132"PLEASE WAIT"
2290X=OPENUP(F$)
2300FORX1=1 TO 12:INPUT£X,R(X1):NEXT
2310FORX1=1 TO 12:INPUT£X,S(X1):NEXT
2320FORX1=1 TO 12:INPUT£X,M(X1):NEXT
2330FORX1=1 TO 12:INPUT£X,P(X1):NEXT
2340FORX1=1 TO 12:INPUT£X,H(X1):NEXT
2350FORX1=1 TO 12:INPUT£X,I(X1):NEXT
2360FORX1=1 TO 12:INPUT£X,W(X1):NEXT
2370FORX1=1 TO 12:INPUT£X,L(X1):NEXT
2380FORX1=1 TO 12:INPUT£X,D(X1):NEXT
2390FORX1=1 TO 12:INPUT£X,G(X1):NEXT
2400FORX1=1 TO 12:INPUT£X,F(X1):NEXT
2410FORX1=1 TO 12:INPUT£X,C(X1):NEXT
2420CLOSE£X
2430ENDPROC
2440DEF PROCMONTH
2450PRINTTAB(0,0);CHR$132CHR$157TAB(0,1);CHR$132CHR$157TAB(10,0)CHR$132CHR$157CHR$13
1CHR$141"CASHFLOW"TAB(10,1)CHR$132CHR$157CHR$131CHR$141"CASHFLOW"
2460PRINTTAB(0,5);"CHOOSE STARTING MONTH:"
2470PRINTTAB(21,6);"A)JANUARY"
2480PRINTTAB(21,7);"B)FEBRUARY"
2490PRINTTAB(21,8);"C)MARCH"
2500PRINTTAB(21,9);"D)APRIL"
2510PRINTTAB(21,10);"E)MAY"
2520PRINTTAB(21,11);"F)JUNE"
2530PRINTTAB(21,12);"G)JULY"
2540PRINTTAB(21,13);"H)AUGUST"
2550PRINTTAB(21,14);"I)SEPTEMBER"
2560PRINTTAB(21,15);"J)OCTOBER"
2570PRINTTAB(21,16);"K)NOVEMBER"
2580PRINTTAB(21,17);"L)DECEMBER"
2590PRINTTAB(0,20);"PRESS OPTION KEY(A-L)"
2600A=GET:IF A<65 OR A>76 THEN GOTO2600
2610A=(A-64)*10:RESTORE (2620+A)
2620READ JAN$,FEB$,MAR$,APR$,MAY$,JUN$,JUL$,AUG$,SEP$,OCT$,NOV$,DEC$
2630DATA J,F,M,A,M,J,J,A,S,O,N,D
2640DATA F,M,A,M,J,J,A,S,O,N,D,J
2650DATA M,A,M,J,J,A,S,O,N,D,J,F
2660DATA A,M,J,J,A,S,O,N,D,J,F,M
2670DATA M,J,J,A,S,O,N,D,J,F,M,A
2680DATA J,J,A,S,O,N,D,J,F,M,A,M
2690DATA J,A,S,O,N,D,J,F,M,A,M,J
2700DATA A,S,O,N,D,J,F,M,A,M,J,J
2710DATA S,O,N,D,J,F,M,A,M,J,J,A
2720DATA O,N,D,J,F,M,A,M,J,J,A,S
2730DATA N,D,J,F,M,A,M,J,J,A,S,O
2740DATA D,J,F,M,A,M,J,J,A,S,O,N
2750ENDPROC
```

Overhead costing program: BBC model B

```
10REM"OVERHEAD COSTING PROGRAM
20REM"COPYRIGHT 1986 T.CROWE
30ON ERROR GOTO80
40MODE6
50VDU5
60PROCASSIGN
70PROCCHART
80PROCCYCLE
90GOTO80
100
110REM"PROGRAM PROCEDURES
120
130REM"MAIN PROGRAM CYCLE
140DEF PROCCYCLE
150T%=0
160PROCKEYSEARCH
170PROCWHICHKEY
180ENDPROC
190
200REM"ASSIGN MAJOR VARIABLES
210DEF PROCASSIGN
220
230REM"DEFINE CONSTANTS
240T%=0:O%=0
250MATAX1=10:MATAX2=20:WETAX=45:HOTAX=40
260BLANK$="        ":TITLE$=""
270
280REM"REDEFINE POUND + DIVIDE SIGNS
290VDU23,35,28,54,48,124,48,48,126,0
300VDU23,33,24,24,0,127,0,24,24,0
310
320REM"DEFINE VARIABLES
330RENT=0:MANT=0:GAS=0:PHON=0:MACH1=0
340MACH2=0:TMAC1=0:TMAC2=0:EQIP=0
350FURN=0:ACON=0:INSU=0:CAR=0:TRAV=0
360EXBT=0:POST=0:CONS=0:WAGE=0
370OTHER=0:YEAR=0:WEEK=0:HOUR=0
380
390REM"CURSOR POSITION VARIABLES
400LOCX=29:LOCY=2
410ENDPROC
420
430REM"PRINT BASIC CHART
440DEF PROCCHART
450@%=5
460PRINT" OVERHEAD/FIXED or INDIRECT COSTS"
470PRINTSPC(13)"DATE:";TITLE$
480PRINTSPC(3)"RENT&RATES"SPC(14)"= "RENT
490PRINTSPC(3)"MAINTENANCE"SPC(13)"= "MANT
500PRINTSPC(3)"ELECTRICITY/GAS"SPC(9)"= "GAS
510PRINTSPC(3)"TELEPHONE"SPC(15)"= "PHON
520PRINTSPC(3)"MACHINERY NEW£ "MACH1"@";:@%=2:PRINTMATAX1;:@%=5:PRINT"%= "TMAC1
530PRINTSPC(13)"S/H£ "MACH2"@";:@%=2:PRINTMATAX2;:@%=5:PRINT"%= "TMAC2
540PRINTSPC(3)"TOOLS"SPC(19)"= "EQIP
550PRINTSPC(3)"FURNITURE"SPC(15)"= "FURN
560PRINTSPC(3)"LEGAL/ACCOUNTANTS"SPC(7)"= "ACON
570PRINTSPC(3)"INSURANCE"SPC(15)"= "INSU
580PRINTSPC(3)"CAR EXPENSES"SPC(12)"= "CAR
590PRINTSPC(3)"TRAVEL"SPC(18)"= "TRAV
600PRINTSPC(3)"EXHIBITIONS"SPC(13)"= "EXBT
610PRINTSPC(3)"POST/STATIONERY"SPC(9)"= "POST
620PRINTSPC(3)"CONSUMABLES"SPC(13)"= "CONS
630PRINTSPC(3)"INDIRECT WAGES"SPC(10)"= "WAGE
640PRINTSPC(3)"OTHER COSTS"SPC(13)"= "OTHER
650PRINT
660PRINTSPC(16)"£~YEAR     = "YEAR
670@%=2:PRINTSPC(16)"£~WEEK(/"WETAX;:@%=5:PRINT")= "WEEK
680@%=2:PRINT" OVERHEAD RATE: £~HOUR(/"HOTAX;:@%=&20208:PRINT")= "HOUR
690IF P%=42 THEN GOTO710
700PRINT:PRINT" PRINT:'P' SAVE:'S' RECALL:'R' WIPE:'W'";
710@%=5
```

Appendix 187

188 Art, Design and Craft

```
 720ENDPROC
 730
 740DEF PROCLOCATE(LX,LY)
 750ON LY GOTO
760,770,780,790,800,810,820,830,840,850,860,870,880,890,900,910,920,930,10,10,940,950

 760T%=42:BLANK$="         ":ENDPROC
 770DUMMY=RENT:ENDPROC
 780DUMMY=MANT:ENDPROC
 790DUMMY=GAS:ENDPROC
 800DUMMY=PHON:ENDPROC
 810IF LX=18 DUMMY=MACH1:ENDPROC ELSE DUMMY=MATAX1:@%=2:BLANK$="     ":ENDPROC
 820IF LX=18 DUMMY=MACH2:ENDPROC ELSE DUMMY=MATAX2:@%=2:BLANK$="     ":ENDPROC
 830DUMMY=EQIP:ENDPROC
 840DUMMY=FURN:ENDPROC
 850DUMMY=ACON:ENDPROC
 860DUMMY=INSU:ENDPROC
 870DUMMY=CAR:ENDPROC
 880DUMMY=TRAV:ENDPROC
 890DUMMY=EXBT:ENDPROC
 900DUMMY=POST:ENDPROC
 910DUMMY=CONS:ENDPROC
 920DUMMY=WAGE:ENDPROC
 930DUMMY=OTHER:ENDPROC
 940DUMMY=WETAX:@%=2:BLANK$="     ":ENDPROC
 950DUMMY=HOTAX:@%=2:BLANK$="     ":ENDPROC
 960
 970REM"KEY RESPONSE
 980DEF PROCKEYSEARCH
 990VDU23;11,0;0;0;0;
1000*FX4,1
1010BLANK$="         "
1020PROCLOCATE(LOCX,LOCY)
1030PRINTTAB(LOCX,LOCY)BLANK$
1040A$=INKEY$(37.5):IF A$<>"" THEN GOTO 1100
1050IF T%=42 GOTO 1070
1060PRINTTAB(LOCX,LOCY)DUMMY;:GOTO 1080
1070PRINTTAB(LOCX,LOCY)TITLE$;
1080A$=INKEY$(37.5):IF A$<>"" THEN GOTO 1100
1090GOTO1030
1100*FX4
1110@%=5
1120ENDPROC
1130REM"WHICH KEY WAS PRESSED
1140DEF PROCWHICHKEY
1150
1160REM"WAS THE DOWN KEY PRESSED?
1170IF ASC(A$)=138 AND LOCY<22 THEN PROCDOWN
1180
1190REM"WAS THE UP KEY PRESSED?
1200IF ASC(A$)=139 AND LOCY>1 THEN PROCUP:ENDPROC
1210
1220REM"WAS THE LEFT KEY PRESSED?
1230IF ASC(A$)=136 AND (LOCY=6 OR LOCY=7) AND LOCX=24 THEN
@%=2:PRINTTAB(LOCX,LOCY)DUMMY:LOCX=18:@%=5:BLANK$="     ":ENDPROC
1240
1250REM"WAS THE RIGHT KEY PRESSED?
1260IF ASC(A$)=137 AND (LOCY=6 OR LOCY=7) AND LOCX=18 THEN
PRINTTAB(LOCX,LOCY)DUMMY:LOCX=24:@%=2:ENDPROC
1270
1280REM"WAS AN INPUT MADE
1290IF LOCY>1 AND ASC(A$)>47 AND ASC(A$)<58 THEN PROCINPUT:PROCWHICHKEY:ENDPROC
1300IF LOCY=1 AND ASC(A$)=13 THEN PROCTITINP:O%=42:ENDPROC
1310REM"WAS PRINT SELECTED
1320IF ASC(A$)=80 THEN PROCPRINT
1330
1340REM"WAS SAVE SELECTED
1350IF ASC(A$)=83 THEN PROCSAVE
1360
1370REM"WAS RECALL SELECTED
1380IF ASC(A$)=82 THEN PROCRECALL
1390
1400REM"WAS WIPE SELECTED
1410IF ASC(A$)=87 THEN RUN
1420ENDPROC
```

```
1430
1440REM"MOVE CURSOR DOWN
1450DEF PROCDOWN
1460IF LOCX=24 THEN @%=2
1470IF LOCY>1 THEN PRINTTAB(LOCX,LOCY)DUMMY
1480@%=5
1490IF LOCY=18 THEN LOCY=21:LOCX=24:@%=2:ENDPROC
1500IF LOCY=1 THEN PRINTTAB(LOCX,LOCY)TITLE$:LOCY=2:LOCX=29:T%=0:ENDPROC
1510IF LOCY=5 THEN LOCX=18
1520IF LOCY=7 THEN LOCX=29:@%=5:BLANK$="       "
1530LOCY=LOCY+1
1540ENDPROC
1550
1560REM"MOVE CURSOR UP
1570DEF PROCUP
1580IF LOCX=24 THEN @%=2
1590PRINTTAB(LOCX,LOCY)DUMMY
1600@%=5
1610IF LOCY=21 THEN LOCY=18:LOCX=29:@%=5:BLANK$="       ":ENDPROC
1620IF LOCY=6 THEN LOCX=29:@%=5:BLANK$="       "
1630IF LOCY=8 THEN LOCX=18
1640LOCY=LOCY-1
1650IF LOCY=1 THEN LOCX=18
1660ENDPROC
1670
1680REM"PRINT OUT PROCEDURE
1690DEF PROCPRINT
1700CLS
1710VDU2
1720P%=42
1730PROCCHART
1740P%=0
1750VDU3
1760ENDPROC
1770
1780REM"SAVE LIST
1790DEF PROCSAVE
1800PRINTTAB(0,24)SPC(39);
1810IF TITLE$="" THEN GOTO 1890
1820PRINTTAB(0,24)" INSERT CORRECT DISC THEN PRESS ANY KEY";
1830A$=GET$
1840X=OPENOUT(TITLE$)
1850PRINT£X,MATAX1:PRINT£X,MATAX2:PRINT£X,WETAX:PRINT£X,HOTAX:PRINT£X,TITLE$:PRINT£X
,RENT:PRINT£X,MANT:PRINT£X,GAS:PRINT£X,PHON:PRINT£X,MACH1:PRINT£X,MACH2:PRINT£X,TMAC1
:PRINT£X,TMAC2:PRINT£X,EQIP:PRINT£X,FURN:PRINT£X,ACON:PRINT£X,INSU
 1860PRINT£X,CAR:PRINT£X,TRAV:PRINT£X,EXBT:PRINT£X,POST:PRINT£X,CONS:PRINT£X,WAGE:PRI
NT£X,OTHER:PRINT£X,YEAR:PRINT£X,WEEK:PRINT£X,HOUR
 1870CLOSE£X
 1880GOTO1900
 1890PRINTTAB(0,24)"        INSERT DATE OF COSTSHEET";:A$=GET$
 1900CLS:PROCCHART
 1910ENDPROC
 1920
 1930REM"CHANGING THE FACTS
 1940DEF PROCINPUT
 1950X=LEN(BLANK$)-1
 1960X1=X:FORY=1 TO X:A$=".."+A$:NEXT
 1970REPEAT
 1980PRINT TAB(LOCX,LOCY)A$;TAB(LOCX+X,LOCY);
 1990VDU23;11,255;0;0;0;
 2000*FX4,1
 2010B$=GET$
 2020IF ASC(B$)>135 AND ASC(B$)<140 THEN X1=2:GOTO2050
 2030IF B$<"0" OR B$>"9" THEN GOTO1980
 2040A$=RIGHT$(A$,X)+B$
 2050X1=X1-1:UNTILX1-1=0
 2060IF ASC(B$)>135 AND ASC(B$)<140 THENPROCALTER:GOTO2080
 2070X1=X:GOTO1970
 2080ENDPROC
 2090DEF PROCTITINP
 2100VDU23;11,255;0;0;0;
 2110A$=BLANK$:PRINTTAB(LOCX,LOCY)A$
 2120*FX4
 2130INPUTTAB(LOCX,LOCY)TITLE$
 2140IF LEN(TITLE$)>7 OR TITLE$="" THEN GOTO2110
```

Appendix 189

```
2150IF LEFT$(TITLE$,1)>="0" AND LEFT$(TITLE$,1)<="9" THEN GOTO2110
2160ENDPROC
2170
2180REM"CHANGE VALUE OF A VARIABLE
2190DEF PROCALTER
2200IF MID$(A$,1,1)="." THEN A$="0"+MID$(A$,2,LEN(A$)) ELSE 2260
2210IF MID$(A$,2,1)="." THEN A$="00"+MID$(A$,3,LEN(A$)) ELSE 2260
2220IF MID$(A$,3,1)="." THEN A$="000"+MID$(A$,4,LEN(A$)) ELSE 2260
2230IF MID$(A$,4,1)="." THEN A$="0000"+MID$(A$,5,LEN(A$)) ELSE 2260
2240IF MID$(A$,5,1)="." THEN A$="00000"+MID$(A$,6,LEN(A$)) ELSE 2260
2250IF MID$(A$,6,1)="." THEN A$="000000"+MID$(A$,7,LEN(A$)) ELSE 2260
2260ON LOCY GOTO
2270,2280,2290,2300,2310,2320,2330,2340,2350,2360,2370,2380,2390,2400,2410,2420,2430,
2440,10,10,2450,2460
2270T%=42:TITLE$=A$:GOTO2470
2280RENT=EVAL(A$):GOTO2470
2290MANT=EVAL(A$):GOTO2470
2300GAS=EVAL(A$):GOTO2470
2310PHON=EVAL(A$):GOTO2470
2320IF LOCX=18 MACH1=EVAL(A$):GOTO2470 ELSE MATAX1=EVAL(A$):BLANK$="        ":GOTO2470
2330IF LOCX=18 MACH2=EVAL(A$):GOTO2470 ELSE MATAX2=EVAL(A$):BLANK$="        ":GOTO2470
2340EQIP=EVAL(A$):GOTO2470
2350FURN=EVAL(A$):GOTO2470
2360ACON=EVAL(A$):GOTO2470
2370INSU=EVAL(A$):GOTO2470
2380CAR=EVAL(A$):GOTO2470
2390TRAV=EVAL(A$):GOTO2470
2400EXBT=EVAL(A$):GOTO2470
2410POST=EVAL(A$):GOTO2470
2420CONS=EVAL(A$):GOTO2470
2430WAGE=EVAL(A$):GOTO2470
2440OTHER=EVAL(A$):GOTO2470
2450WETAX=EVAL(A$):BLANK$="        ":GOTO2470
2460HOTAX=EVAL(A$):BLANK$="        ":GOTO2470
2470DUMMY=EVAL(A$):A$=B$
2480PROCCALCULATE
2490PROCLOCATE(LOCX,LOCY):CLS:PROCCHART
2500ENDPROC
2510
2520REM"CALCULATE COSTSHEET
2530DEF PROCCALCULATE
2540TMAC1=(MACH1/100)*MATAX1
2550TMAC2=(MACH2/100)*MATAX2
2560YEAR=INT(RENT+MANT+GAS+PHON+TMAC1+TMAC2+EQIP+FURN+ACON+INSU+CAR+TRAV+EXBT+POST+C
ONS+WAGE+OTHER)
2570TMAC1=INT(TMAC1):TMAC2=INT(TMAC2)
2580WEEK=INT(YEAR/WETAX):HOUR=WEEK/HOTAX
2590ENDPROC
2600DEF PROCRECALL
2610PRINTTAB(0,24)"                                                    ";
2620INPUTTAB(0,24)"DATE:"NAME$
2630PRINTTAB(0,23)" INSERT CORRECT DISC THEN PRESS ANY KEY";
2640A$=GET$
2650X=OPENIN(NAME$)
2660INPUT£X,MATAX1:INPUT£X,MATAX2:INPUT£X,WETAX:INPUT£X,HOTAX:INPUT£X,TITLE$:INPUT£X
,RENT:INPUT£X,MANT:INPUT£X,GAS:INPUT£X,PHON:INPUT£X,MACH1:INPUT£X,MACH2:INPUT£X,TMAC1
:INPUT£X,TMAC2:INPUT£X,EQIP:INPUT£X,FURN:INPUT£X,ACON:INPUT£X,INSU
2670INPUT£X,CAR:INPUT£X,TRAV:INPUT£X,EXBT:INPUT£X,POST:INPUT£X,CONS:INPUT£X,WAGE:INP
UT£X,OTHER:INPUT£X,YEAR:INPUT£X,WEEK:INPUT£X,HOUR
2680CLOSE£X
2690CLS:PROCCHART
2700ENDPROC
```

Appendix 191

Product costing program: BBC model B

```
10REM"PRODUCT COSTING
20REM"COPYRIGHT:T.CROWE 1986
30
40MODE3
50ON ERROR GOTO120
60PROCINIT
70
80REM"MAIN CYCLE
90PROCCALC
100PROCCHART
110PROCINPUT
120CLS:GOTO90
130
140REM"DEFINE VARIABLES
150DEF PROCINIT
160P=0
170DESC$=""
180CODE$=""
190SUBCON=0
200DIM MAT$(6),MAT(6,3),X$(3)
210DIM LAB(2,3)
220DIM OERHEAD(3),PROFIT(2),DISCNT(2)
230DIM TTAL(4),MARK(2),VAT(2)
240CSTPRICE=0:SLGPRICE=0:SHOPPRI=0
250LOCX=12:LOCY=1
260ENDPROC
270
280REM"STRING CONVERSION
290DEF PROCCONVERT(C,CHECK)
300IF CHECK=42 THEN C=C*100
310C=INT(C)
320C$=STR$(C)
330IF C=0 AND CHECK=42 THEN C$=C$+"00"
340IF CHECK=42 THEN C$=FNDECIMAL(C$)
350ENDPROC
360DEF FNDECIMAL(X$)=LEFT$(X$,LEN(X$)-2)+"."+RIGHT$(X$,2)
370
380REM"PRINT CHART
390DEF PROCCHART
400VDU23;11,0;0;0;0;
410PRINT"PRODUCT COSTING"
420PRINT"DESCRIPTION:";SPC(20-LEN(DESC$));DESC$;" CODE:";SPC(7-LEN(CODE$));CODE$
430PRINT"MATERIALS:";
440FOR X=1 TO 6
450FOR Y=1 TO 3
460IF Y>1 THEN PROCCONVERT(MAT(X,Y),42) ELSE PROCCONVERT(MAT(X,Y),0)
470X$(Y)=C$
480NEXT
490IF X>1 THEN PRINTSPC(10);
500PRINT;X" ";SPC(9-LEN(MAT$(X));MAT$(X);" QTY ";
510PRINTSPC(4-LEN(X$(1)));X$(1);"  @   ";
520PRINTSPC(9-LEN(X$(2)));X$(2);" = ";SPC(9-LEN(X$(3)));X$(3)
530NEXT
540PRINT"SUBCONTRACTORS:";SPC(31);" ";
550PROCCONVERT(SUBCON,42):X$(1)=C$
560PRINT;SPC(9-LEN(X$(1)));X$(1)
570PROCCONVERT(TTAL(1),42):X$(1)=C$
580PRINTSPC(40);"TOTAL    ";SPC(9-LEN(X$(1)));X$(1);SPC(19-LEN(X$(1)));X$(1)
590PRINT"LABOUR:";SPC(13);
600FORX=1 TO 2
610FORY=1 TO 3
620IF Y=1 THEN PROCCONVERT(LAB(X,Y),0) ELSE PROCCONVERT(LAB(X,Y),42)
630X$(Y)=C$
640NEXT
650IF X>1 THEN PRINTSPC(20);
660PRINT;X;". ";SPC(4-LEN(X$(1)));X$(1);" Hrs @   ";SPC(9-LEN(X$(2)));X$(2);" = ";SPC(9-LEN(X$(3)));X$(3)
670NEXT
680PROCCONVERT(TTAL(2),42):X$(1)=C$
690PRINTSPC(40);"TOTAL    ";SPC(9-LEN(X$(1)));X$(1);SPC(19-LEN(X$(1)));X$(1)
700PROCCONVERT(OERHEAD(1),0):X$(1)=C$
```

192 Art, Design and Craft

```
710FORX=2 TO 3:PROCCONVERT(OERHEAD(X),42):X$(X)=C$:NEXT
720PRINT"OVERHEAD";SPC(15);SPC(4-LEN(X$(1)));X$(1);" Hrs @
";SPC(9-LEN(X$(2)));X$(2);" = ";SPC(9-LEN(X$(3)));X$(3);SPC(19-LEN(X$(3)));X$(3)
730PROCCONVERT(CSTPRICE,42):X$(1)=C$
740PRINTSPC(50);"COST PRICE:";SPC(15-LEN(X$(1)));X$(1)
750PROCCONVERT(PROFIT(1),0):X$(1)=C$
760PROCCONVERT(PROFIT(2),42):X$(2)=C$
770PRINTSPC(54);"PROFIT @ ";SPC(3-LEN(X$(1)));X$(1);"%";SPC(9-LEN(X$(2)));X$(2)
780PROCCONVERT(TTAL(3),42):X$(1)=C$
790PRINTSPC(67);SPC(9-LEN(X$(1)));X$(1)
800PROCCONVERT(DISCNT(1),0):X$(1)=C$
810PROCCONVERT(DISCNT(2),42):X$(2)=C$
820PRINTSPC(52);"DISCOUNT @ ";SPC(3-LEN(X$(1)));X$(1);"%";SPC(9-LEN(X$(2)));X$(2)
830PROCCONVERT(SLGPRICE,42):X$(1)=C$
840PRINTSPC(47);"SELLING PRICE:";SPC(15-LEN(X$(1)));X$(1)
850PROCCONVERT(MARK(1),0):X$(1)=C$
860PROCCONVERT(MARK(2),42):X$(2)=C$
870PRINTSPC(47);"RETAIL MARKUP @
";SPC(3-LEN(X$(1)));X$(1);"%";SPC(9-LEN(X$(2)));X$(2)
880PROCCONVERT(TTAL(4),42):X$(1)=C$
890PRINTSPC(67);SPC(9-LEN(X$(1)));X$(1)
900PROCCONVERT(VAT(1),0):X$(1)=C$
910PROCCONVERT(VAT(2),42):X$(2)=C$
920PRINTSPC(56);"+VAT @ ";SPC(3-LEN(X$(1)));X$(1);"%";SPC(9-LEN(X$(2)));X$(2)
930PROCCONVERT(SHOPPRI,42):X$(1)=C$
940PRINTSPC(43);"SHOP WINDOW PRICE:";SPC(15-LEN(X$(1)));X$(1)
950IF P=42 GOTO970
960PRINTSPC(15);"PRINT '@' SAVE ';' RECALL ':' NEW COSTING '/'"
970ENDPROC
980
990REM"CALCULATE CHART
1000DEF PROCCALC
1010ADD=0
1020FOR X=1 TO 6
1030MAT(X,3)=MAT(X,1)*MAT(X,2)
1040ADD=ADD+MAT(X,3)
1050NEXT
1060TTAL(1)=SUBCON+ADD:ADD=0
1070FOR X=1 TO 2
1080LAB(X,3)=LAB(X,1)*LAB(X,2)
1090ADD=ADD+LAB(X,3)
1100NEXT
1110TTAL(2)=ADD
1120OERHEAD(3)=OERHEAD(1)*OERHEAD(2)
1130CSTPRICE=TTAL(1)+TTAL(2)+OERHEAD(3)
1140PROFIT(2)=(CSTPRICE/100)*PROFIT(1)
1150TTAL(3)=CSTPRICE+PROFIT(2)
1160SLGPRICE=(TTAL(3)/(100-DISCNT(1)))*100
1170DISCNT(2)=(SLGPRICE/100)*DISCNT(1)
1180MARK(2)=(SLGPRICE/100)*MARK(1)
1190TTAL(4)=SLGPRICE+MARK(2)
1200VAT(2)=(TTAL(4)/100)*VAT(1)
1210SHOPPRI=TTAL(4)+VAT(2)
1220ENDPROC
1230DEF PROCLOCATE
1240ON LOCY
GOTO1250,1270,1270,1270,1270,1270,1270,1300,10,1310,1310,10,1330,10,1350,10,1360,10,1
370,10,1380
1250IF LOCX=12 THEN BLANK$="                 ":DUMMY$=DESC$ ELSE BLANK$="
":DUMMY$=CODE$
1260GOTO1390
1270IF LOCX=12 THEN BLANK$="       ":DUMMY$=MAT$(LOCY-1):GOTO1390
1280IF LOCX=26 THEN BLANK$="    ":PROCCONVERT(MAT(LOCY-1,1),0):DUMMY$=C$:GOTO1390
1290IF LOCX>26 THEN BLANK$="
":PROCCONVERT(MAT(LOCY-1,2),42):DUMMY$=C$:GOTO1390
1300BLANK$="        ":PROCCONVERT(SUBCON,42):DUMMY$=C$:GOTO1390
1310IF LOCX=23 THEN BLANK$="    ":PROCCONVERT(LAB(LOCY-9,1),0):DUMMY$=C$:GOTO1390
1320BLANK$="       ":PROCCONVERT(LAB(LOCY-9,2),42):DUMMY$=C$:GOTO1390
1330IF LOCX=23 THEN BLANK$="    ":PROCCONVERT(OERHEAD(1),0):DUMMY$=C$:GOTO1390
1340IF LOCX=35 THEN BLANK$="       ":PROCCONVERT(OERHEAD(2),42):DUMMY$=C$:GOTO1390
1350BLANK$="    ":PROCCONVERT(PROFIT(1),0):DUMMY$=C$:GOTO1390
1360BLANK$="    ":PROCCONVERT(DISCNT(1),0):DUMMY$=C$:GOTO1390
1370BLANK$="    ":PROCCONVERT(MARK(1),0):DUMMY$=C$:GOTO1390
1380BLANK$="    ":PROCCONVERT(VAT(1),0):DUMMY$=C$:GOTO1390
1390ENDPROC
```

Appendix 193

```
1400
1410REM"ALTER CHART
1420DEF PROCINPUT
1430PROCLOCATE
1440*FX4,1
1450PRINTTAB(LOCX,LOCY);BLANK$
1460A=INKEY(37.5)
1470IF A>0 THEN GOTO 1530
1480IF DUMMY$="" THEN DUMMY$="_"
1490PRINTTAB(LOCX,LOCY);SPC(LEN(BLANK$)-LEN(DUMMY$));DUMMY$
1500A=INKEY(37.5)
1510IF A>0 THEN GOTO 1530
1520GOTO1450
1530IF A<>136 THEN GOTO 1620
1540IF LOCX=12 OR LOCX=23 OR LOCX=63 THEN GOTO 1430
1550IF DUMMY$="_" THEN DUMMY$=""
1560PRINTTAB(LOCX,LOCY);SPC(LEN(BLANK$)-LEN(DUMMY$));DUMMY$
1570IF LOCX=38 THEN LOCX=12:GOTO 1610
1580IF LOCX=35 AND LOCY>8 THEN LOCX=23:GOTO1610
1590IF LOCX=26 THEN LOCX=12:GOTO 1610
1600IF LOCX=35 THEN LOCX=26
1610GOTO1430
1620IF A<>137 THEN GOTO 1710
1630IF LOCX=38 OR LOCX=35 OR LOCX=64 THEN GOTO 1430
1640IF DUMMY$="_" THEN DUMMY$=""
1650PRINTTAB(LOCX,LOCY);SPC(LEN(BLANK$)-LEN(DUMMY$));DUMMY$
1660IF LOCX=12 AND LOCY=1 THEN LOCX=38:GOTO1700
1670IF LOCX=12 THEN LOCX=26:GOTO 1700
1680IF LOCX=26 THEN LOCX=35:GOTO 1700
1690IF LOCX=23 THEN LOCX=35:
1700GOTO1430
1710IF A<>139 THEN GOTO 1860
1720IF LOCY=1 THEN GOTO1430
1730IF DUMMY$="_" THEN DUMMY$=""
1740PRINTTAB(LOCX,LOCY);SPC(LEN(BLANK$)-LEN(DUMMY$));DUMMY$
1750IF LOCY=2 THEN LOCY=1:LOCX=12:GOTO 1850
1760IF LOCY>2 AND LOCY<8 THEN LOCY=LOCY-1:GOTO 1850
1770IF LOCY=8 THEN LOCY=7:LOCX=35:GOTO 1850
1780IF LOCY=10 THEN LOCY=8:LOCX=48:GOTO1850
1790IF LOCY=11 THEN LOCY=10:GOTO 1850
1800IF LOCY=13 THEN LOCY=11:GOTO 1850
1810IF LOCY=15 THEN LOCY=13:LOCX=35:GOTO 1850
1820IF LOCY=17 THEN LOCY=15:GOTO 1850
1830IF LOCY=19 THEN LOCY=17:GOTO 1850
1840IF LOCY=21 THEN LOCY=19:GOTO 1850
1850GOTO1430
1860IF A<>138 THEN GOTO 1980
1870IF LOCY=21 THEN GOTO1430
1880IF DUMMY$="_" THEN DUMMY$=""
1890PRINTTAB(LOCX,LOCY);SPC(LEN(BLANK$)-LEN(DUMMY$));DUMMY$
1900IF LOCY=13 THEN LOCY=15:LOCX=63:GOTO 1970
1910IF LOCY<22 AND LOCY>10 THEN LOCY=LOCY+2:GOTO 1970
1920IF LOCY=10 THEN LOCY=11:GOTO 1970
1930IF LOCY=8 THEN LOCY=10:LOCX=23:GOTO 1970
1940IF LOCY=7 THEN LOCY=8:LOCX=48:GOTO 1970
1950IF LOCY>1 AND LOCY<7 THEN LOCY=LOCY+1:GOTO 1970
1960IF LOCY=1 THEN LOCY=2:LOCX=12:GOTO 1970
1970GOTO1430
1980IF A=13 PROCALTER:ENDPROC
1990IF A=64 CLS:VDU2:P=42:PROCCHART:P=0:VDU3:ENDPROC
2000IF A=47 THEN RUN
2010IF A=59 THEN PROCSAVE:ENDPROC
2020IF A=58 THEN PROCRECALL:ENDPROC
2030GOTO1430
2040DEF PROCALTER
2050PRINTTAB(LOCX,LOCY);BLANK$
2060VDU23;11,255;0;0;0;
2070INPUTTAB(LOCX,LOCY)X$
2080VDU23;11,0;0;0;0;
2090ON LOCY
GOTO2100,2130,2130,2130,2130,2130,2130,2170,10,2180,2180,10,2200,10,2220,10,2230,10,2
240,10,2250
2100IF LOCX=12 THEN DESC$=X$:GOTO2120
2110CODE$=X$
2120ENDPROC
```

194 Art, Design and Craft

```
2130IF LOCX=12 THEN MAT$(LOCY-1)=X$
2140IF LOCX=26 THEN MAT(LOCY-1,1)=VAL(X$)
2150IF LOCX=35 THEN MAT(LOCY-1,2)=VAL(X$)
2160ENDPROC
2170SUBCON=VAL(X$):ENDPROC
2180IF LOCX=23 THEN LAB(LOCY-9,1)=VAL(X$):ENDPROC
2190IF LOCX=35 THEN LAB(LOCY-9,2)=VAL(X$):ENDPROC
2200IF LOCX=23 THEN OERHEAD(1)=VAL(X$):ENDPROC
2210IF LOCX=35 THEN OERHEAD(2)=VAL(X$):ENDPROC
2220PROFIT(1)=VAL(X$):ENDPROC
2230DISCNT(1)=VAL(X$):ENDPROC
2240MARK(1)=VAL(X$):ENDPROC
2250VAT(1)=VAL(X$):ENDPROC
2260
2270REM"SAVE ROUTINE
2280DEF PROCSAVE
2290IF CODE$="" THEN PRINTTAB(0,23)"                        ":PRINTTAB(0,23)"INPUT CODE FIRST":A$=GET$:ENDPROC
2300X=OPENOUT(CODE$)
2310PRINT£X,DESC$
2320FOR X1=1 TO 6
2330PRINT£X,MAT$(X1)
2340FOR X2=1 TO 2
2350PRINT£X,MAT(X1,X2)
2360NEXT:NEXT
2370PRINT£X,SUBCON
2380FOR X1=1 TO 2
2390FOR X2=1 TO 2
2400PRINT£X,LAB(X1,X2)
2410NEXT:NEXT
2420FOR X1=1 TO 2:PRINT£X,OERHEAD(X1):NEXT
2430PRINT£X,PROFIT(1)
2440PRINT£X,DISCNT(1)
2450PRINT£X,MARK(1)
2460PRINT£X,VAT(1)
2470CLOSE£X
2480ENDPROC
2490
2500REM"RECALL ROUTINE
2510DEF PROCRECALL
2520INPUTTAB(0,24)"CODE:"CODE$
2530IF CODE$="" THEN ENDPROC
2540X=OPENIN(CODE$)
2550INPUT£X,DESC$
2560FOR X1=1 TO 6
2570INPUT£X,MAT$(X1)
2580FOR X2=1 TO 2
2590INPUT£X,MAT(X1,X2)
2600NEXT:NEXT
2610INPUT£X,SUBCON
2620FOR X1=1 TO 2
2630FOR X2=1 TO 2
2640INPUT£X,LAB(X1,X2)
2650NEXT:NEXT
2660FOR X1=1 TO 2:INPUT£X,OERHEAD(X1):NEXT
2670INPUT£X,PROFIT(1)
2680INPUT£X,DISCNT(1)
2690INPUT£X,MARK(1)
2700INPUT£X,VAT(1)
2710CLOSE£X
2720ENDPROC
```

Index

Index

account book (ledger), 10
accountants, 39–40
 services of, 171–2
accounting, 41
 common terms in, 42–4
accounts payable book, 49
accounts receivable book, 49
added value, 87
address book, 8
addresses, useful, 173
advertising, 99–101
artwork, photographing, 151
assets, 42–4

balance sheet, 43
bank account, business, 10, 40
bank loan application, 68
bank manager, the, 172
bank overdraft, 61
bank reconciliation statement, 44, 49
bank term loans, 61
Beeston, Mary and Larry, 138–42
bills of sale, 132
bookkeeping, basic, 38
breach of contract, 20
 remedies for, 21
Broadbent, Roger, 151
brochures, 95
business bank account, 10, 40
business cards, 9, 94
business organisation, 22

calendar of trade events, 8
cancellation clauses, 134
capital, 43
card index, 8
cash analysis, 38
cashflow, 64
 example of, 66, 67, 73
cash payments book, 48
cash receipts book, 48
chemical hazards, 149
colour prints, 154
colour temperature, 153
commission agreements, 130

commissions, 129
 for design work, 134
 negotiation of, 129
company formation, 24
computers, use of, 11
confidentiality, 34, 137
consequential loss, 80
consideration, 17
consignment selling, 118–9
 records of, 120
consultancy agreement, 137
consumer profiles, 89
contact lenses, hazards of, 149–50
contracts, 16–21
 acceptance of, 17
 and Sale of Goods Act (1979), 20
 breach of, 21
 conditions of, 20
 definition of, 16
 formation of, 19
 misrepresentation in, 19
 mistakes in, 19
 offer of, 16–17
 remedies for breach of, 21
 terms of, 17–18
 warranties of, 20
contracts of sale, 132–4
controlled variation, 88
conversion filters, 155
copyright, 25
 and commissioned works, 35
 assignment of, 36, 137
 duration of, 28–9
 infringement of, 29
 ownership of, 29
 protection of, 29
 transfer of, 29, 35
Copyright Act 1956, 25
COSIRA, 71
cost price, 107
costing, 105
Crafts Council, 71
credit note, 111
credit terms, 63
curriculum vitae, 9, 95

Index

Darlow, Michael, 84
delivery date, 116
delivery, late, 116
delivery note, 111
depreciation, 44
diary, 7
direct sales, 120
discounts, 107
documentation, 110, 113
 for export, 144
dust hazards, 148

electricity hazards, 147
equity, 43
equity capital, 57
ex-factory price, 107
exhibition,
 agreement for, 126–7
 offer of, 126
expenses, 39, 135
export credit guarantees, 145
exporting, 143

fairs, 120
fees, 122
filing system, 8
films, types of, 154
finance, major sources of, 61
financial management, 51
financial records, 38
fire hazards, 148
fluorescent lighting, 155
fume and dust hazards, 148
funds,
 and start-up, 53
 and working capital, 43, 52
 external sources of, 61, 69
 internal sources of, 63
 need for, 51

galleries, 125
gallery agreement, 127
gallery exhibition, 126
gallery representation, offer of, 127

health hazards, 146
 legislation for, 150
 toxic substances and, 148
hire purchase, 61

income tax, 74
 allowable deductions for, 39
insurance, 78
 and consequential loss, 80
 and property, 74
 and risk management, 78
 liability, 80
 personal, 80
 types of, 79
insurance brokers, 80, 172
interest rates, 58
interest, true rate of, 59
invoices, 111

labelling, for export, 144
labour costs, 107
late delivery, 116
leasing finance, 62
ledgers, 10
letterheads, 9, 94
liability, 42
liability insurance, 80
licence, 36
lighting,
 and exposure determination, 155
 and texture, 165
 contrast ratios for, 158
 for 2D work, 162
 for 3D work, 165
lighting sources, 160
limited liability companies, 23
literary works, 27
loan guarantee scheme, 69
loans, personal, 63

machinery hazards, 147
marketing, 82
 and pricing, 83
 and promotion, 91
 segmentation, 82
marketing mix, the, 83
mark-up, 118
media release, 97
mounting slides, 167

National Insurance, 76

objectives, 4
orders, 111
overdrafts, 61
overheads, 106

packing and despatching, 143
paperwork, 110, 113
 for export, 144
partnerships, 22
 agreement in, 23
passing off, 31
Patent Office, the, 34
patents, 33
 and confidentiality, 34
pensions, 76
personal computer, use of, 11

Index

personal loans, 63
petty cash, 40
photographing artwork, 151
physical stress hazards, 149
pilferage, 144
planning controls, 12
portfolio, 95
pre-planning, 3, 14
premises, 12
press releases, 97
pricing, 104
product costing, 106, 109
product mix, 83
professional image, 91
professional services, 171
profit, 55, 107
profit and loss statement, 45
promotion, 91
 personal, 101
 tools for, 92
publications, 176
publicity, 97

quotations, 135

raising money, 68
range building, 87
record keeping, 38–50
registered designs, 30
Registrar of Companies, 24
repeat selling, 88
restricted offering, 88
revenue, 44
risk management, 78
royalties, 122

sale and lease-back, 62
sale or return, 117
sales *see* selling
sample, sale by, 20
selling,
 channels for, 114
 direct, 120
 wholesaling, 115
shows and fairs, 120
slide mounting, 167
sole trader, 22
solicitors, 172
solvents, as health hazards, 146
sources of finance, 69
start-up, 7
 funds for, 53
statements, 112
stress hazards, 144
subcontractors, 64

taxation, 74
toxic substances, 148
trade creditors, 63
trade marks, 32
transportation, export, 143
travelling expenses, 135

Value Added Tax, 75

welding hazards, 149
wholesaling, 115
working capital, 43, 52

year programmer, 9